Asian Art in The Art Institute of Chicago

Asian Art in

Elinor L. Pearlstein and James T. Ulak

With Contributions

The Art Institute of Chicago

by Naomi Noble Richard and Deborah Del Gais Muller

Preface by Yutaka Mino

The Art Institute of Chicago

The Art Institute of Chicago
Publications Department
Susan F. Rossen, Executive Director

Edited by Peter Junker,
assisted by Anne Rose Kitagawa
Production by Katherine Houck Fredrickson,
assisted by Manine Golden

Designed by Lynn Martin, Chicago
Typeset by Paul Baker Typography, Inc., Evanston, Illinois
Printed by Dai Nippon Printing Co., Ltd., Tokyo

Photographs by the Department of Imaging
and Technical Services
Alan B. Newman, Executive Director
Robert Hashimoto, principal photographer
Photograph on page 79 by
The Metropolitan Museum of Art, New York

Front cover:
Detail of *Maize and Cockscomb*
Six-fold screen; colors and gold leaf on paper
Japan, Edo period; mid-seventeenth century; Ill. pp. 114–15

Frontispiece:
Detail of *Bamboo-Covered Stream in Spring Rain*
Painted by Xia Chang (1388–1470); Handscroll; ink on paper
China, Ming dynasty; dated 1441

Hardcover ISBN: 0–8109–1916–8
Softcover ISBN: 0–86559–095–8

Contents

Preface and Acknowledgments 6
Yutaka Mino

The Department of Asian Art 7
Elinor L. Pearlstein

Prehistoric and Early Dynastic China 11

Eastern Zhou and Han Decorative Style 23

Furnishings for this World and the Next 29

Buddhist Sculpture: Divine Compassion and Worldly Elegance 37

Ceramics and Silver of the Golden Age 45

Song Ceramics and Later Porcelain Traditions 55

Traditions of Chinese Painting 67

Ceramic Art of Korea 81

Resplendent Presence: Japanese Sacred Imagery 87

Images of Zen: Visions of Severity and Surprise 103

The Emergence of Japanese Decorative Taste 111

Images of the Floating World 127

Catalogue 147

Preface and Acknowledgments

The works of art that are illustrated in this volume were chosen from The Art Institute of Chicago's collection of more than twenty thousand Asian objects, representing the achievements of artists in virtually every surviving medium over a period of five thousand years. For myself and my colleagues, the prospect of creating a book that provides an accessible and brief introduction to this outstanding collection was both a challenge and an honor.

In selecting individual artworks for publication, we necessarily focused on but a few, brilliant points within a vast and varied cultural landscape. Our intention was not to create a comprehensive atlas of Asian art, nor even to represent the full scope of the Asian collection. While the Department of Asian Art is also steward to objects from India, Southeast Asia, and much of the Near and Middle East, the present volume restricts itself to art from China, Korea, and Japan, those nations represented in our galleries of East Asian Art. Within those limits, this book concentrates on the strengths of the Art Institute's collection, following routes of inquiry and discussion suggested by areas of particular depth or by single works of eminent quality.

Much of the formative work for this publication resulted from our 1992 installation of the remodeled and

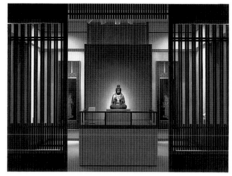

Entrance to the Galleries of East Asian Art, 1992

expanded galleries of East Asian art. These galleries, after three years of planning and construction, now extend over 16,500 square feet and offer visitors a superb space for viewing our distinguished East Asian collection. For their countless contributions to this installation, and for their willingness to share their enthusiasm and expertise in the pages of this volume, thanks are due to my colleagues, Elinor L. Pearlstein, Associate Curator of Chinese Art, and James T. Ulak, Associate Curator of Japanese Art. I also wish to thank two accomplished writers and friends of the department, Naomi Noble Richard and Deborah Del Gais Muller, for their substantial individual contributions to this volume. Finally, I would like to express special appreciation to Anne Rose Kitagawa for her careful and insightful review of the manuscript, and to Peter Junker for his patient and inspired editing.

This book honors generations of artists and salutes Chicago's early connoisseurs, collectors, and philanthropists, from whose visionary aspirations and efforts we continue to benefit. Today their leadership is carried on by numerous individuals, foundations, and institutions. Mr. T. T. Tsui, Mrs. Hugo Sonnenschein, and Suzanne and Richard Barancik have each made generous individual gifts toward the realization of the present installation. Other notable donations to the department have been made by the National Endowment for the Arts, the Government of Japan, The Mitsubishi Bank, Ltd., The Daniel F. and Ada L. Rice Foundation, The Chauncey and Marion Deering McCormick Foundation, The Stickle Foundation, and Asahi Shimbun, Japan.

For more than seventy years, the dedication of such donors has occasioned the involvement of passionate amateurs and museum professionals in building not just a collection, but a department committed to the comprehensive study of Asian art. I am pleased to have this opportunity to remember the labors of art historians, conservators, and others too numerous to name. Most especially, I thank the Art Institute Members and the people of Chicago for their determination to maintain a worthy and welcoming home for Asian art into the twenty-first century.

Yutaka Mino
Curator of Asian Art

The Department of Asian Art

Twenty-nine years before The Art Institute of Chicago established a curatorial department devoted to Asian art, the World's Columbian Exposition of 1893 brought the arts of East Asia into the city's cultural sphere. Japanese painting, ceramics, metalwork, textiles, and woodblock prints, selected primarily by Ernest Francisco Fenollosa (1853–1908), Curator at the Museum of Fine Arts, Boston, and a pioneering scholar of Asian art in the West, were represented in the Exposition's Palace of Fine Arts. A *ho-o-den* (phoenix villa) inspired by a famous eleventh-century Buddhist temple on the outskirts of Kyoto was constructed in Jackson Park by Japanese artisans. This modest but meticulously designed building (which remained intact until 1946) was visited by thousands of Chicagoans, among them businessman Clarence Buckingham (1854–1913) and architect Frank Lloyd Wright (1867–1959).

The Art Institute of Chicago building at Michigan Avenue and Adams Street was completed the same year, 1893, in part to house numerous international conferences held under the auspices of the Exposition. The exterior of the new building expressed the broad-minded and idealistic aspirations of the museum's founding trustees. Engraved around its entablature were the names of artists whose works the Art Institute was envisioned to contain. There, together with Michelangelo, Rembrandt, van Eyck, and other venerable names of Western art, is inscribed the name of Kanaoka — a tenth-century Japanese painter of

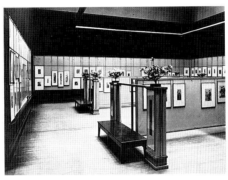

1908 Exhibition of Japanese Prints, Designed by Frank Lloyd Wright

legendary stature but with no surviving pictures.

Within a year of the Exposition, Clarence Buckingham became an avid collector of Japanese woodblock prints. Wright too began to collect, but somewhat later. In 1902, Frederick William Gookin (1853–1936) — a bank employee of the Buckingham family who had begun collecting prints in the 1880s — embarked on a full-time career as a dealer and advisor to Clarence Buckingham. In 1908, the Art Institute exhibited 655 prints, lent primarily by Buckingham, Wright, and Gookin, in an installation designed by Wright, who later attributed his own "elimination of the insignificant" to his study of Japanese woodblock prints. Upon Buckingham's death in 1913, his collection of almost 1,400 prints was moved to the Art Institute. Gookin was appointed to oversee and maintain the collection the following year.

Kate Sturges Buckingham (1858–1937) presented her brother's prints to the Art Institute in 1925, together with an endowment for future purchases. That gift was but a portion of the donations of art and funds that were to make Kate Buckingham the most prominent contributor to the Asian art collection. She continued to add prints through-

out her life, with advice from Gookin's successor, Helen Gunsaulus. The third Keeper of the Clarence Buckingham Collection of Japanese Woodblock Prints was Margaret Gentles, who succeeded Gunsaulus in 1943. Today the Buckingham Collection exceeds twelve thousand sheets, including works in all major styles and schools (see the chapter "Images of the Floating World"). A complementary collection of Japanese illustrated books was begun by Martin A. Ryerson (1856–1932), a founding trustee and president of the Art Institute.

The Art Institute's earliest Chinese acquisitions reflect the eclectic taste of the Victorian era. This taste was exemplified in the collection of Samuel Mayo Nickerson (1830–1914), a founder of First National Bank; his mansion at Erie and Wabash was lavishly furnished with mementos of his world tour. The Nickerson gift of 1900 included a group of Western paintings and nearly 1,300 Chinese and Japanese "curios." In the original Nickerson galleries, crowded cases of Chinese metalwork, ceramics, lacquer, and glass were exhibited together with paintings by Delacroix, Inness, and others. Nickerson's enduring legacy is an endowment that has enabled the department to purchase earlier Japanese and Chinese art, including a number of paintings (see p. 104) and a monumental stone head of Guanyin, the Buddhist god of mercy (pp. 38, 39).

The Department of Oriental Art, encompassing the arts of the Near and Far East, was formally established in

1922. The sculpture of Guanyin was among the first major acquisitions of Charles Fabens Kelley (1885–1960), who became the museum's Assistant Director and second Curator of Oriental Art in 1923, following the brief tenure of J. Arthur MacLean. Kelley's arrival coincided with current interest in early Chinese art and archeology, which was stimulated in Chicago by the 1908 appointment of Berthold Laufer (1874–1934) as Curator of Asiatic Ethnology at the Field Columbian Museum, now the Field Museum of Natural History.

Laufer had been appointed Honorary Curator of Chinese Antiquities at the Art Institute in 1920. His scholarly inspiration is acknowledged in the correspondence of almost all early donors. Major loan exhibitions organized in 1917 and 1918 by the Antiquarian Society, an auxiliary of connoisseurs founded before the incorporation of the museum, featured Chinese objects from the Field. In 1922, Laufer wrote

Clarence Buckingham

the catalogue for a major auction of Chinese ritual bronzes in New York. Three of these bronzes, including a stately wine vessel (p. 17) were purchased by Kate Buckingham, forming the beginning of a collection of ancient bronzes given to the Art Institute in memory of her sister, Lucy Maud Buckingham (1870–1920). The Lucy Maud Buckingham Memorial Collection expanded to include more than forty aesthetically and historically significant bronzes, some purchased after Kate's death with funds she bequeathed to the museum (see pp. 18, 24).

Kate Buckingham also collected in other areas of Chinese antiquity. In 1925, she purchased more than one hundred decorated tomb bricks that are now known to represent distinct regional styles of mortuary construction. Most unusual are a pair of doors stamped with vigorous images from daily life and mythology (pp. 30–31).

The focus on early Chinese art was further strengthened by Edward Sonnenschein (1881–1936) and Louise B. Sonnenschein (d. 1949), who, during the 1920s and early 1930s, formed one of the outstanding jade collections in the West. The Sonnenscheins recognized that the Chinese defined jade to include a wider range of stones than nephrite and jadeite, and their purposeful search for the earliest evidence of Chinese stone-working led them to collect many undecorated, seemingly "primitive" weapons, tools, and ornaments. Their collection numbers over one thousand pieces, including tools and ritual implements of the Neolithic period (see p. 14) and extending through elegant personal accessories of the late Bronze Age (see pp. 25, 26). It was given to the Art Institute in 1950.

The museum's remarkable collection of Chinese ceramic tomb figures represents the combined bequests of two benefactors: Russell Tyson (1867–1963) and Potter Palmer II (1875–1943). Tyson, a real estate executive

Kate Sturges Buckingham

and trustee, chaired the Oriental committee from its inception through 1952. The son of a mercantile executive, Tyson was born in Shanghai and grew up in Boston among the family's collection of Chinese furniture. His initial acquisitions were a highly selective group of Korean stonewares (see pp. 80, 82, 83). He also purchased Chinese tomb figures, both lead-glazed and painted, that exemplify the highest level of mortuary sculpture from the Han through Tang dynasties (see pp. 48, 51). Potter Palmer II, son of Potter and Bertha Honoré Palmer (whose collection of paintings by Degas, Monet, and Renoir forms the nucleus of the Art Institute's celebrated holdings of French Impressionism), was President of the Board of Trustees between 1925 and 1943, when the great Buckingham and Tyson collections were being

formed. His own collection includes many superb sculptures (see pp. 46, 50). Objects from the Palmer collection have been loaned to the Art Institute since the 1920s, and family members have generously given additional pieces over the years.

In 1925, Tyson organized The Orientals, a group of collectors and scholars, to stimulate interest in the Oriental department, hold seminars, and attend lectures and concerts. Kate Buckingham, Martin Ryerson, and Potter Palmer II were founding members. Membership dues were used for museum acquisitions. A penetratingly realistic, dry-lacquer head of a Buddhist *luohan* (see p. 42) was one of the organization's earliest and most important purchases. Through the years, The Orientals — individually and as a group — have contributed to the Art Institute's extraordinarily comprehensive collection of Chinese ceramics (see pp. 46, 50–52, 56–61, 64). In 1941, the museum received a large bequest from Member Henry C. Schwab (1868–1941), a Chicago shoe manufacturer, which included a number of important Ming and Qing porcelains (see p. 65).

Among collectors of their time, Florence Ayscough (1878–1942), a writer, lecturer, and translator of Chinese literature, and Harley Farnsworth MacNair (1891–1947), Professor of Chinese History and Institutions at the University of Chicago, were notable for their interest in painting, rather than objects. Their careers brought the couple together in Shanghai, where they acquired scrolls by later Chinese painters such as Xu-Gu (see p. 79) and Ren Bonian.

In the late 1920s, collections formed by some of Japan's first industrialists were sold at auction, making available a number of early Buddhist paintings. Kate Buckingham's subsequent gift of the scrolls *Descent of the Amida Trinity* (pp. 92–93) helped initiate the museum's concentration in this area. Charles Kelley continued to acquire distinguished examples of Japanese scroll and screen painting such as *Landscape of the Four Seasons* by Sesson Shūkei (pp. 106–107).

Jack Sewell followed Kelley as Curator of Oriental and Classical Art. Between 1958 and 1988, Sewell led the department in its purchases of

Russell Tyson

Japanese Buddhist sculpture (see pp. 88, 90 94, 95) and painting (see pp. 96, 101), as well as works from Southeast Asia. Endowments established by Kate Buckingham, Samuel Nickerson, and other forward-looking donors also enabled the department to acquire earlier Chinese paintings such as *Wangchuan Villa* (detail, pp. 72–73) and *Autumn Clearing in the Misty Woods* (p. 78). Although our present holdings can only begin to illuminate the long history of China's primary visual art, works such as these offer a worthy stimulus to further development.

During Sewell's years of leadership, the department reflected the general trend in museums toward increasing curatorial specialization. Donald Jenkins, an authority on Japanese art, served as Associate Curator between 1969 and 1972, and Osamu Ueda was hired in 1972 as Keeper of the Clarence Buckingham Collection, a position he held for eighteen years. In 1985, ceramics expert Yutaka Mino was hired as Curator of Japanese and Chinese Art.

In 1988, the Department of Oriental and Classical Art was redefined as the Department of Asian Art to more specifically encompass China, Korea, Japan, India, Southeast Asia, Indonesia, and those arts of the Near East most closely related to Asian traditions. Western classical art was transferred to the Department of European Decorative Arts and Sculpture. Yutaka Mino was made the first head of the reconstituted department and soon began directing the 1992 reinstallation of the galleries of East Asian art.

The galleries of East Asian art are the manifest vision of men and women who recognized beauty and historical significance in the arts of remote cultures. Today, in a period that brings East and West into closer proximity, the evidence of their dedication and knowledge assembled at The Art Institute of Chicago is fit inspiration for scholars and appreciative museum visitors from throughout the world.

Elinor L. Pearlstein
Associate Curator of Chinese Art

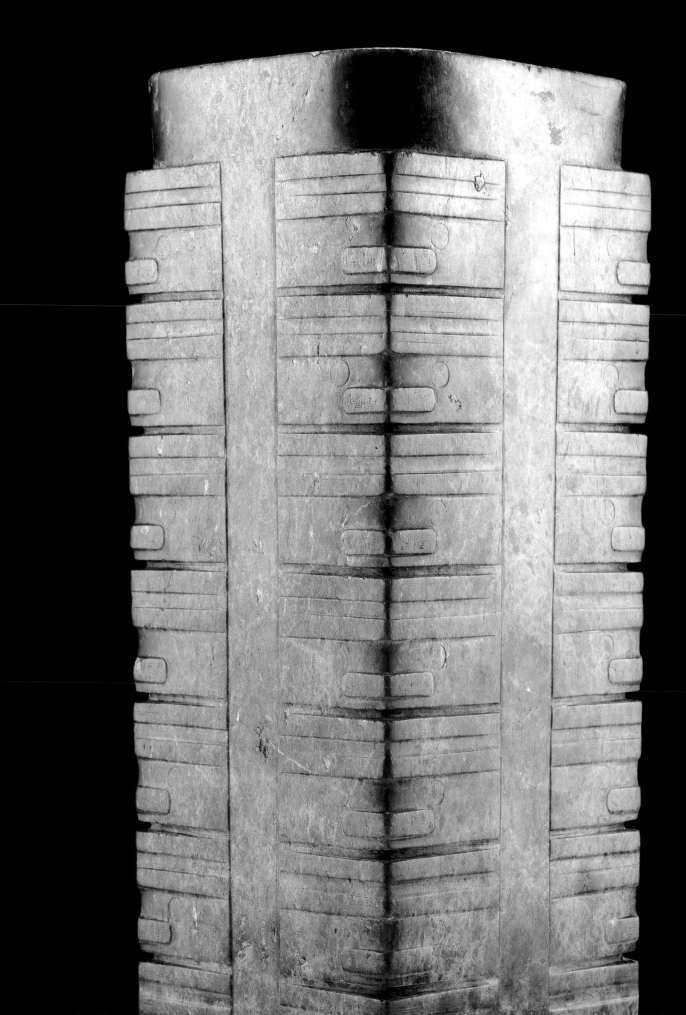

Prehistoric and Early Dynastic China

From the remote past of China's earliest village communities, the role of the artist in enriching the furnishings of life and the afterlife is increasingly being revealed. Skillfully and sensitively crafted artifacts, recovered from dwelling sites and cemeteries, have prompted scholars to rewrite prehistory and redraw the map of neolithic (New Stone Age) cultures. The astonishing extent and quality of recent finds have progressively enlarged our notion of early village life from an image of a unified "cradle of Chinese civilization" to a scenario in which a multitude of regional cultures emerged and interacted between the sixth and second millennia B.C. These cultures, whose geographic scope and chronological sequence are still being deciphered, are recognized as distinct communities whose inhabitants cultivated plants, practiced stock breeding, domesticated animals, and developed specialized crafts in clay, stone, bone, basketry, and textiles.

Objects of clay and stone are the most durable and representative of neolithic life and the foundations of many of China's most enduring artistic traditions, which display a predilection for materials drawn from the earth. Although their creators and owners are anonymous, these artifacts, considered in their underground contexts, offer glimpses of the human societies that inhabited this vast and ancient landscape.

Until very recently, neolithic China was described almost exclusively as a complex of "pottery cultures," each named after a locale where ceramic vessels distinctive in shape and decoration were first unearthed from cemeteries and dwelling sites. The practical need for containers of all kinds and the accessibility of clay have made ceramic vessels the most ubiquitous of human creations. Mere utility was transformed into beauty through a masterful integration of technology and design demonstrated by the Chinese potter as early as 5000 B.C. In the Art Institute, this formative stage is exemplified by earthenware storage jars and basins of the Majiayao Yangshao culture, which occupied northwest Gansu and Qinghai provinces in the fourth and third millennia B.C. The thin-walled, robust volume of a late Majiayao jar (p. 12) was built up of coils of clay, then compacted with a paddle, smoothed, and pared. Some steps of this process seem to have been executed on a slow turntable. Two loop handles were attached at midsection after the final shaping. Double gourds filled with crosshatching, symmetrically disposed around the sloping shoulder, enhance the form. These surface patterns, fluently painted with iron-rich pigments, display very early mastery of the flexible paint brush. Technically and aesthetically assured, such vessels also reveal consummate control of kiln temperatures, a technology which would later be critical to the achievements of China's Bronze Age foundries.

Although the most frequently found, ceramics are by no means the only surviving evidence of neolithic craft and aesthetic impulse. Craftsmanship of a different, more intensive nature appears in a variety of stones collectively known as *yu* in China and as jade in the West. Nephrite, the primary stone worked in ancient China, most commonly occurs in the form of boulders or small pebbles whose rough, weathered "skin" camouflages their internal beauty. It is unknown when artisans and patrons first recognized the subtle visual and tactile qualities concealed in nephrite — translucency, depth, variegated and lustrous color, and smooth finish. Hard, fine-grained, and resistant to carving, jade must be slowly and laboriously worn away by abrasive paste (in neolithic times, probably quartz sand mixed with water) applied to its surface with rotary saws, grinders, and drills. Thin jade axes and blades, found in the graves of the elite alongside sturdy weapons and farming implements of common stones, were ground and shaped with hand-powered wood, stone, or bone tools not fundamentally different from the power-driven tools of modern jade workshops. An ax from the third millennium B.C.

11

Globular Jar (Guan)
China, Neolithic period
Circa 2500 B.C.
Earthenware with
painted decoration

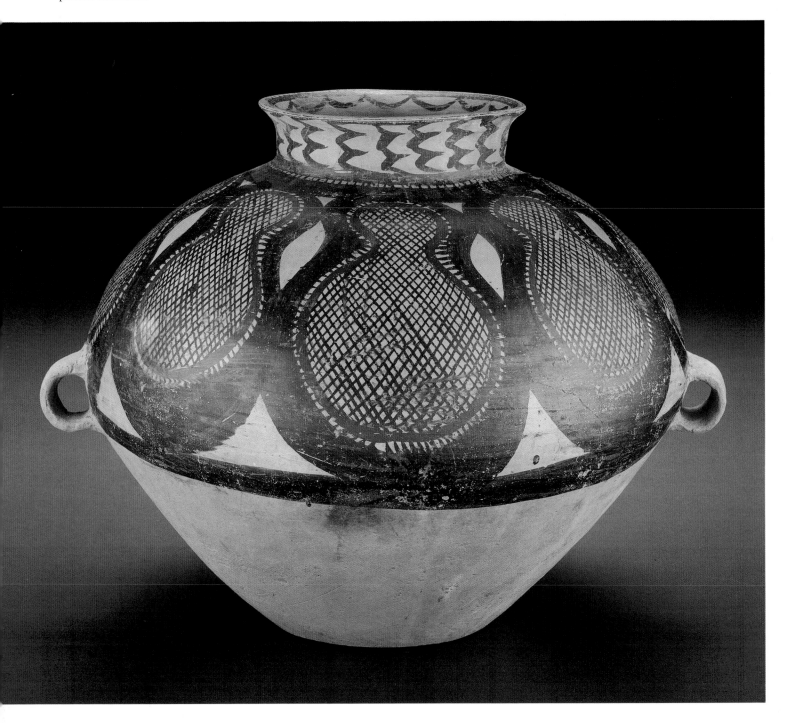

Ax (Yue)
China, Neolithic period
First half of third
millennium B.C.
Jade (nephrite)

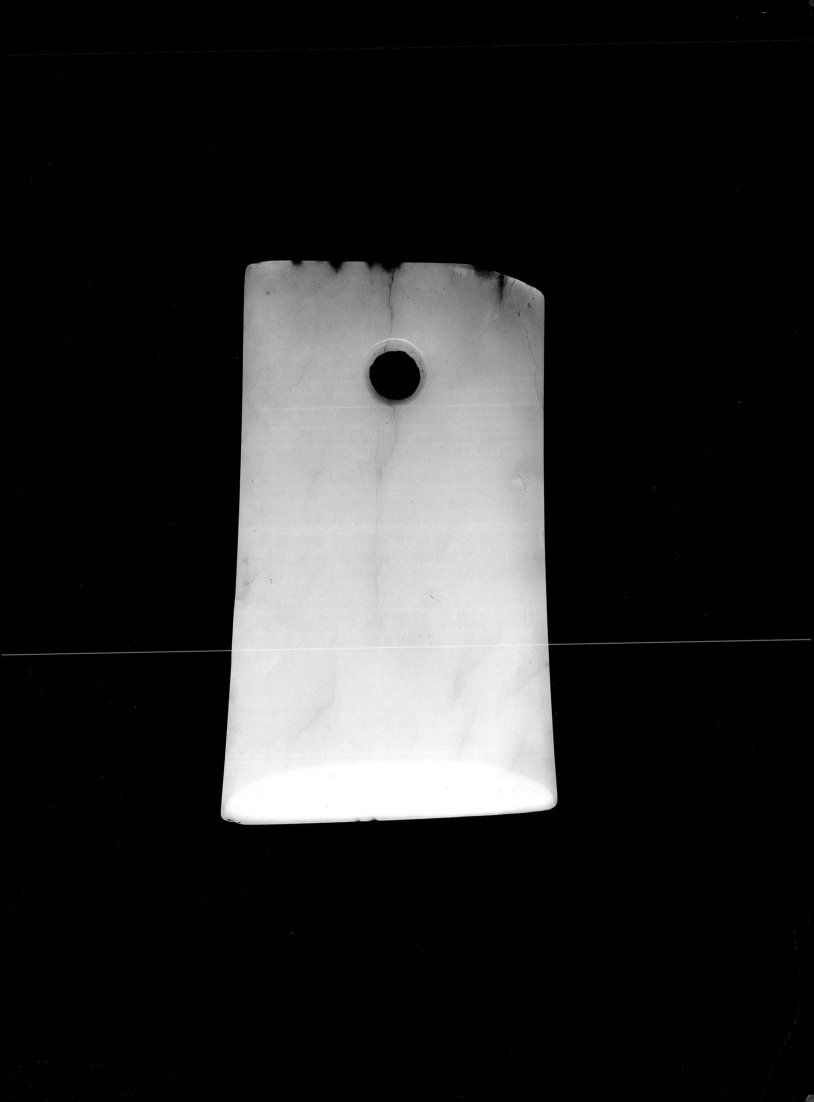

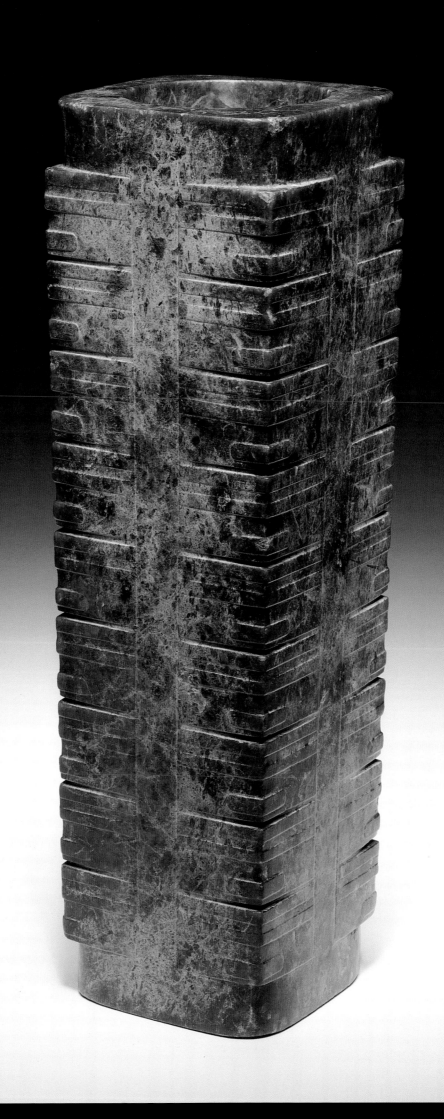

Tubular Prism (*Cong*)
China, Neolithic period
Third millennium B.C.
Jade (nephrite)

Dawenkou culture of northeast China (p. 13), transformed from a quarried pebble into a thin slice of stone through acute judgment and dexterity, is an object of unexpected depth and subtlety. Its vertical sides are gently flared and tapered, its cutting edge softly beveled in a sweeping arc, its conical hole carefully bored from one side, and its surface polished to a high luster. Displaying no edge wear, and obviously too fragile for practical use, such a blade may have been fashioned and cherished as an emblem of authority or status. Whether it was so used by a living person or made exclusively for burial is unknown.

In a tall cylinder with a tubular interior and rectangular exterior surface (p. 10 and opposite), intriguing geometric form achieves mathematical precision. The burial context of such prisms, known in later texts as *cong,* has recently been elucidated by their discovery in graves of the southeastern Liangzhu culture, a rice-farming people of the mid-fourth and third millennium B.C. in the environs of present-day Shanghai. In certain of the shallow Liangzhu graves (presumably those of political and spiritual rulers), prisms, disks, and perforated axes were carefully arranged over and around the body. Some graves afford evidence that the jade-laden body was ritually burned during funerary rites. Although these rites cannot be fully reconstructed the disciplined order apparent in the burial is clearly paralleled in the design of these *cong*. In the Art Institute example, the inner cylinder has been smoothly bored with a tubular drill, probably a shaft of bamboo. The outer prism is meticulously tapered and subdivided into vertical tiers, whose corners display masklike images composed of circular eyes and horizontal nose and/or mouth bars. Finely incised meander patterns, barely visible within the bars, impart textural contrast to this compelling imagery. Although such masks may have served some ritual or protective function, their significance eludes modern interpretation. Unlike the ax, the *cong* form is unique to jade and has no utilitarian counterpart. Found exclusively in burial areas, it may be identified as one of the earliest objects made for purely mortuary or other ceremonial rituals.

The transition from neolithic to Bronze Age China saw the gradual rise of urban centers and of rival states ruled by hereditary clans. The succession of dominant states, whose political and military fortunes are chronicled in legend and history, became known as the "Three Dynasties": Xia (c. 2100–c. 1700 B.C.), Shang (c. 1700–c. 1050 B.C.) and Zhou (c. 1050–256 B.C.). Though sophisticated jades, primitive objects of copper and bronze, and urban aggregations of dwelling, manufacturing, and burial sites have been attributed to the earliest of these periods, the existence of the Xia as a political entity has yet to be unequivocally demonstrated.

The authority of the Shang, however, has been powerfully apparent since the discovery early in this century of the capital city, Yin, where inscribed "oracle bones" attest to the reigns of the last nine Shang kings (c. 1300–c. 1050 B.C.). These "ruins of Yin" (as the place was known in historical times) lie west of the modern-day city of Anyang, in northern Henan province, and have been excavated since 1928. These sites reveal a political and ceremonial center for a highly literate aristocracy that ruled with brutality, expended enormous resources on worship rituals, and interred their highest leaders in immense burials signifying their wealth and supremacy. The burial offerings, including hecatombs of human and animal victims as well as objects of great beauty and richness, attest to the magnificence and the terrible power of the Shang kings.

15

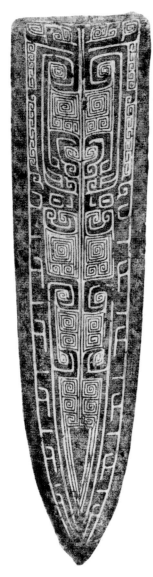

Leg of tripod
wine vessel
(opposite):
ink impression
on paper

Shang nobility paid homage to a supreme deity through the intercession of their ancestors, whose prophetic wisdom was sought through divination. Questions about the future, inscribed or carved on tortoise shells and addressed to deceased kinsmen, are among the earliest known manifestations of the Chinese written language. These "oracle bone" inscriptions affirm that good weather, health, and the favorable outcome of warfare, harvests, hunts, and trade were all held to be dependent on a hierarchy of gods and ancestors.

Divine goodwill was enlisted and repaid with ritual offerings of food and drink. Bronze vessels made to contain these offerings are the supreme aesthetic and technological achievement of Shang civilization. In the ruins of Anyang, thousands of vessels have been unearthed from foundations of temple altars and from underground tombs in which they were buried as gifts to the departed royalty and elite. Some vessels were cast with inscriptions that record the individual or clan who commissioned them, the name of the ancestor in whose memory the vessel was dedicated, or, more rarely, the name of the vessel shape. There were about twenty primary vessel shapes that could be included in ritual table settings. These have been classified by later historians according to their uses in preparing, heating, serving, or storing meat, grains, water, and grain "wine." The preponderance of large and magnificent wine vessels confirms the ceremonial status of alcoholic spirits, which were brewed from millet or other grains and served warm. Whatever their individual shapes and particular uses, all bronze ritual vessels shared one overriding social function: They signified the exalted social status of their owners, a status embodied for the Shang elite in the exclusive right to make sacrifice to their ancestors and

to be sumptuously interred with an abundance of ritual vessels.

A tripod vessel, or *jia* (opposite), which would have been placed over fire to heat sacrificial wine, displays the taut profile and precise surface decoration that distinguishes the finest bronzes commissioned for the Anyang royalty. By the second half of the twelfth century B.C., when this vessel was cast, the Shang had invented and perfected a remarkable technology now known as piece-mold casting. A clay mold was formed around a model of the desired vessel; this outer mold was cut into sections, which were carved or impressed with decoration on their inner surfaces. The decorated piece-molds were fired, reassembled, and interlocked around a clay core, with small bronze spacers (the thickness of the vessel walls) holding the piece-molds and core apart. Into the space between core and piece-molds, molten bronze was poured, simultaneously receiving its shape and decoration from the piece-molds. Once the bronze had solidified and cooled, the piece-molds were removed and the core dug out. Such a process produced this dramatically proportioned tripod, in which pieces of the core left inside the sharply tapered legs are still visible. Shaping and decorating were part of the same creative process, in which metallurgists and potters presumably worked side by side. Bronze is an alloy of copper and tin, sometimes with traces of other metals. In China's early foundries, lead was regularly added to the compound. While the achievements of foundrymen in mining and smelting bronze is universal to Bronze Age civilizations in the East and West, the artistic role of the potter is unique to early Chinese metallurgy.

The mold maker's ingenuity and precision are apparent in this vessel's surface decoration, which is intricately executed in several levels of relief. Two tiers of monster masks, each formed

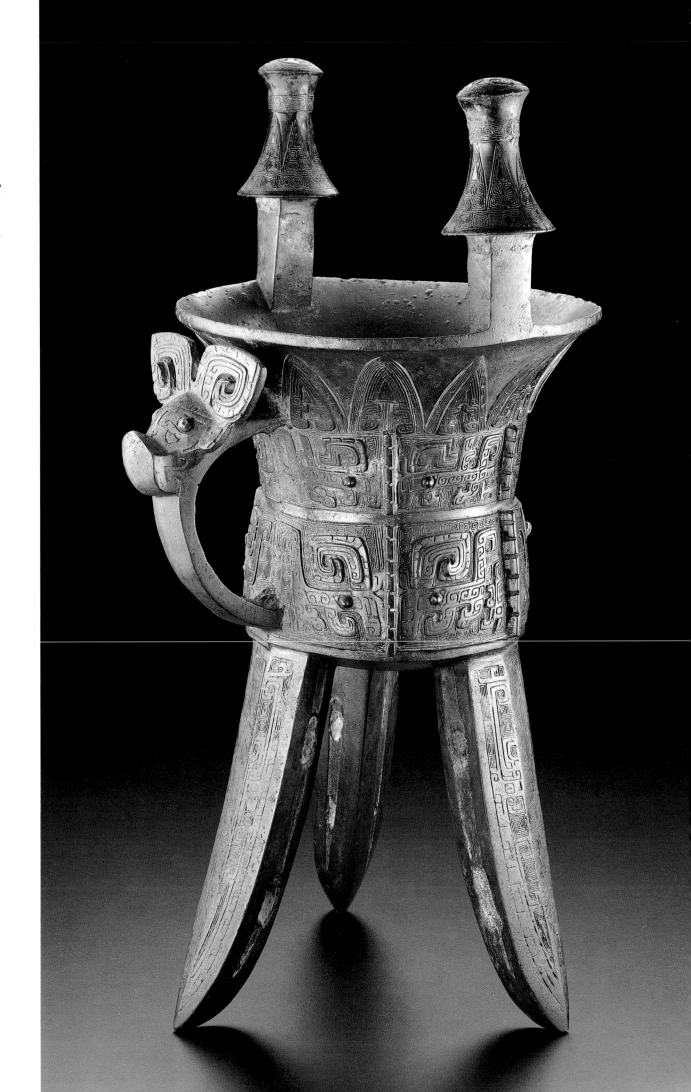

**Tripod Wine
Vessel (*Jia*)**
China,
Shang dynasty
Twelfth
century B.C.
Bronze

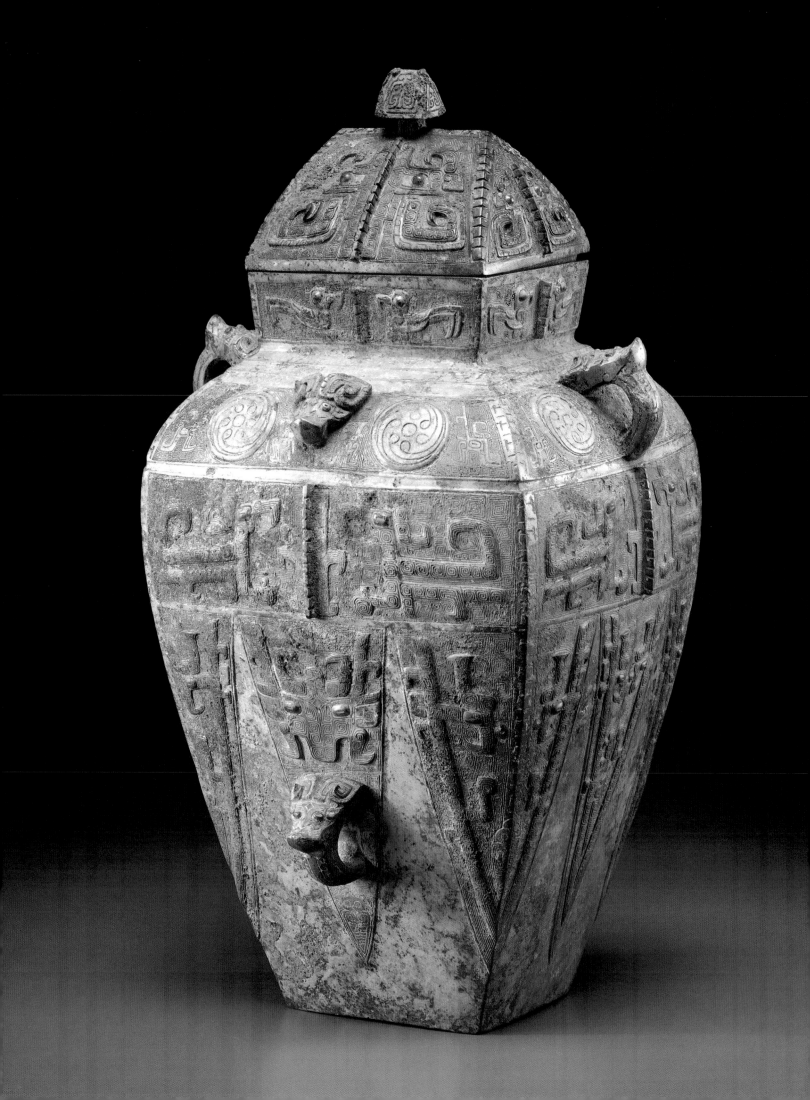

of hooks and spirals around a pair of staring eyes, encircle the flared bowl, riveting the viewer with their stark frontality and haunting power. Elongated versions of these masks, which may be read as paired serpents, descend the legs (see rubbing, p. 16), while a snub-nosed bovine head with sculpted horns crowns the strap-handle. This intriguing imagery, set off by a background of fine, squared spirals, reappears in endless variations on Shang bronzes (as well as on more perishable materials, including bone, lacquer, and wood carving), but eludes modern interpretation. In post-Shang literature, the monster mask is known as a *taotie,* but the term never appears in contemporary oracle-bone inscriptions. Whether the Shang perceived the *taotie* as auspicious, ominous, or purely decorative remains one of the great enigmas of early Chinese art.

A more diverse menagerie of natural and invented creatures animates a *fanglei,* or square-shouldered jar for wine storage (opposite). Here the horned *taotie,* inverted across the roof-like lid, recurs along the body within pendant triangular blades, each of which also contains a wide-eyed cicada at its tip; the cicada is found often on Chinese bronzes, perhaps because its extraordinarily long life cycle carried associations of regeneration. Confronted pairs of jaunty, stylized birds encircle the neck of the vessel, with similarly disposed dragons — each with down-curved head plume and up-curved tail around the widest part of the body. Birds and dragons are separated by a shoulder band of whorl circles, nose-diving dragons, and four fully sculpted bovine heads, two purely decorative and two surmounting lug handles. Two more such handles were cast on below to facilitate lifting. Compact, sharply cast spirals covering both the relief-cast *taotie,* dragons, and birds, and their receding background

impart a shimmering effect to the surface, now covered with layers of patina. Cuprite red, malachite green, and azurite blue — products of mineral corrosion formed during centuries of burial in moist earth — are esteemed by collectors for their intrinsic beauty and as manifestations of antiquity.

In the mid-eleventh century B.C., a vigorous people known as the Zhou overthrew the Shang. The Zhou capital near modern Xi'an, Shaanxi province, then the northwestern frontier of the Chinese world, has given the name Western Zhou to this period. To consolidate power over their vast domain, the Zhou kings initiated a political system similar to that of feudal Europe after the fall of Rome: Conquered territories were parceled out and royal kinsmen established as regional lords. This dynastic rupture is not reflected in bronzes made during the reigns of the founding Zhou emperors. By the end of the century, however, Shang qualities of austerity and refinement had yielded to heavier forms and more exuberant and robust surface decoration.

The bulging, curvilinear silhouette of a house-shaped wine container, or *fangyi* (pp. 20, 21), is emphasized by prominent, hooked flanges, which also accent the surface divisions created by sectional mold casting. The elements of surface decoration — high-relief *taotie* masks, crested and plumed birds, and dragons with reverted heads — are extravagantly shaped: Fringed with elaborate hooks and quills, their curves and coils extend and replicate to symmetrically fill the divided panels of the body and lid.

Identical dedicatory inscriptions cast within the interior of the base and the lid read: "Rong zi [son of Rong] made [this] precious sacrificial vessel." Such inscriptions, studied as historical documents as well as calligraphic art, contribute to our understanding of the chronology and patronage of ancient Chinese bronzes.

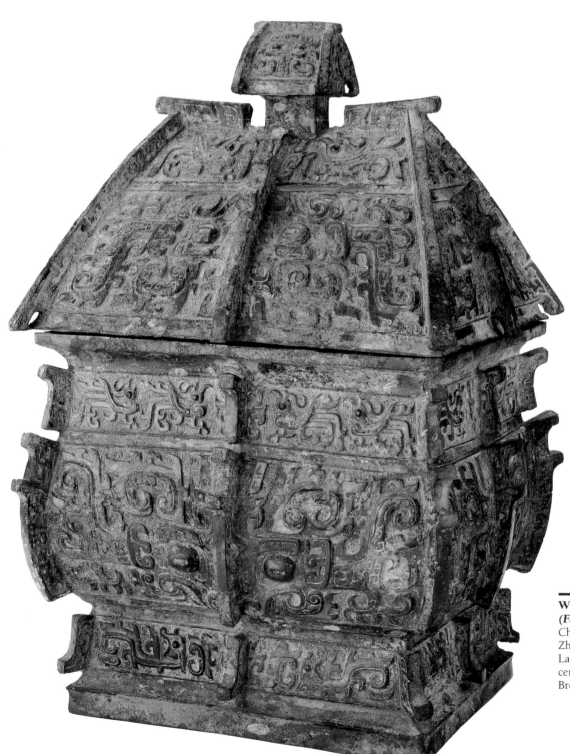

**Wine Vessel
(*Fangyi*)**
China, Western
Zhou dynasty
Late eleventh
century B.C.
Bronze

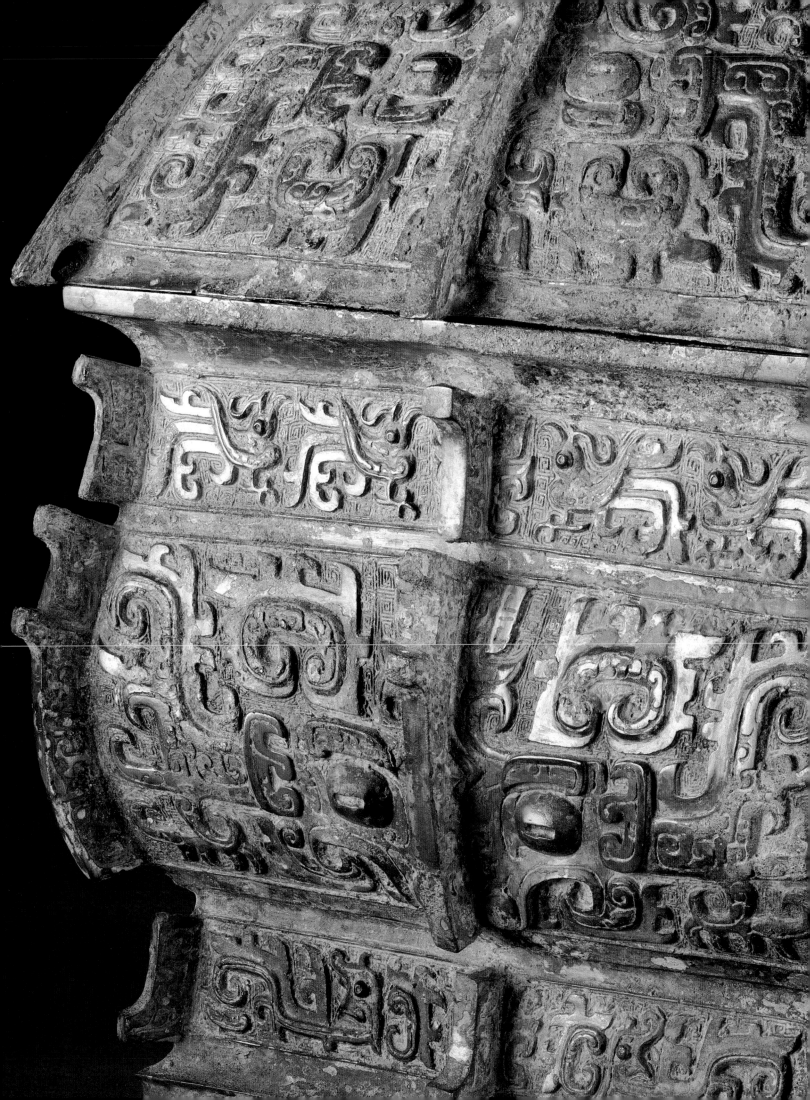

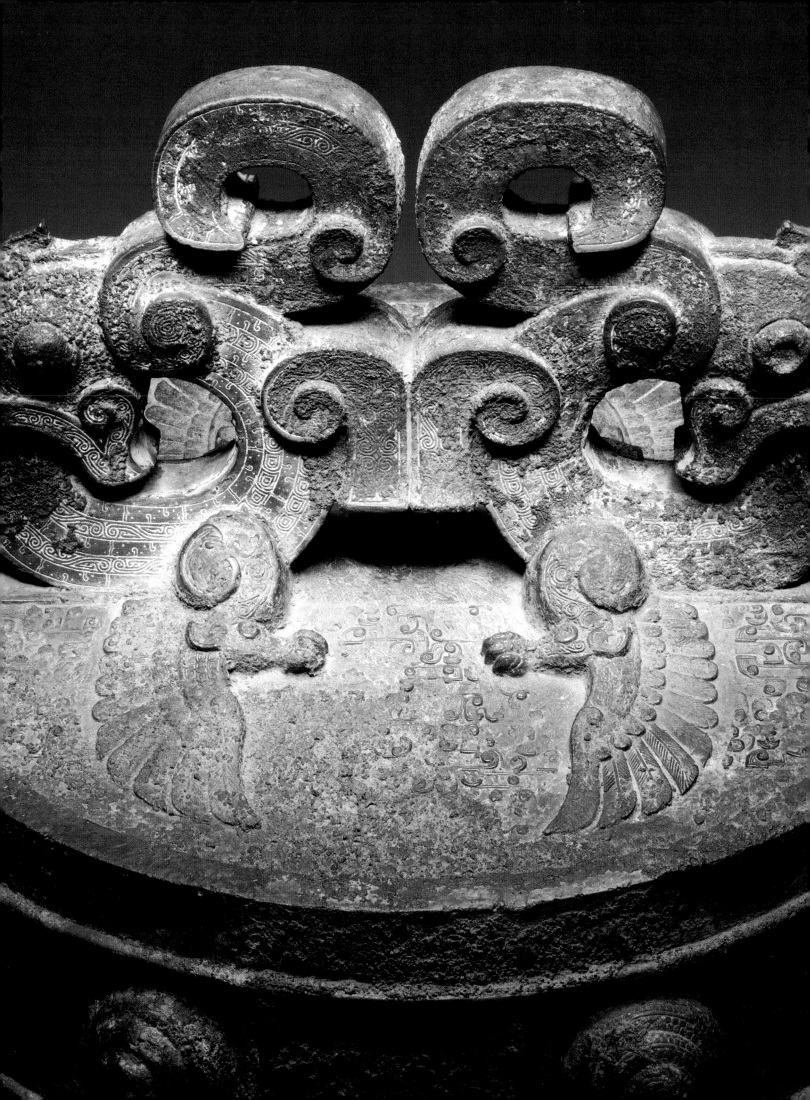

Eastern Zhou and Han Decorative Style

In 771 B.C., its power eroded and its borders violated by foreign armies, the Zhou government transferred its capital eastward from Xi'an to the vicinity of present-day Luoyang, Henan province. The period beginning in that year and ending in 256 B.C. (when the shrunken and enfeebled Zhou state disappeared entirely) is known as Eastern Zhou. As the decline of the central Zhou government accelerated, the empire splintered into separate states, ushering in more than five centuries of intensifying interstate conflict and rapid and far-reaching social and political change. Traditionally, Eastern Zhou is further subdivided into the Spring and Autumn period (770–481 B.C.) and the aptly termed Warring States period (480–221 B.C.), named after two historical compilations of this convulsive but progressive age. At first through complex diplomacy and ever-shifting alliances, and later through wars of increasing scale and ferocity, each local ruler attempted to assert hegemony or, more ambitiously, to create and control a unified empire.

This political competition was played out in an atmosphere of intellectual ferment, economic development, social mobility, and artistic brilliance. The prosperous but increasingly devitalized hereditary aristocracy commissioned works of art as personal attributes of wealth and prestige, as well as symbols of political authority and religious obligation. Simultaneously, the growth of cities as commercial centers stimulated brisk trade and the emergence of an affluent merchant class affording a new clientele for luxury articles. Craftsmen responded to the materialistic tastes of this burgeoning elite with objects of unprecedented technical refinement and visual splendor.

Court orchestras, performing at ancestral rites and seasonal ceremonies and banquets, conferred great prestige to their patrons during this period. The artistry and acoustical expertise of bronze casters was demonstrated in the production of clapperless bells; these were cast in tuned sets of graduated size, suspended from horizontal beams, and sounded by striking them from the outside with wooden mallets. Each bell was designed to emit two tones: one by striking the center of the lower panel; another by striking the side. A monumental bell from such a chime set (pp. 22, 24) is lavishly decorated with several layers of relief. Its lower (striking) panel was cast with interlaced bands and dragon heads accented with raised curls; above are registers of protruding knobs (which may have muted sustained vibrations to permit fast rhythms) in the form of coiled serpents, alternating with bands of dragon-head interlace similar to that in the striking area. The suspension "loop" (detail, opposite) was fashioned as two winged dragons whose crested heads recurve to swallow their tails. Their feathered wings and sharp claws, spread across the top surface of the bell, are cast over a third interlace pattern accented with raised curls. Close scrutiny of each pattern reveals a gridlike repetition of identical elements or clusters of elements, created by successive impressions of a single die-stamp in the piece-molds. This technique, which answered to a new fascination with densely packed surface patterns that repeat the same motifs, facilitated bronze decoration of unprecedented complexity and precision.

A similar fascination challenged the imagination and dexterity of craftsmen working in jade. Both surfaces of a curvilinear plaque (p. 25, top), depicting a dragon with arched hindquarters and lowered forequarters, are thoroughly enriched with a compact profusion of smoothly rounded C-shaped curls. This sparkling relief has been patiently modeled in the intractable stone, using abrasive paste applied with bevel-edge grinders. The development and mastery of progressively sturdier rotary tools, following the advent of hard iron alloys by the seventh and sixth centuries B.C., enabled jade carvers to employ a wide variety of surface designs that rival, in their textural richness, those found on contemporary cast bronze.

By the late Warring States period, artists in both bronze and jade had

23

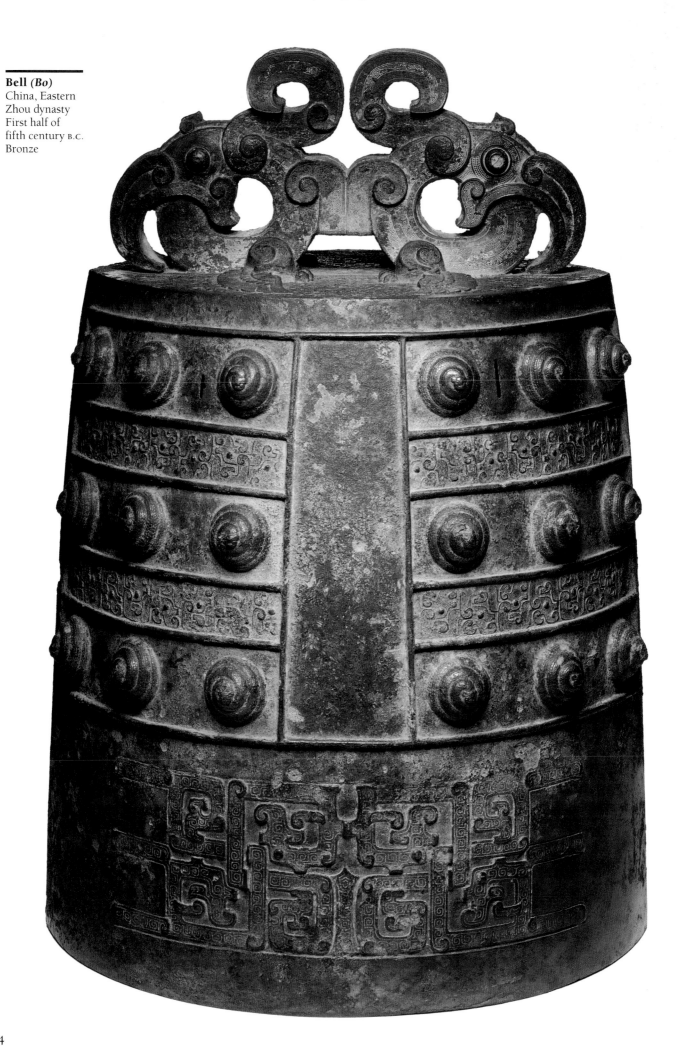

Bell *(Bo)*
China, Eastern
Zhou dynasty
First half of
fifth century B.C.
Bronze

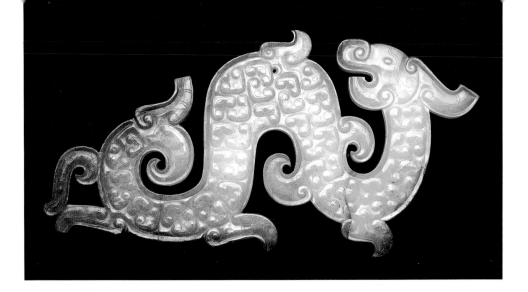

Arched Dragon Pendant
China, Eastern Zhou
dynasty, Warring
States period
Fourth/third century B.C.
Jade (nephrite)

Wine Vessel (*Hu*)
China, Eastern Zhou
dynasty, Warring
States period
Fourth/third century B.C.
Bronze, gold and
silver inlays

achieved remarkable fluency in form
as well as in surface design. Their
collaboration is exquisitely illustrated
in a small garment hook, whose but-
tonlike knob on the back served to
fasten a belt or robe (p. 26, top). Here,
a dragon of jade curls sinuously within
its bronze mount—a composite crea-
ture combining a bull's head and a ser-
pentine body terminating in a fishlike
tail curled over one horn. The dragon's
finely incised curls are echoed in a
complex pattern of gold and silver
embellishing the mount. Thin strands
of these malleable metals, applied indi-
vidually or compacted together into
thicker ribbons, were pressed into
grooves in the bronze, then ground
flush with the surface and polished
to a high luster. This combination of
descriptive and abstract patterns—
facial features, scales, volutes, and
spirals—is a masterwork of metallic
inlay.

Such brilliantly colorful, curvilin-
ear surface decoration was largely
influenced by the painting of the time.
Polychrome lacquers, painted with a
flexible brush, introduced to other arts
a new repertory of fluid and dynamic
designs. Sweeping brush strokes cer-
tainly inspired the tapered swirls of
inlaid silver encircling a diminutive,
pear-shaped vessel (right), executed
in the same technique as the garment

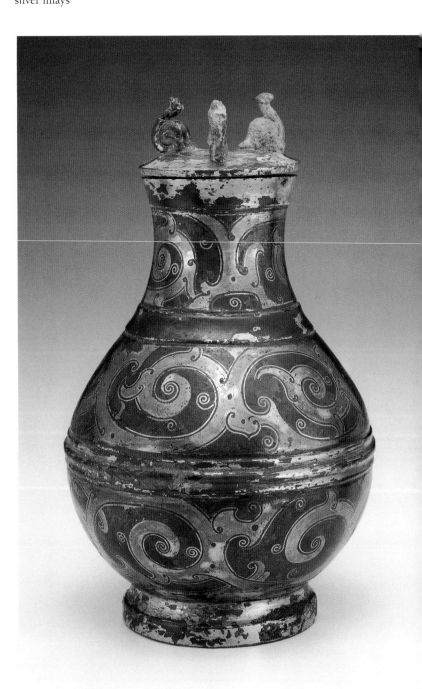

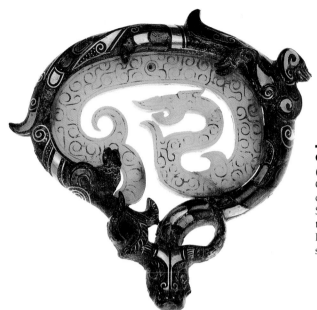

hook. Fine lines and spirals bordering these broad swirls were worked into thin, recessed grooves; their superb condition testifies to the durability of this delicate technique. By contrast, the plain bands that separate the registers of scrollwork, as well as the trio of birds perched atop the domed lid, were embellished with precut sheets of gold leaf, which were simply applied to the bronze surface by heating and burnishing. These have been more vulnerable to flaking, and are not as well preserved.

This decorative style proved more enduring than its aristocratic patrons. It survived the turbulent conquest of rival kingdoms and unification of the empire by the Qin dynasty (221–206 B.C.) and continued into the Han dynasty (206 B.C.–A.D. 220), the first generally centralized empire of appreciable duration. The rhythmic animal silhouettes animating an openwork jade sheath of the early Han (right) belie the unyielding quality of the stone with their fluent, "painterly" style, reminiscent of earlier inlaid bronzes. A sprightly bird and stealthy, catlike dragon, each anchored by identical legs and claws, display an artful ma-

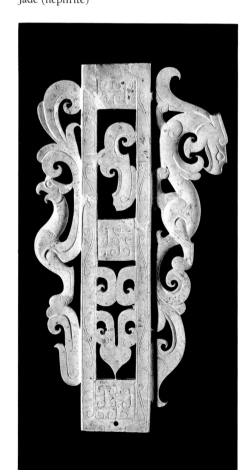

nipulation of zoomorphic form and abstract ornament, their undulating bodies extending into thick, splayed curves of tail and plumage. The intricate central oblong, ornamented on both sides, was drilled lengthwise, indicating that the sheath was designed to contain a dagger blade, now lost. Its fragile delicacy, enhanced by smooth contours and hair-fine surface detail, also suggests that the sheath was created as a pure objet d'art—perhaps for a desk implement, a ritual weapon, or a sumptuous burial gift commensurate with its owner's princely status.

The supernatural dragon, whose diverse and composite forms evolved in pre-Han mythology and art, became prominent in the Han as an auspicious creature associated both with imperial authority and with the ever-changing nature of the universe. As the dragon was endowed with the same dynamic energy that animates clouds and vapors, it was graphically combined with expanding and contracting patterns of great imagination and vitality. In a magnificent bronze vessel of the early Han (opposite), dragons with interlaced trunks merge with scrolling "cloud" patterns to create continuous bands of ornament. This dragon "arabesque," lightly incised in the bronze, is enriched by thin films containing diluted gold and silver. Bits of these precious metals were dissolved in mercury and painted onto the bronze; the mercury volatilized in firing, leaving a brilliant, two-toned surface. This development of pictorial decoration and of colored surface layers, more akin to painting than to casting, marked both the pinnacle and the passing of the Chinese bronze age.

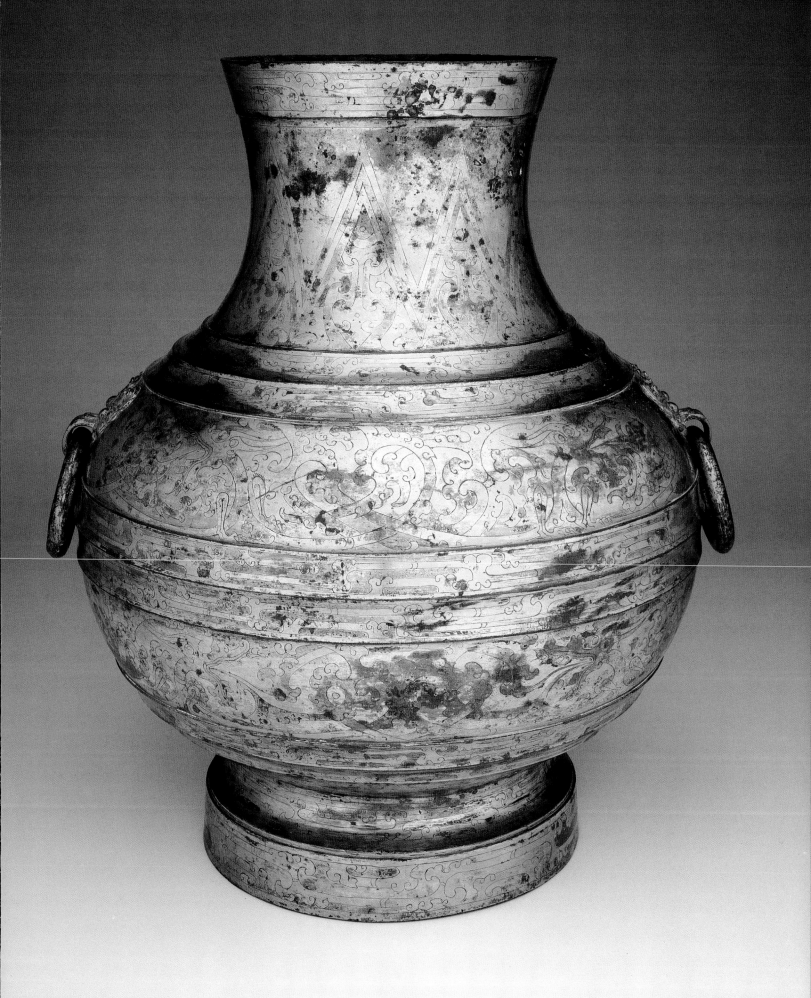

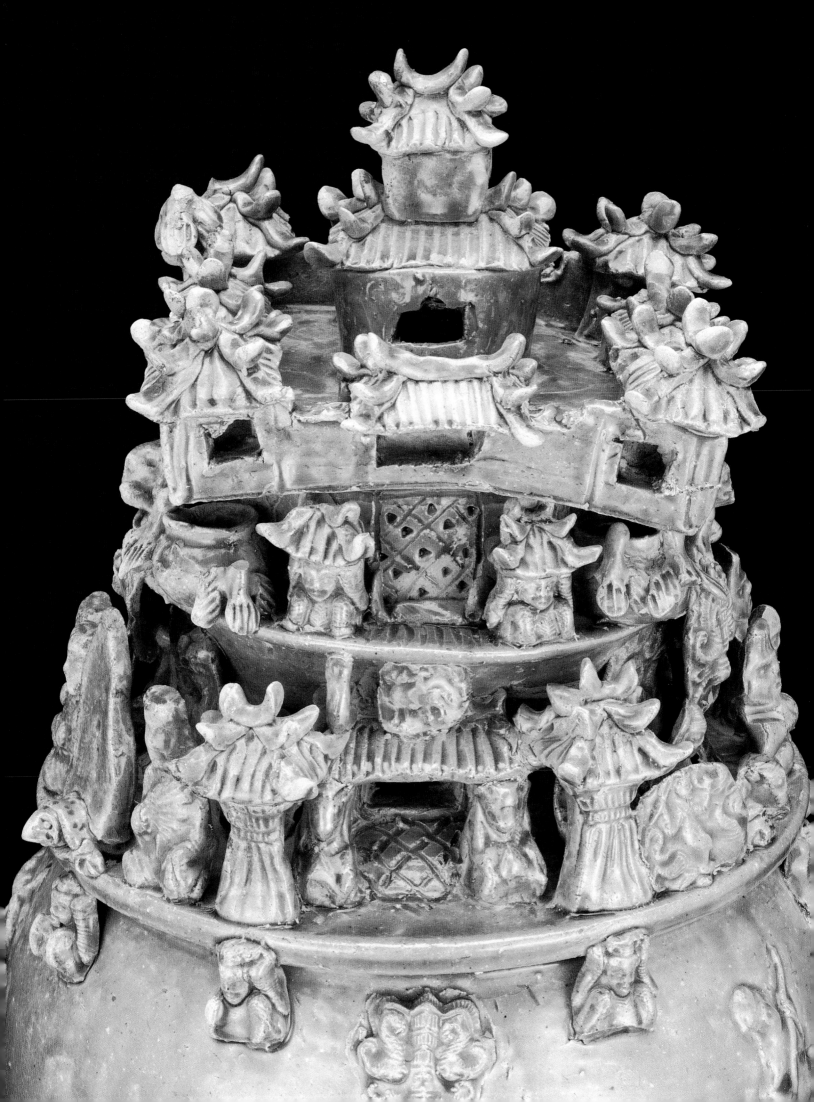

Furnishings for this World and the Next

The true heirs and beneficiaries of the ruthless conquest of China's feudal kingdoms by the First Sovereign Emperor of Qin (221–206 B.C.) were the rulers of the Han dynasty (206 B.C.–A.D. 220). Following fifteen years of rebellion and civil strife under Qin despotism, the Han succeeded in inaugurating four centuries of centralized authority. Confucian ideals of meritocracy and benevolent rule, combined with new prosperity, allowed government officials and landowning gentry (two groups considerably merged in practice) to rise in status and privilege, eventually displacing princely families. This rising "middle class" looked to funerary art as a means of proclaiming, simultaneously, family prestige and unimpeachable filial devotion. Artisans responded with a flourishing industry in grave goods, which developed as an independent artistic tradition. Although the majority of artifacts unearthed from Han tombs are routinely executed and, like Egyptian tomb furnishings, are interesting primarily for the glimpses they afford of everyday life, many are distinguished as highly creative examples of ceramic, sculptural, and pictorial art.

Ideas about life, death, and immortality were shared by all levels of Han society. It was generally believed that the human soul was dual in nature, and that its two parts separated at death. While the physical soul (po) remained close to the body, seeking nourishment, comfort, and entertainment in familiar surroundings, the more restless, ethereal soul (hun) ascended to an otherworldly paradise that was the realm of the ancestral spirits. Special beings (xian), having achieved total spiritual freedom, acquired immortality, the power of flight (or "spirit travel") and other magical abilities. These views of the hereafter affected the structure, decoration, and furnishings of underground tombs, which were designed as lifelike dwellings for the deceased.

A montage of motifs depicting the earthly and spirit world of Han covers a pair of earthenware doors from the entrance to a small, rectangular tomb chamber constructed of hollow bricks (pp. 30, 31). Before firing, the clay was repeatedly impressed with stamps depicting humans, animals, imaginary beings, and emblems of good fortune and protection from evil. Centered on each door are guardian images, both realistic and emblematic. Two long-robed sentries (identified by inscriptions as tingzhang, village constables who doubled as policemen and postal officials) flank a door-pull or door-knocker in the form of a ring-snouted monster mask. This taotie motif, adapted from vessels of the earlier Bronze Age, functions here as a protective symbol. Han mythology offers clues to other motifs, including the spade-shaped tree (often identified as an evergreen or cypress), symbolic of family continuity and longevity, and a disk enclosing a bird in flight, identified with the sun.

Surrounding this central square are border strips depicting vigorous activity. Musicians and long-sleeved dancers perform before an audience; archers on horseback pursue tigers, hares, and deer among undulating hills and precipitous peaks. A mountain setting also provides the background for a cavalcade of chariots, and for deer, tigers, and wispy, semihuman elves (representing xian immortals) engaged in furious chase. Such integrated compositions of figures in landscape offer intriguing evidence for the subjects and styles of contemporary paintings on silk, paper, and other perishable materials, of which a bare handful survive.

The universal demand for tomb furnishings broadened the scope of Han funerary art far beyond rare and costly articles of bronze and jade to humbler objects of clay and wood. "Spirit objects" (mingqi), made exclusively for burial, reflect an increasingly humanistic and mundane view of the afterlife. These include models of daily necessities and luxuries, as well as figurines of humans and animals made as surrogates for live companions. A sturdy

**Pair of
Tomb-Chamber Doors**
China, Western
Han dynasty
First century B.C.
Earthenware
with impressed and
carved decoration

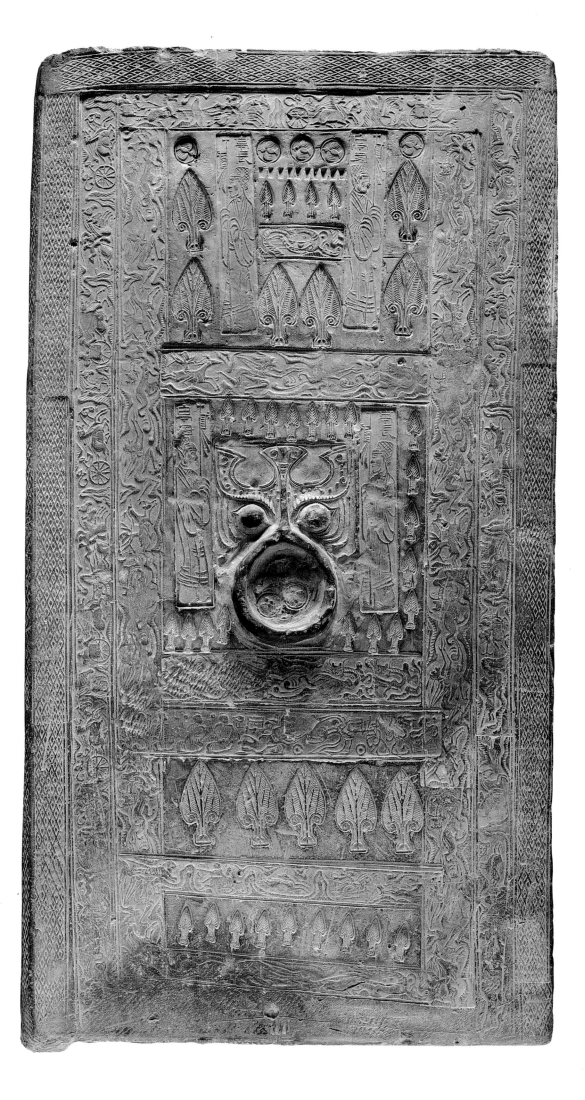

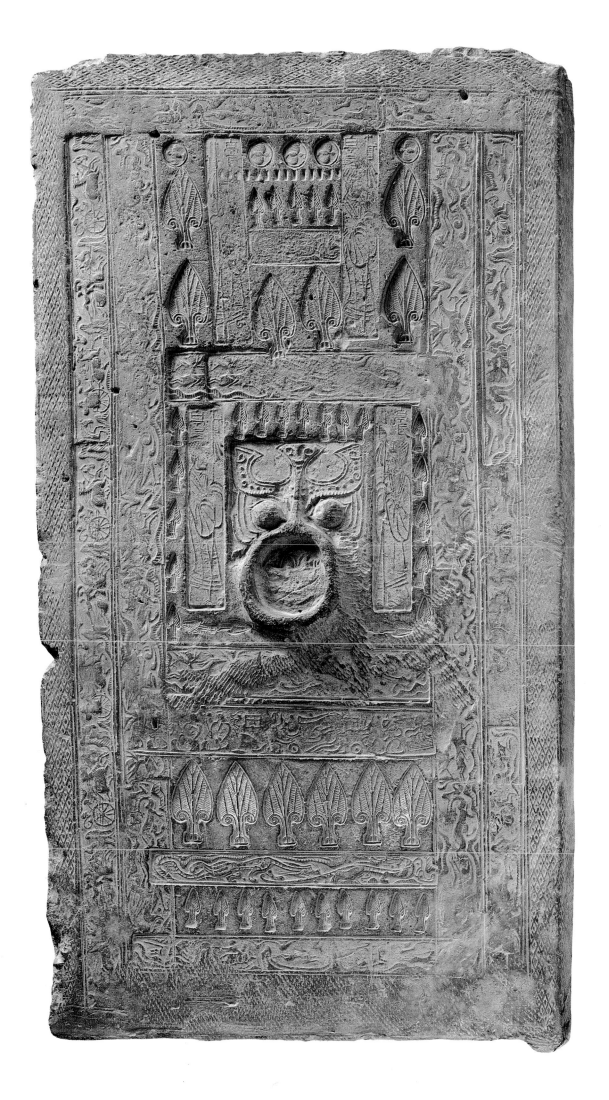

31

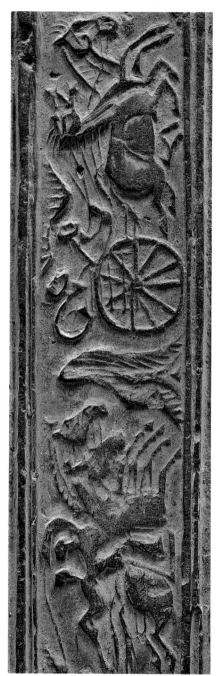

mastiff of the late Han (opposite) stands harnessed and alert, teeth clenched, eyes wide, ears pricked for intruders. Its compact, hollow earthenware body has been molded in two halves, joined lengthwise along the head, chest, back, and rump. Knifepared legs and incised facial features were added by hand, after which a fluid lead glaze (colored olive green by copper oxide) was applied, and the figure was fired. Centuries of burial have decomposed this glaze into thin layers, which reflect light with silvery iridescence.

Lead-glazed tomb figures of such simple and appealing subjects enjoyed widespread popularity, but a densely populated urn (pp. 28, 34) reflects a different ceramic tradition and funeral rites peculiar to the southeast coastal region surrounding modern Shanghai. By the late third century, when this vessel was created, the Han empire had disintegrated, unraveled by internal strife and threatened by nomadic Central Asian tribes beyond its northern borders. National unity was revived under the Western Jin dynasty (265–317), but only for about two generations. A flood of invasions sent the northern Chinese fleeing south and plunged the country into a deep and prolonged period of division known as the Southern and Northern dynasties (317–589) or, more simply, the Six Dynasties period.

However chaotic, this era of imperial breakdown and incessant warfare witnessed remarkable cultural achievements under both Chinese and foreign regimes. Among the most notable is the development of celadon-glazed stoneware (which required a much higher kiln temperature than earthenware). From primitive beginnings in the Bronze Age, iron-rich clay and glaze were fired in a reduction (oxygen-deprived) kiln atmosphere to produce a range of putty, khaki, and grayish or bluish greens. Initially created by accident, then sought by trial and error, celadon glazes of consistent color and texture were progressively mastered through carefully calculated formulas at several kilns producing both everyday and funerary wares.

An unusually complex and intriguing example of Western Jin celadons, this object displays the thin, translucent glaze and characteristically uneven streaks of early wares. A profusion of birds, monkeys, bears, dragons, immortals, and kneeling men decorates the sealed lid, the figures individually molded and applied onto two balconylike mouth-rims beneath a multistory pavilion. The combination of real and mythical creatures follows the iconography of Han funerary art. Monster mask ring-handles suspended over the rim are now purely decorative. Intermingled with such familiar motifs, however, is the new and unexpected image of the Buddha, distinguished by his meditating posture, topknot, and halo. The marginal role of Buddhist images in this decorative scheme reflects the adoption of the alien Indian religion, as the Chinese then understood it, into a hospitable melange of different, simultaneously held spiritual beliefs. In the lowest register appears a prominent vertical tablet carried on the back of a tortoise — a common form of memorial stone. Based upon that image and upon

**Mastiff
(Tomb Figure)**
China, Eastern
Han dynasty
Second century A.D.
Earthenware with
green lead glaze

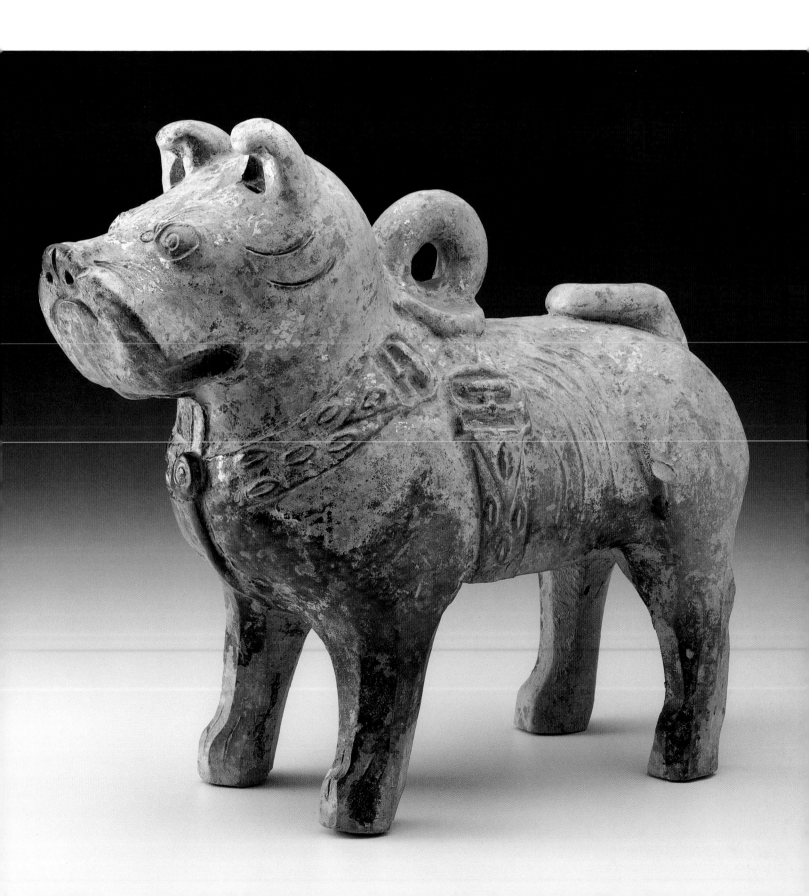

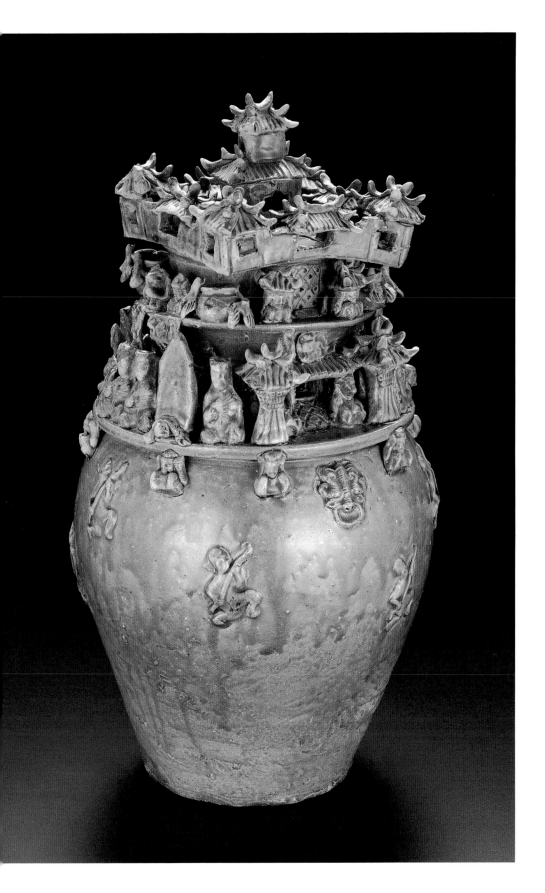

ancient texts, modern scholars identify this vessel type as a *hunping* or "urn of the soul," a symbolic dwelling place for the spiritual soul of the deceased.

In addition to embodying a mixture of different beliefs, this jar also exhibits a formative stage of celadon glaze, which was to become more uniform in color and texture throughout the Six Dynasties period. By the time China was again drawn together under a single emperor, who called his dynasty Sui, potters had developed thick, opaque glazes that enhanced well-proportioned forms and restrained surface decoration. In a graceful vase of the period (opposite), the swelling, ovoid body contracts to a gently canted shoulder, slender flaring neck, and cupped mouth. This upper half is crisply articulated with horizontal bands, loop handles, and lion heads. The opaque, olive glaze, filled with a network of fine cracks formed by shrinkage upon cooling, runs down the exterior in thick drops and pools to a glassy powder blue. In subsequent centuries, such accidental effects were deliberately induced for their decorative beauty.

Funerary Urn (*Hunping*)
China, Western Jin dynasty; late third century A.D.
Stoneware with olive-green glaze

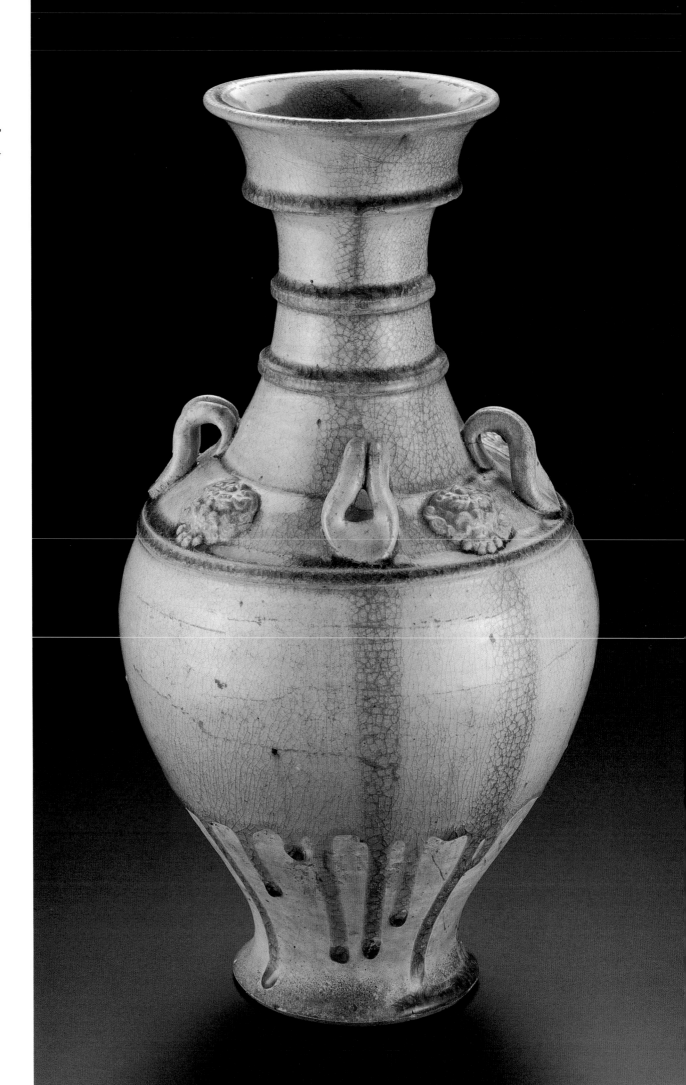

Vase (Hu)
China, Sui dynasty
Circa 581–618
Stoneware with
pale green glaze

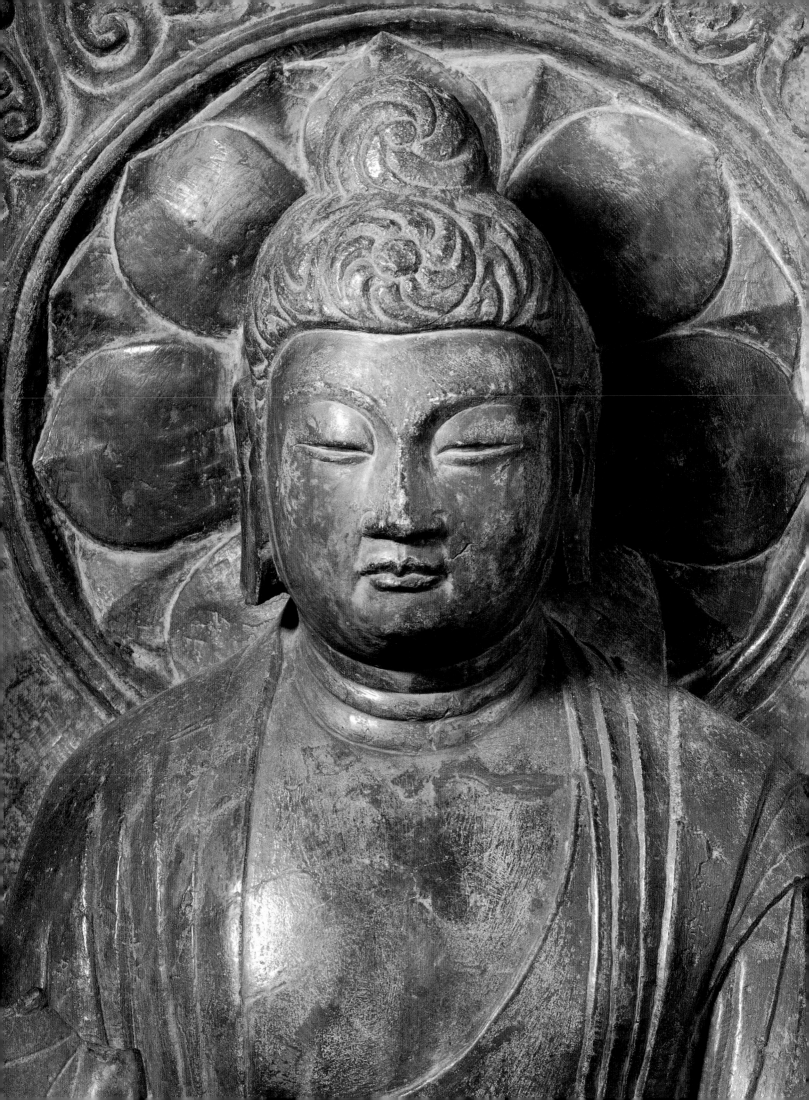

Buddhist Sculpture:
Divine Compassion and Worldly Elegance

Buddhism reached China from India, apparently via the oasis city-states of Central Asia, during the first century A.D. In China, Buddhism remained an obscure and marginal sect, probably consisting mostly of the worship of icons believed to have magical power, until after the fall of the Han dynasty, in the year 220. The religion developed from the teachings of Gautama Sakyamuni (c. 563–483 B.C.), later known as the Buddha. Born into a princely Indian family that carefully shielded him from all knowledge of human suffering, Sakyamuni abruptly renounced his royal status upon his first encounters with these circumstances in order to seek their origin. Eventually, he came to understand that life is nothing but suffering and illusion. He taught that the way to escape from the endless cycle of rebirth, to which every living thing is subject, is to suppress all physical desire and to seek Enlightenment, through which one may achieve Nirvana, or release.

During the period of disunity in China between the fall of the Han and the reunification of an empire under the Sui dynasty in 589, political chaos, personal hardship, and the failure of Confucian teachings to offer either remedies or comfort opened people's minds to Buddhism. During these three and one-half centuries, the religion penetrated the educated upper classes, including the courts of the

many short-lived Chinese dynasties and "barbarian" kingdoms then dividing the rule of the country. Out of this Buddhicized elite was formed a class of scholarly monks, who took as their chief work the translation of an enormous number of Buddhist texts and the elucidation of these in traditional Chinese terms for a Chinese audience. To the lower classes of those difficult times, Buddhism offered the spiritual consolations of a devotional religion replete with intercessor deities, and, more practically, afforded refuge in the burgeoning monasteries from military service, forced labor, and crushing taxes. By the end of this period, Buddhism had permeated every level of Chinese society in all parts of the country.

During the Sui dynasty and the first half of the Tang (618–907), Buddhism was pre-eminent not only in the religious but also in the intellectual and artistic life of China. Although new teachings continued to come from India, the most important schools of Chinese Buddhism were native-grown. The empire, reunited and expanding, was prosperous as never before, and official patronage was lavish, if rarely exclusively pious in its motives. Buddhist temples multiplied and flourished. Buddhist sculpture (and, without a doubt, painting — which has not survived) engendered and enlisted powerful currents of artistic creativity.

By the mid-ninth century, even before furious persecutions were unleashed against the Buddhist establishment by the later Tang government,

the creative force of Chinese Buddhism seems to have abated. The resurgent, Buddhist-tinctured Confucianism of the Song and later dynasties not only reinforced a useful social doctrine, but it also became the sole road to government service and membership in the new scholar-official-gentry elite. Having lost the attention of the educated upper classes, Buddhism also lost forever its intellectual primacy, and its power of artistic innovation also diminished somewhat. Buddhism continued, however, as a popular, devotional religion and as one element in the syncretic doctrine of the "Unity of the Three Teachings" (Confucianism, Buddhism, and Daoism).

Sectarian differences appeared in Buddhism quite soon after its beginnings, the principal division being that between the older, Theravada, or Hinayana ("Lesser Vehicle") tradition still current in Southeast Asia, and the Mahayana ("Greater Vehicle") tradition embraced in China, Korea, and Japan. The mature Mahayana Buddhism of Tang and later China was considerably unlike the austere doctrine of a self-motivated search for Enlightenment, without deities (and, therefore, without icons or worship), first taught in India by Sakyamuni Buddha in the sixth and fifth centuries B.C. Briefly, Mahayana Buddhism was a religion of salvation and many paradises, in which Buddha had become a godhead, an

37

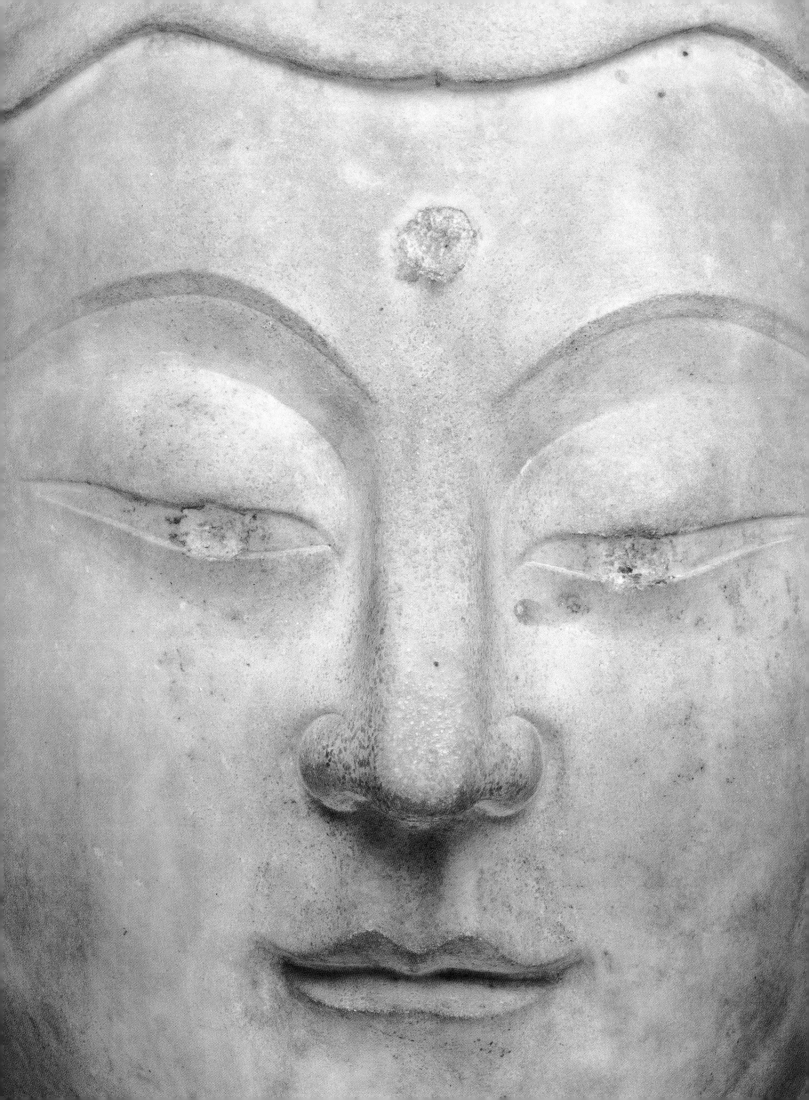

Head of Guanyin
China, late Northern
Qi or Sui dynasty
Late sixth century A.D.
Marble with traces of
metal fittings at crown

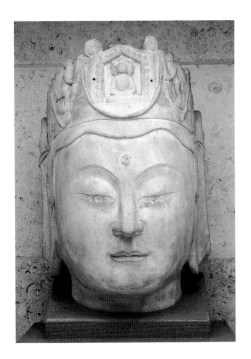

object of worship along with a host of bodhisattvas who, somewhat like the saints of Catholicism, serve intercessory roles. Bodhisattvas are human beings who have attained Enlightenment but willingly postpone entry into Nirvana (and eternal release from suffering) in order to help other sentient beings along the noble path. Also revered were the luohan (Sanskrit: *arhats*), "perfected beings" who had attained Enlightenment in their present life and would enter Nirvana at the end of it; these included contemporary and later disciples of the Buddha.

Though the luohan, who did not forgo Nirvana in order to help other beings, belonged originally to the Theravada tradition, from the seventh century and, more especially, from the tenth, they were absorbed into the Mahayana pantheon as protectors of Buddhist law. Founder-monks of the various schools of Buddhism were venerated as holy men and often as wonder-workers, if not as deities. All these holy ones were made into icons, depicted in art as both tokens and objects of worship.

The benign, altruistic aspect of Mahayana Buddhism is well expressed in a beautifully sculpted marble head of the bodhisattva Guanyin (Sanskrit: Avalokiteśvara; opposite and left), made in the late sixth century. Guanyin is the bodhisattva of limitless compassion, or the manifestation of the universal compassion of the Buddha Amituo (Sanskrit: Amitabha), whose seated image in the center of Guanyin's crown is a clear indication of the bodhisattva's identity. The Buddha Amituo shares with Guanyin a readiness to come to the assistance of those who summon him. Serene benevolence emanates from Guanyin's gentle, meditative expression (somewhat altered from the original by later recutting of the pupils of the eyes). The mark between his eyebrows is an *urna*, from which the light of wisdom radiates to illuminate the universe; his elongated earlobes, seen on most Buddhist icons, refer to the heavy earrings worn by Indian rulers, including Sakyamuni before he relinquished his worldly status. The idealized geometry of the face, with its sharply defined lips, eyelids, brows, and wings of the nose, creates a sense of reserve and inner power. The body from which this head was severed was certainly likewise geometricized, and abstracted into a columnar shape. The effect of similar images that survive intact is one of majestic dignity and peace.

Ideals of the period called High Tang inform a small stone image (pp. 36, 40) of the seated Mi-le (Sanskrit: Maitreya). The robust corporeality of this figure relates it to the sculptural style practiced at major Buddhist centers such as Chang'an (present-day Xi'an). An inscription on the base of the image states that it was dedicated in the year 705 by the Buddhist disciple Yan Zongchun "for the sake of [his] deceased parents and seven generations of deceased ancestors, present family members, and all paternal and maternal relatives." The inscription also mentions that the figure was

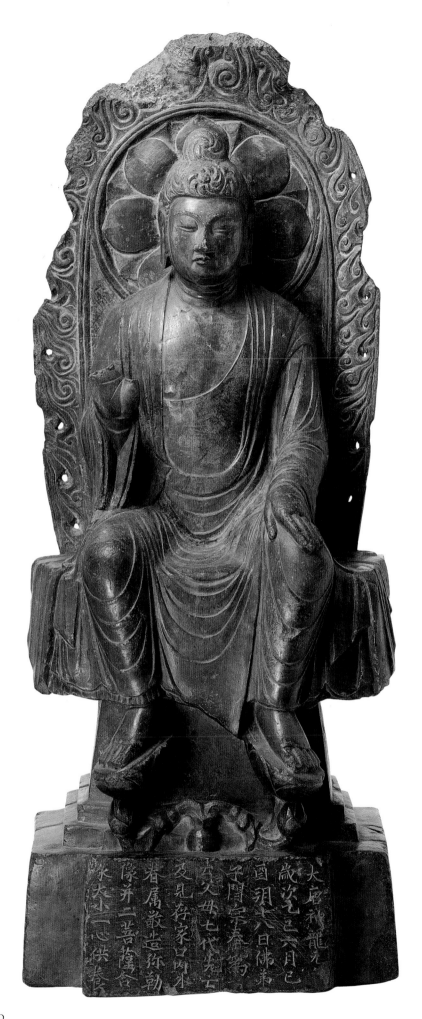

part of a triad, originally flanked by two bodhisattvas representing emanations of Mi-le's power and mercy, respectively.

Mi-le is the Buddha of the Future, successor to Sakyamuni. His elongated earlobes and *urna* are attributes of divinity seen on bodhisattva as well as Buddha images, but the *ushnisha*, a hemispherical protuberance at the top of the head representing Enlightenment and wisdom, is more often restricted to representations of Buddha. The halo and flaming nimbus signify the "Buddha's light." Here, the halo assumes the form of a lotus, which, because it emerges unsullied from the mud, symbolizes the Buddha nature inherent within all living things. Mi-le's feet, planted on lotus blossoms, symbolize his readiness to enter the world of sentient beings.

This sculpture, although small, conveys a tangible sense of substance. The folds of the Buddha's garments emphasize the firm fleshiness of the body beneath, and his face is more fully rounded than that of Guanyin. The facial features are still idealized, slightly schematic, and unnaturally sharp in outline; but here the curves present a more naturalistic sense of the face.

This image was made at the end of the reign of an empress who culti-

Mi-le Buddha
China, Tang dynasty
Dated 705
Limestone

vated a special association with Mi-le. The empress, Wu Zetian, usurped the throne after her husband's death and ruled with an iron hand from 684 to 705. Her allies at court discovered in a minor Buddhist text a reference to a female deity who by reason of her virtue would be reborn as a universal ruler. By ingenious interpretation, this female deity was identified with Mi-le, who was, in turn, identified with Empress Wu, thus justifying the political usurpation and, at the same time, demonstrating the empress's religious merit. Although this sculpture dates to the last year of her reign, after she had disclaimed the connection to Mi-le, it still demonstrates some of the connotations that such an image may have embodied.

A later bodhisattva (right), while highly idealized, is yet less abstract and more thoroughly corporeal than the two preceding images. The drapery of its clothing, which falls in a less patterned, more lifelike manner than those on the Mi-le, seems intended not to conceal but rather to call attention to the tautly modeled, robust body beneath. The supple figure inclines almost imperceptibly to one side, enhancing one's impression of a living being. This piece embodies the quintessence of the so-called High Tang style, which strongly reflects the

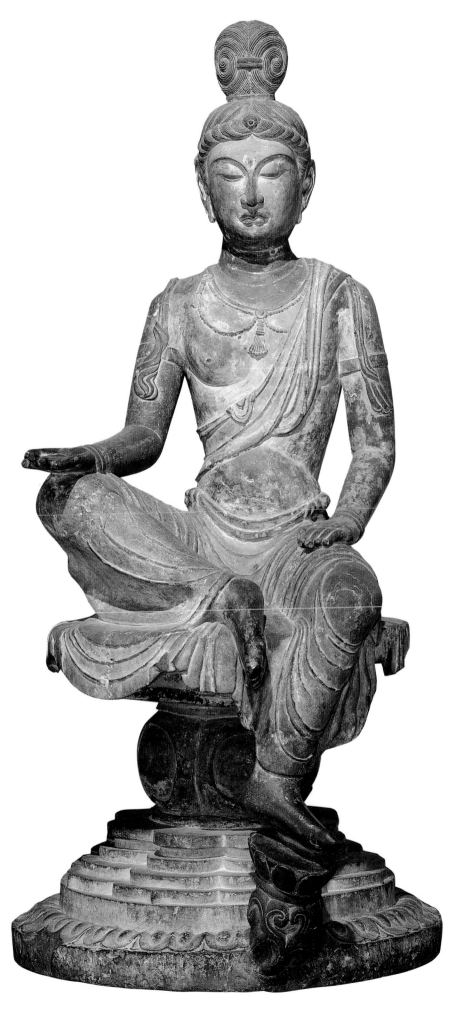

Bodhisattva
China, Tang dynasty
First half of
eighth century
Limestone with traces
of polychromy

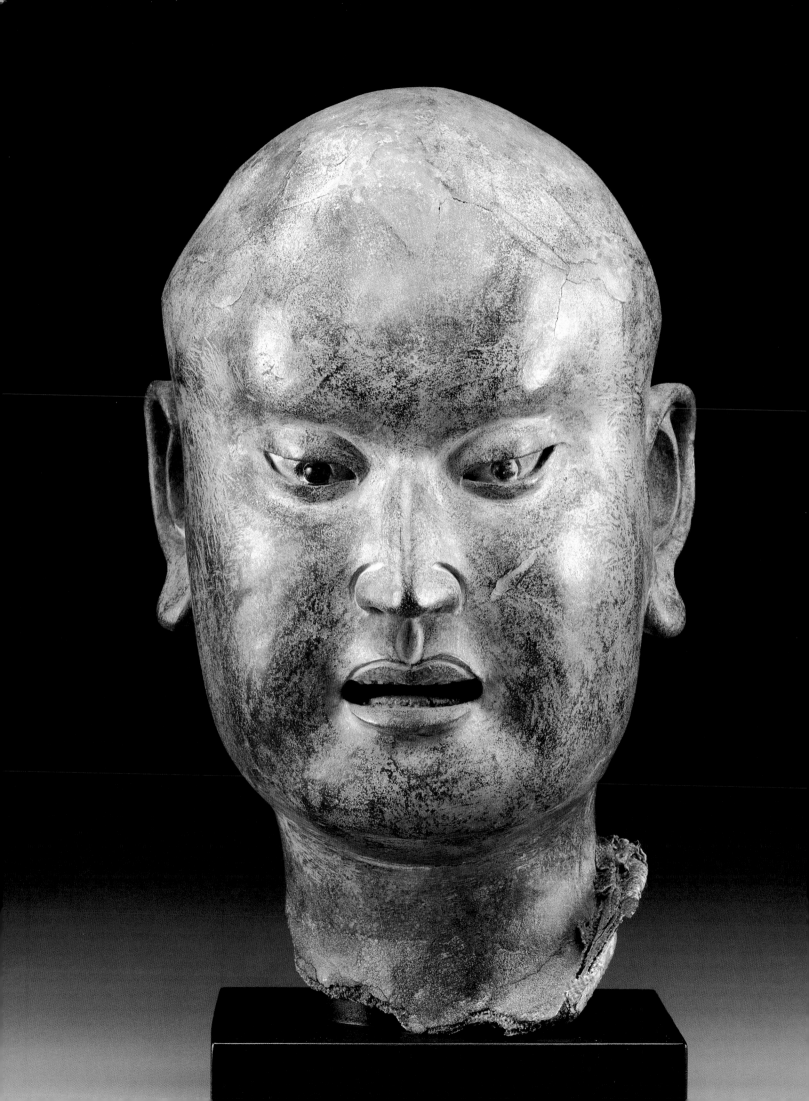

Head of a Luohan
China, Northern Song,
Liao, or Jin dynasty
Circa eleventh century
Hollow dry lacquer

self-assured cosmopolitanism of China in the first half of the eighth century. In its elegant sensuousness, the image specifically reveals the influence of Indian sculptural style of the Gupta period (350–650), tempering the Chinese tendency to linearity, patterning, and abstraction. This bodhisattva presents a most conspicuously aristocratic image of divinity. In contrast to the Mi-le image, unadorned and seated four-square with both legs pendant, this figure sits in the more casual posture known as "royal ease," is adorned in princely fashion with flowing scarves and jewelry, and wears a coiffure elaborately crimped and pulled, Indian-fashion, into a high topknot. All of this is appropriate for bodhisattvas, who have chosen to remain in the world and whose perfection therefore may reveal itself in worldly guise. A figure such as this would most likely have been an "attendant" bodhisattva, flanking a central image of Sakyamuni or Amituo Buddha in a triad or pentad of icons on a temple altar. Originally, this sculpture would have been brightly painted; traces of paint still remain on some of its surfaces.

Buddhism adapted itself to Chinese culture and was in turn modified by it. Perhaps the essential difference

between the earlier Buddhist schools, of which the Theravada is the only survivor, and the later, Mahayana schools, was the replacement of the luohan — the rigorous seeker of personal Enlightenment — by the altruistic bodhisattva. But it seems clear that the moral strength and determination of the luohan struck a responsive chord in the Chinese, long familiar with ideas of self-cultivation and self-purification in Confucianism and Daoism. Images of luohan survive from the seventh century but became notably popular in the tenth, particularly among Chan (Zen) Buddhists, for whom personal effort (not worship or learning) was the chief means to Enlightenment.

The convincingly human appearance of the finely modeled luohan's head (opposite) is far removed from the other images illustrated here, but the linear sense of design so characteristic of Chinese sculpture in general is still present in the depiction of his features. His animated expression is heightened by the colored beads used to represent his irises and pupils, and by his mouth, open as if about to speak. The image most likely dates from the Northern Song dynasty or from the succeeding Liao (907–1125) and Jin (1115–1234) dynasties of nomadic conquerors, who established independent empires in northern China. The complete sculpture to which this head once belonged was probably one of a canonical grouping of sixteen or (later) eighteen luohan in a temple image hall.

Luohan figures generally fall into three types: those of markedly foreign features, supposedly Indian or Central Asian; those of grotesque features, usually elderly, whose faces and bodies bear witness to stringent effort along the way to Enlightenment; and those of unmistakably Chinese features and usually serene, if intense, expression. These last are most often young,

and it is to this group that the present work belongs.

The highly convincing portrayal of the luohan is partially dependent upon the lacquer technique in which it was executed. Dry-lacquer sculpture such as this is made by building up layers of lacquer-soaked cloth around a wooden or clay core or an armature of wood or metal; when the approximate shape of the intended sculpture has been thus formed, a lacquer-based, malleable paste is applied, out of which the exact shape is modeled. The technique lends itself to the creation of modeled forms such as portrait heads. Painted or gilded details may enhance the finished image. Originally a glossy black, the surface of the present sculpture is now worn. But the expression of the luohan remains compelling, despite changes in its appearance over time.

Though all of the images reproduced in this chapter are icons, made as objects of worship and contemplation, they are greatly diverse in appearance and in their emotional impact on the viewer. The distinctive aspects of each image were not only the result of changes in artistic styles over time; they were also intended to reflect the particular qualities and attributes of that divinity. Iconographically, the Guanyin embodies the physical beauty of a perfected being along with the vastly compassionate attentiveness of "He Who Hears the Cries of the World." The physical presence and regal composure of Mi-le convey an unselfconscious assurance befitting the Universal Ruler, an appellation often applied to the Buddha. By contrast, the bodhisattva figure in the "High Tang" style reveals a more self-conscious poise and a worldly, even courtly, elegance. Finally, in the face of the young luohan we see the intensity and ardor of the struggle toward ultimate truth and liberation — a way at once agonizing and joyful.

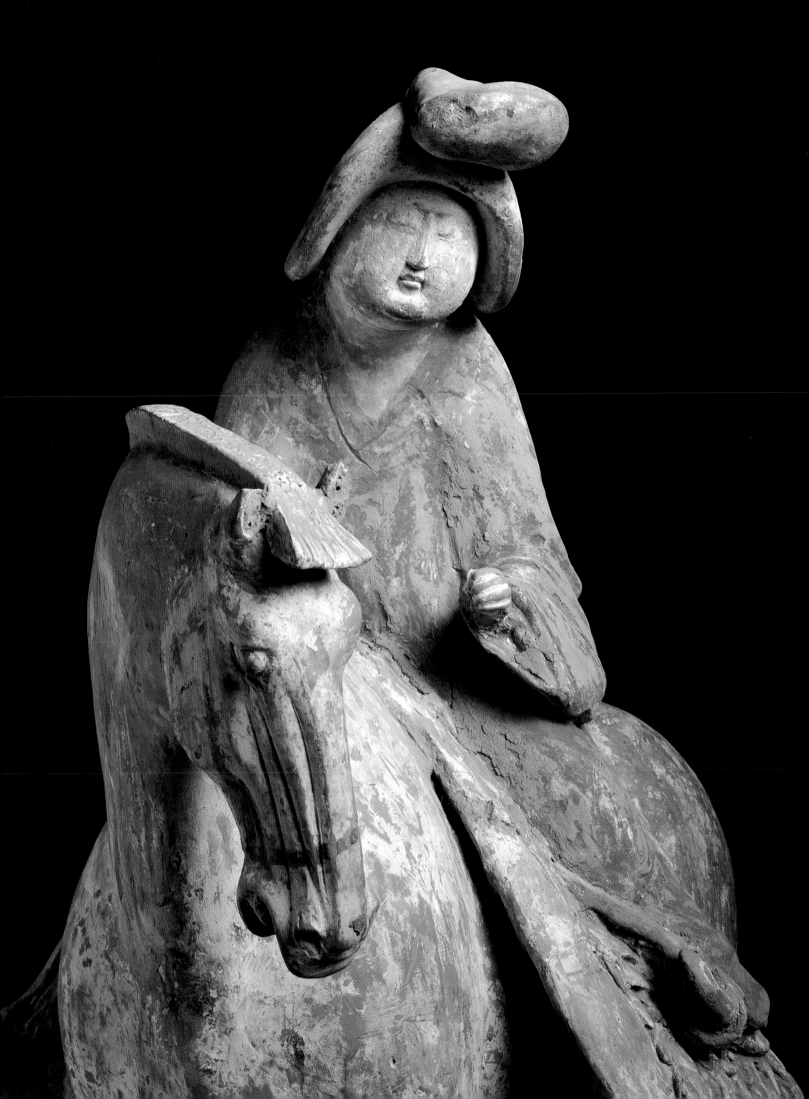

Ceramics and Silver of the Golden Age

In a pattern of political and military events that echoed the Qin and Han conquests eight hundred years earlier, an ambitious court official and military commander proclaimed the dynasty of Sui in 581 A.D. and united China by 589, only to have his son lose the empire to a far more powerful and enduring dynasty, the Tang (618–907). The Tang dynasty was China's second great imperial era — a time of such grandeur and unprecedented international prestige that it is generally acknowledged as a "golden age." Through the first half of the Tang dynasty, China consolidated and expanded its formidable power to become the economic, cultural, and spiritual center of Asia. Lucrative and far-flung trade extended the "Silk Road" across Central Asia, Iran, India, and the Roman Orient, opening sea routes to India, Korea, Southeast Asia, and Japan. Ambassadors, merchants, students, craftsmen, and religious pilgrims all converged on China's great northern cities, most notably Chang'an (present-day Xi'an) and Luoyang, the twin capitals of the Tang. These and other political and commercial centers were imbued with cosmopolitan sophistication. The Tang were intensely curious about foreign people, tolerant of foreign ideas, and enamored of foreign luxuries. Strangers were assimilated into native culture with the confidence born of an attitude of enlightened superiority.

This expansive dynasty achieved its apogee of strength, prosperity, and vitality between the late seventh and mid-eighth century. During this period, as we have seen in the previous chapter, Buddhism became a truly Chinese religion, enjoying strong imperial and aristocratic patronage. Secular art, as in earlier eras, survives almost exclusively in the form of objects buried with the elite. But Tang tombs, far more vividly than those of any other era, present the images and evoke the values of courtly society. Tombs of the imperial family, located in cemeteries outside the capital, were constructed and decorated to simulate palace precincts, with passageways, antechambers, and burial chambers painted with scenes of royal pageantry and leisure. Ceramic vessels and sculptures were carefully arranged in these chambers or crammed into niches specially hollowed to contain them. These ceramic objects were, for the most part, made specifically for burial, but the tombs also contain furnishings and accessories of precious metals and gemstones, most of which seem to have served the uses of daily life before being interred with their owners. So much wealth was consumed in the competition for ever-more-lavish burials that imperial decrees were issued to limit the size and quantity of tomb furnishings according to the rank of the deceased; twentieth-century tomb finds prove that such quotas were blithely ignored.

An ovoid jar (p. 52) exemplifies the Tang taste for splendor in its assertive rotundity and brilliantly hued, complexly patterned lead glazes. Han dynasty potters were limited to monochrome lead glazes, which were applied raw to a dark clay body (see p. 34). By the Tang period, the potters were selecting whiter clays or camouflaging darker clays with a white slip (liquid clay) to create a clean ground for carefully fritted (melted and crushed) glazes mixed with metallic oxide colorants — predominantly green derived from copper, and a range of yellow, amber, and brown hues derived from iron. These fluid glazes could be dripped, spotted, splashed, and allowed to freely streak and overlap, or they could be neatly contained within the outlines of designs stamped or applied on the body. In this jar, control and spontaneity are combined. Generously proportioned floral medallions, molded and applied to the shoulders, show a jewel-like precision inspired by contemporary metalwork and contrast most effectively with the blur of splashed glazes. These glazes, poured in successive washes, were mottled with drops of wax or with powdered clay applied as a resist, an effect that was probably inspired by tie-dyed silks imported from Central Asia.

Tomb figures of animals also display increasing vibrancy and splendor. In art as in life, the Chinese prized strong, swift, and beautiful horses. The Tang imperial stables held some of the finest horses in Asia, obtained chiefly from

45

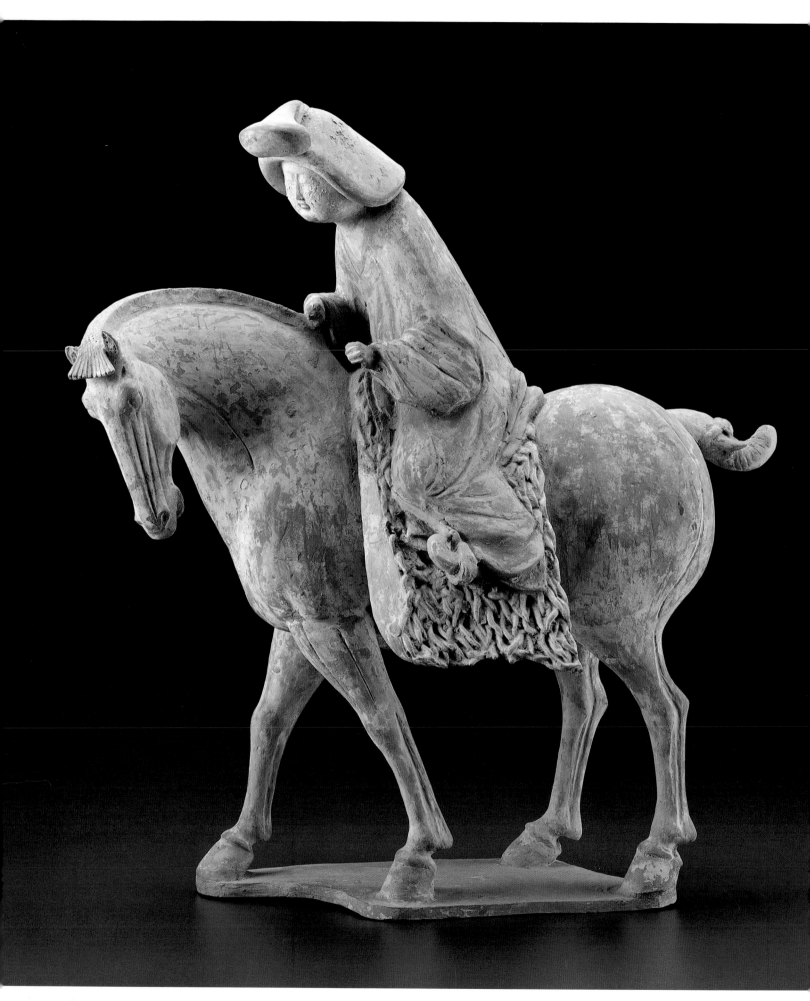

Equestrienne
China, Tang dynasty
First half of eighth century
Earthenware,
polychrome pigments

subjugated Turkic tribes in the north, in a brisk trade of silk for horses. The proudest chargers served in diplomatic missions, processions, and sport. Predictably, models of those treasured animals were commissioned in great quantity for burial retinues. In the best of these, the conventionalized poses of assembly-line production were transcended to produce powerful sculptures that were both keenly observed and artfully stylized. A stunning tour de force of ceramic sculpture (p. 51) at once captures and abstracts the bearing of an aristocratic steed, its powerfully arched neck lengthened and its head shortened to create a sleek play of contours. Such a dynamic stance required an ambitious assembly of hollow clay sections, both molded and hand-modeled, that were joined on an armature and trimmed and smoothed before finishing. The beautifully parted and combed mane, crisply molded tack with hanging brass plaques, and neatly apportioned glazes exhibit the extraordinarily high craftsmanship attained by the most prestigious workshops.

Other figures offer close glimpses of the aristocracy with whom they were buried. The statue of a serene young lady gazing into her square hand mirror (p. 50) captures a quiet moment in the life of the sophisticated and fashion-conscious Tang court, where exotic influences on furnishings, clothing, coiffure, and makeup continually altered Chinese ideals of beauty. The waisted stool on which this beauty sits was new among domestic furnishings at this time. Ceramic figures, wall paintings, and stone engravings excavated from dated tombs enable us to follow these rapidly changing fashions. In the early eighth century, when this figure was made, youth and slenderness constituted the feminine ideal. Close-fitting, layered ensembles, partially inspired by Persian and Central Asian styles, were the rage. The figure's cap-sleeved jacket and long stole are worn over a narrow-sleeved blouse and long skirt, which falls gracefully to reveal her upturned "cloud toe" shoes. As is characteristic of these figures, the garment was completely glazed, the colors applied to flow with its fluently carved folds; her face was left unglazed and was delicately painted in unfired pigments, of which only traces survive. The upswept, curled topknot, one of several elaborate coiffures described by Tang writers, would in real life have required frequent checks in the mirror — a thin bronze disc or plaque with one surface polished to reflective sheen and the other cast with decorative designs and perforated for a cord.

A more animated moment of courtly life is portrayed by an equestrienne figure of the second quarter of the eighth century, when amplitude replaced slenderness as the standard of beauty (p. 44 and left). Large, unglazed figures such as this one, originally painted with unfired pigments, are among the rarest and most convincingly sculpted. Gently guiding her horse, this matronly rider leans forward, in the direction of the turn. Her pose and the position of her hands on the (no longer extant) reins mark her, now as then, as an expert horsewoman. Twisted strands of clay describe the texture of her saddle blanket. Her substantial weight is conveyed by the heavy folds of her wide-sleeved robe and by her broad face, endowed with puffy cheeks, small, full lips, and a double chin. These features, idealized in paintings as well as sculptures of the so-called High Tang, are further rounded by her coiffure, full at the sides and loosely gathered, with one lock of hair precariously dangling over her forehead. This may be the hair style known in Tang literature as "falling from a horse." Finally, the lady's downward glance closely follows that of her horse, while her upturned shoes echo her mount's decoratively tied tail, lending a sense of quiet harmony to this subtle and sensitive sculpture.

As the deceased required protection as well as companionship, guardian figures were commonly included in tomb retinues. An armored guardian of haughty, impenetrable expression (pp. 48, 49) was probably stationed close to the burial chamber to repel potential evil. He stands on a rocky plinth, with fist clenched to brandish a weapon, now lost. His multilayered parade armor combines a helmet with upturned earflaps; neck and shoulder guards; scalloped breast and backplates secured by knotted ropes over a tunic with pleated hem; flared elbow cuffs over long, tight sleeves; and protective leggings under a sweeping skirt. The elements of this elaborate uniform were meticulously modeled in clay before firing and richly embellished with colors and gold pigment afterward. The painted patterns combine curled tendrils and scalloped floral scrolls, giving elegantly decorative flourishes to the armor of this impassive guardian.

Such a graceful fusion of geometric and floral motifs, pervasive in late seventh- and early eighth-century art, appears at its most refined in silver. Precious metals had seldom been exploited by earlier Chinese craftsmen, who had favored clay, lacquer, jade, and bronze for vessels and personal implements. Under Tang patronage, however, silver was made into a variety of luxury objects decorated with adap-

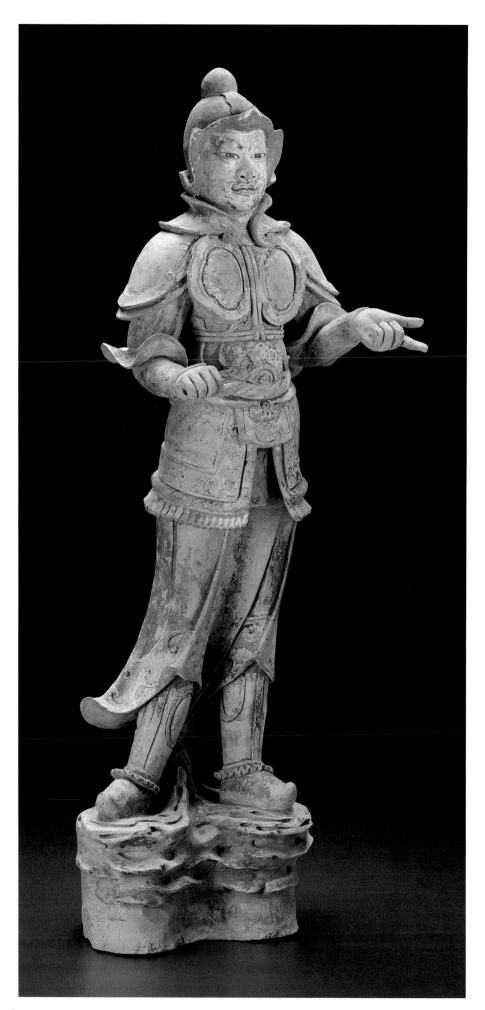

Armored Guardian
China, Tang dynasty
First half of eighth century
Earthenware, polychrome
pigments, gilding

48

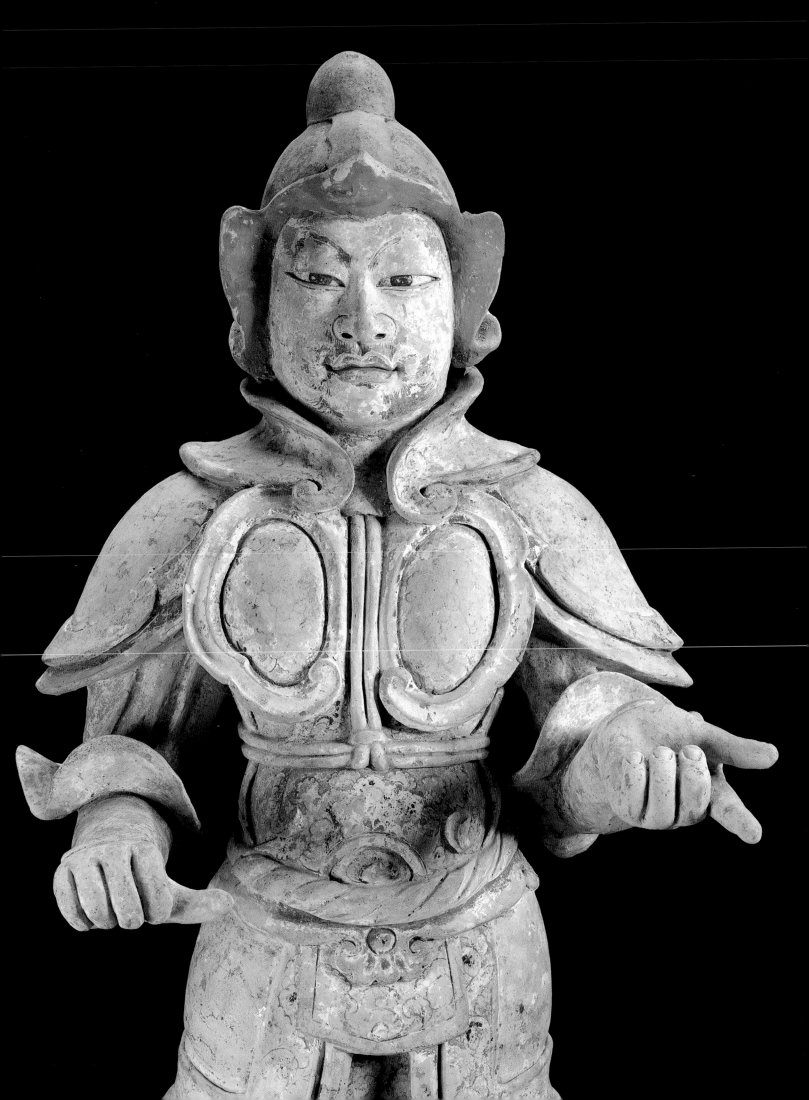

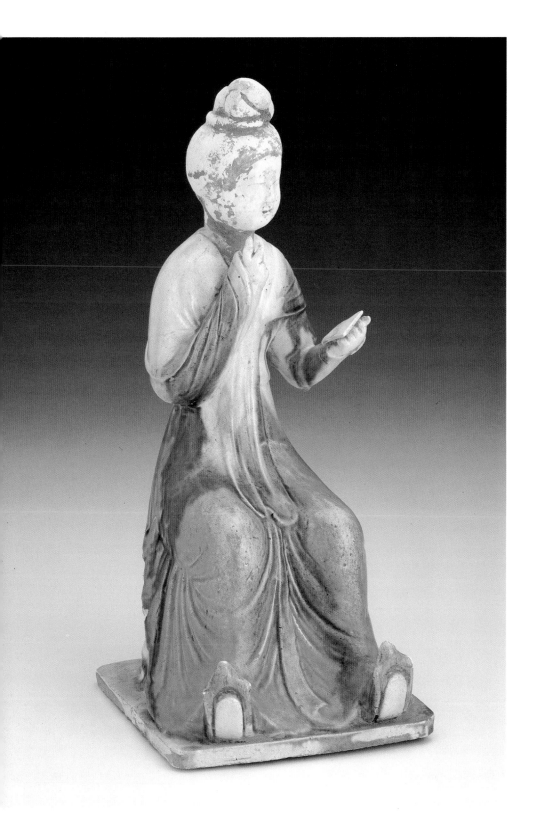

tations and variations of Near Eastern, Central Asian, and Indian motifs. Some of these accessories were cast, but most were tooled from sheets of thin silver. Following repoussé techniques long established in Sasanian Iran and Central Asia, vessels were hammered from the back into intricately shaped sections. Surface ornament was delicately beaten from the front with a small chisel (a technique called chasing), and the background of tiny circles (ringmatting) created with a punch. Final sparkle could be added with parcel gilding, selectively applied to patterns and borders.

These silver vessels often took exotic forms: a stem cup for wine (p. 53, top), was inspired by goblets made in the Sasanian and Sogdian empires, but originally derived from Hellenistic styles of the Mediterranean world. In this graceful example, the low, spreading foot gently flares into faceted petals suggesting a lotus flower. Since the introduction of Buddhism to China, the lotus — which emerges unstained from muddy water and therefore carries associations of purity and nonattachment to worldly concerns — had become a pervasive motif in secular as well as religious art. Two layers of petals, beaten in repoussé, enclose birds, floral sprays, and clusters of grapes — all delicately chased and gilded against a ringmatted ground. This mixture of native and imported decorative motifs, which followed the seventh-century introduction of grapevines and grape wine from Iranian and Turkic lands, is executed with a linear fluency that is distinctively Chinese.

Scissors were a familiar implement that might hang from the belt or complement the desk of a well-appointed

Seated Woman with Mirror
China, Tang dynasty
First half of eighth century
Earthenware,
three-color lead glazes

Horse
China, Tang dynasty
First half of eighth century
Earthenware,
three-color lead glazes

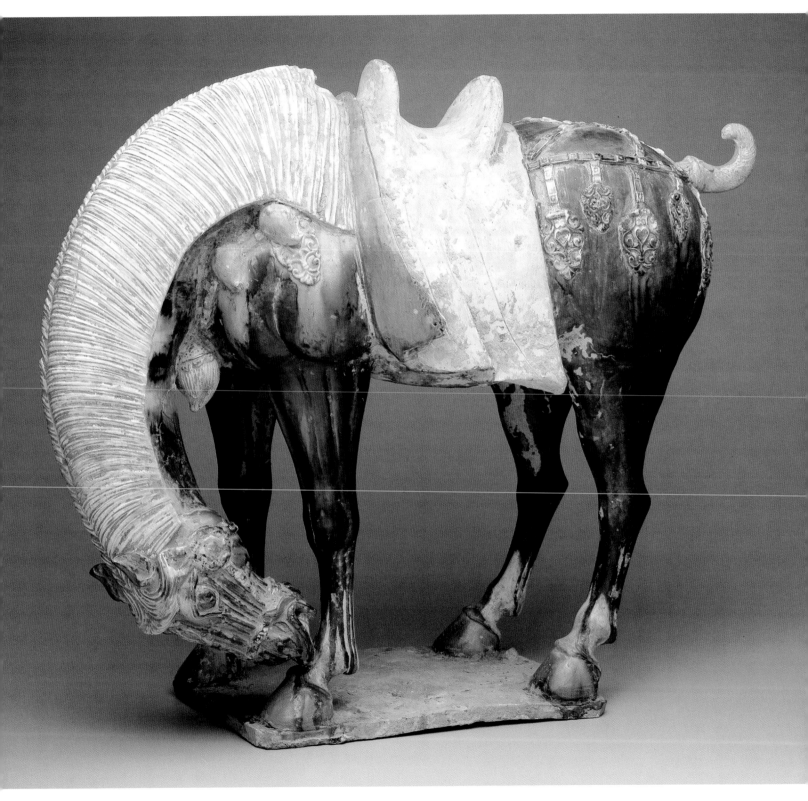

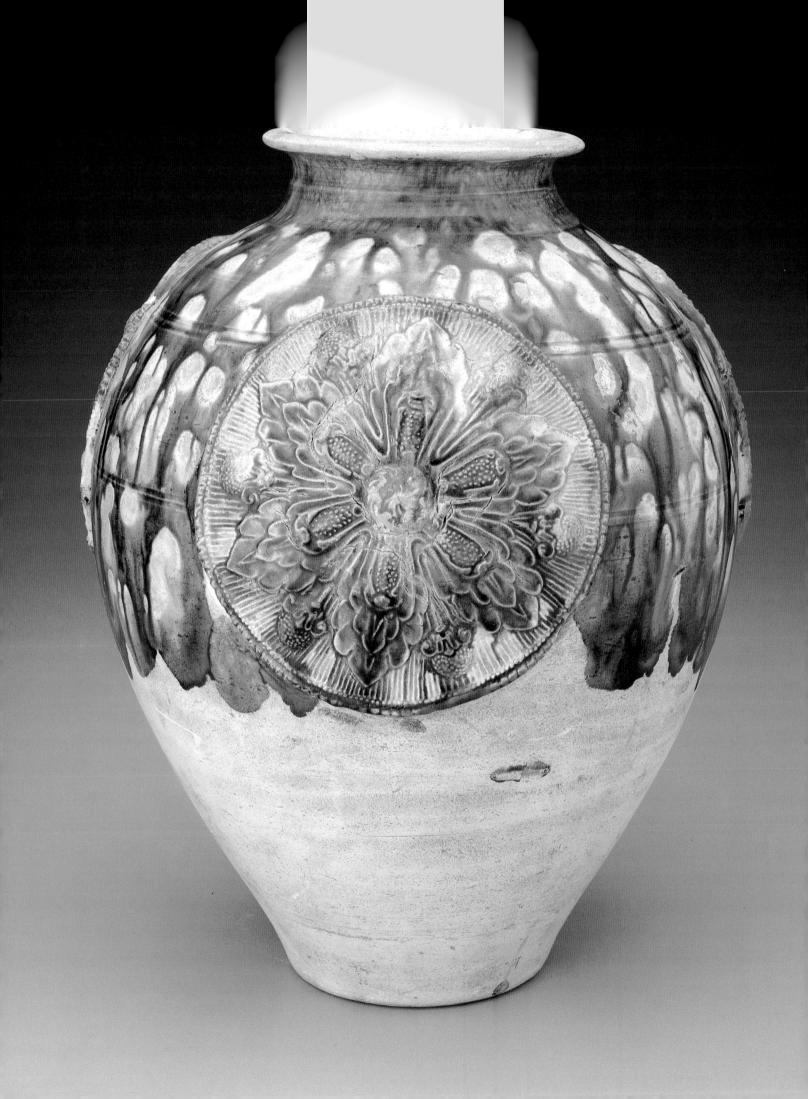

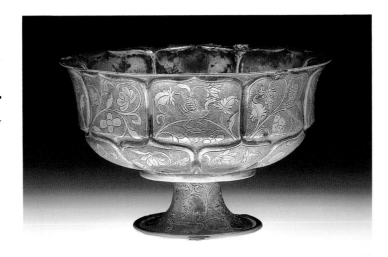

Stem Cup
China, Tang dynasty
First half of
eighth century
Silver

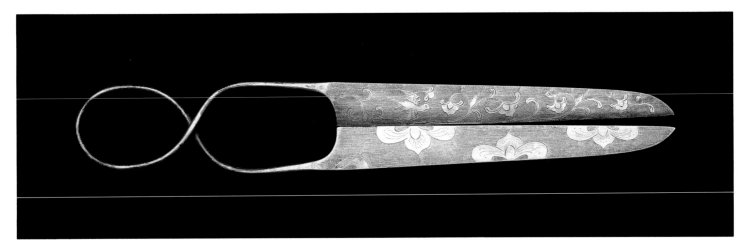

Scissors
China, Tang dynasty
First half of
eighth century
Silver

Jar
China, Tang dynasty
First half of
eighth century
Earthenware, three-
color lead glazes

gentleman. In this elegant pair of spring-handle shears (above) made from a single piece of silver, the cutting surfaces are beaten flat to slide past each other; the outer surfaces are slightly convex. All four surfaces are luxuriously chased with birds, undulating floral scrolls, and trifoliate petals. Although these floral patterns may be traced to the leaf palmette of classical Mediterranean origin, they have been thoroughly transformed over the centuries and miles. By the early eighth century, Chinese craftsmen inventively adapted innumerable combinations of birds and flowers, both stylized and lifelike, to decorate a multitude of foreign and native shapes.

Whether because silver tomb furnishings were prohibited or because most tombs had been looted before their excavation, silver has rarely been found in Tang tombs. Precious metalwork has been found primarily in large hoards, stored or hidden by privileged owners during periods of social and political upheaval. Rebellions of the mid-eighth and ninth centuries severely curtailed the life of cultivated luxury evoked by such exquisitely delicate objects. Through the late Tang, a declining aristocracy gradually lost its exclusive claim on luxury goods. The growth of new urban and commercial centers opened new markets for an emerging class of prosperous landowners and merchants, who patronized high quality and increasingly specialized crafts. In the subsequent Song dynasty, these social and economic changes would contribute to cultural achievements of unsurpassed sophistication and diversity.

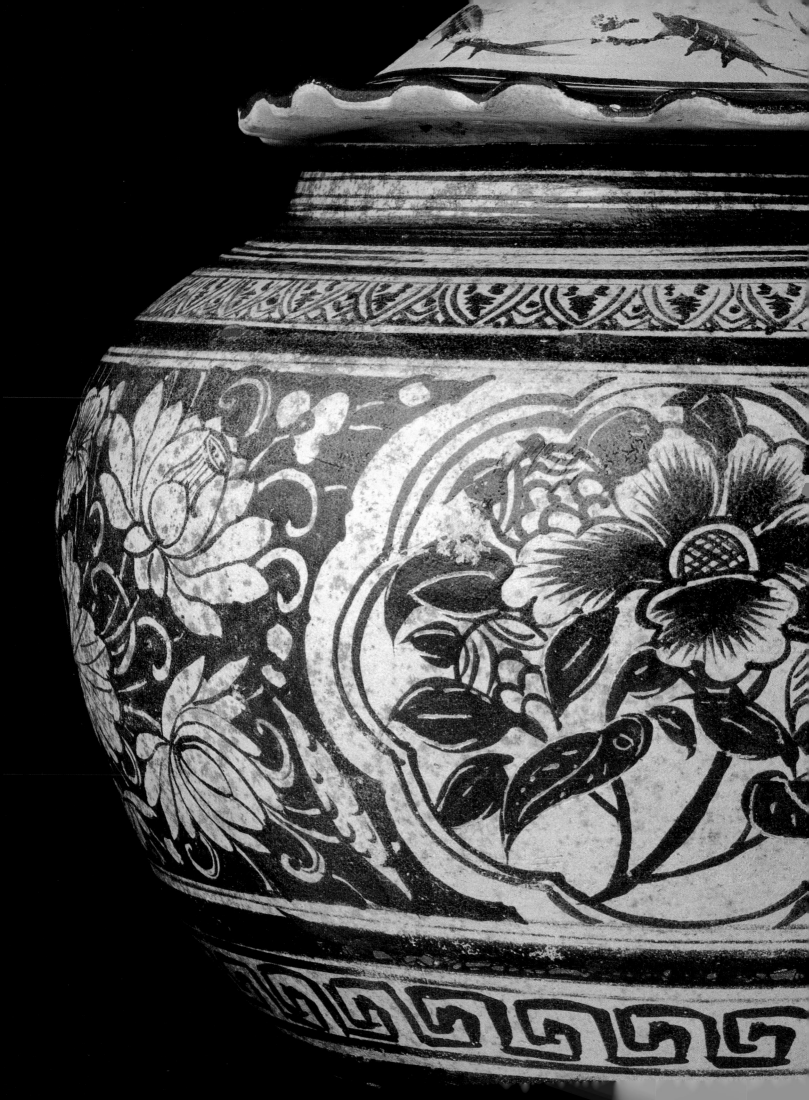

Detail of Jar
China, Southern Song
dynasty; early
thirteenth century
Jizhou ware; stoneware,
underglaze iron slip
See page 63.

Song Ceramics
and Later Porcelain Traditions

With the Song dynasty (960–1279), China entered upon three centuries of intellectual sophistication and aesthetic refinement that was unequaled in post-Classical Europe until the Renaissance. This cultural efflorescence was fostered by the newly affluent and well-educated classes that emerged from social and economic changes of the tenth and eleventh centuries. Wealthy merchants, profiting from the explosive growth of commerce and transportation, and scholar-officials *(wenren),* who achieved rank and fortune through education rather than birthright, joined the hereditary elite as patrons of art and arbiters of civilized taste.

In sharp contrast to the military vigor and cosmopolitan expansiveness of the Han and Tang dynasties, the whole tenor of Song society was civilian and introspective. Though exceedingly prosperous, the empire remained cut off from western Asia by its hostile, seminomadic neighbors to the north — the Western Xia, the Liao, and the Jin — from whom the Chinese temporarily bought peace with annual tribute payments thinly veiled as "gifts." When, in the early twelfth century, the Song unwisely upset this arrangement, the Jin Tartars invaded and conquered north and central China. Remnants of the Song court fled south, reestablishing their government southwest of modern Shanghai. By this time,

however, the Jin themselves actively patronized Chinese art and institutions in the north, while the Southern Song, as the reconstituted Chinese court came to be called, reigned over a severely constricted but peaceful, prosperous, and culturally brilliant empire. The arts of the Song, in both north and south, were distinguished by a return to native Chinese traditions and by a profound appreciation of nature.

Craftsmanship, particularly in ceramics, became increasingly specialized throughout the Northern Song (960–1127) and Southern Song (1127–1279). Stonewares and porcelains produced for imperial and aristocratic use have been traditionally classified according to their known or presumed places of manufacture. One of the most extensive and well-documented kiln complexes, located near the market town of Longquan, near modern Shanghai, continued to perfect the celadon-glazed stonewares which Chinese potters had been developing since the Six Dynasties period. A beautiful example of Longquan production is a covered vessel that may have served as a funerary urn (p. 56). The urn is datable to the tenth century, the first century of Longquan production, as we know from kiln-site excavations of fragmentary vessels with similarly carved and combed floral patterns. Its shiny, translucent, gray-green glaze is pooled — and therefore darker — within the lines of carving, thus emphasizing the overlapping lotus petals and undulating scroll of sketchy peony blossoms. The rising momentum of its

strongly proportioned, swelling and tapered profile is capped by a broadly domed lid, molded and carved in the form of an inverted lotus leaf and surmounted by an attentive dog that has been hand-modeled with disarming simplicity.

The quest for uniformly white porcelain culminated during the Northern Song at an enormous kiln complex concentrated in ancient Ding prefecture, southwest of modern Beijing. The transparent Ding-ware glaze, fired in an oxygen-rich atmosphere to a warm ivory color, is barely distinguishable from the thinly potted, fine-grained, grayish-white clay body. Between the tenth and twelfth centuries, the highest quality Ding porcelain was reserved for dishes and bowls made exclusively for the dining tables of the Northern Song imperial court. Decorators, drawing upon a wealth of floral motifs, achieved unprecedented fluency and linear rhythm in underglaze carved and incised decoration. Interwoven peony scrolls, symbolic of beauty and prosperity, are spread across the center of a shallow plate (p. 58), their feathery leaves gently cut with a slanted blade to create a shadowy effect. A palmette scroll encircles the flat rim, whose edge was left unglazed to prevent sticking when the plate was fired upside-down. This "dry" edge, a characteristic of Ding ware that reputedly discredited it in the discriminating

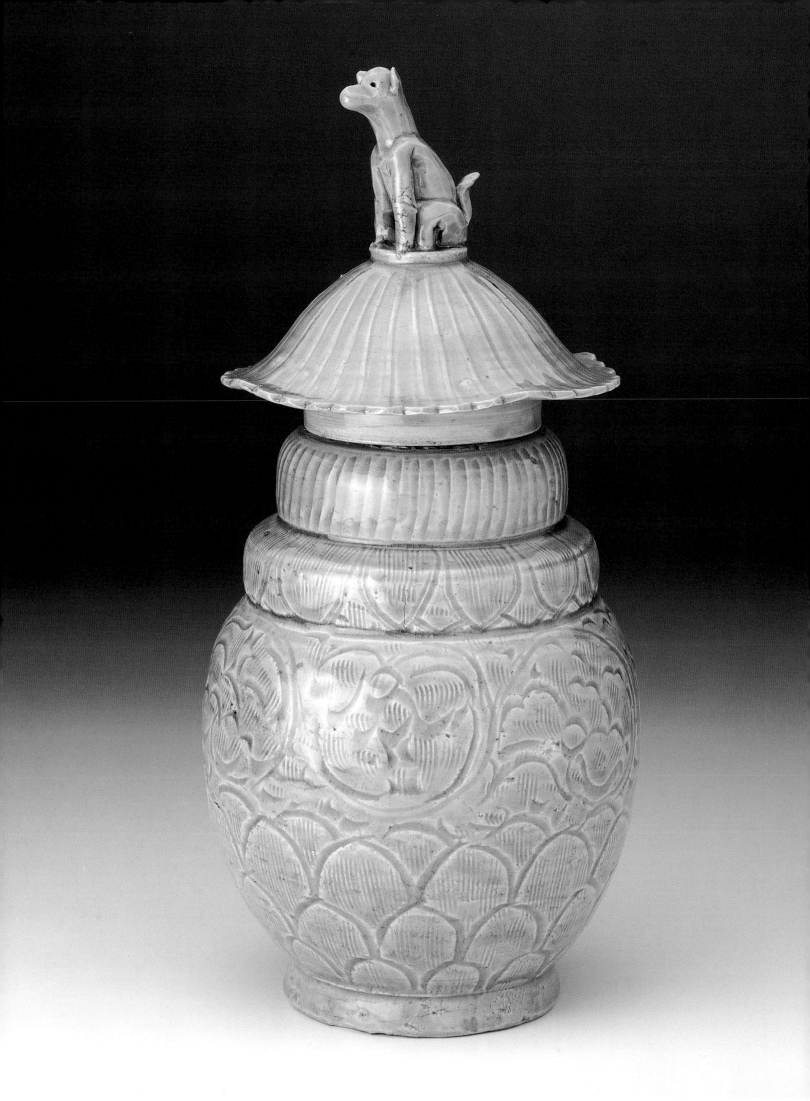

eyes of one Song emperor, is, typically, bound with a metal band — an attractive solution that assured continued appreciation of this exquisite type of ceramic beyond the imperial court.

By the time the Jin conquerors appropriated the Ding kilns in the early twelfth century, carved, pre-fired stoneware molds were widely employed to impress patterns in thread-like relief beneath the glaze. In an exceptionally crisp example of molded Ding ware, the interior of a shallow dish (p. 59) reveals a natural idyll: a pair of mandarin ducks (symbolically associated with wedded bliss) are poised in an inlet luxuriantly over-grown with lotus and other water plants, while a dragonfly hovers above. This poetic composition, encircled by blossoms and cloudlike volutes, was inspired by more literal "bird and flower" studies of contemporary painters. The designs on carved Ding ware, for which the decorator plied his knife like a painter's brush, have a sponta-neous, flowing, and painterly quality, in contrast to the dense, brocadelike surfaces of the mold-impressed pieces. Toward the end of the Northern Song and under the Jin conquerors, molded Ding ware seems to have supplanted carved, possibly because of the relative

economies of production: each carved piece had to be decorated individu-ally, but a single mold could be used many times.

Shape and decoration are more dynamically harmonized in a tall, high-shouldered vessel known in late Chinese texts as a *meiping*, or prunus vase, but more likely intended to contain wine or other liquids (p. 61). In a rich, all-over design perfectly scaled to the elegantly tapered form, small boys climbing amid wind-blown tendrils of lotus flowers and lilylike blossoms are deeply carved against a finely combed background. This motif, ultimately derived from Indian Bud-dhist art, was symbolic of fertility and general good fortune, and is pervasive in Song silver and textiles as well as ceramics. The distinctive blue-green glaze, described in Chinese as *qingbai* (bluish-white) or *yingqing* (shadow blue), was imparted by traces of iron oxide and titanium fired in a reduc-tion kiln. Pieces of this extraordinary quality are attributed to the kilns at Jingdezhen, in Jiangxi province, which later became China's pre-eminent cen-ter of ceramic production. Never pa-tronized by the imperial court, *qingbai* production nonetheless expanded to other kiln centers, and the wares were exported throughout Asia. Vases of similarly imposing shape and vigorous design have been excavated in Japan, where they were especially appreciated at Buddhist temples.

In an incense burner also believed to have originated at the Jingdezhen kilns (p. 60), the Song tastes for domestic luxury and for idealized nature merge in a connoisseur's object of surpassing beauty and refinement. Here the *qingbai* glaze uniformly sheaths two complex forms: the basin, elevated on a lobed foot and containing an artichokelike lotus opening into

two tiers of small, pointed petals; and a detachable, disk-shaped cover sup-porting a waterfowl that is delicately carved and stippled to articulate its luminous plumage. Fragrant smoke wafted gently from the bird's mouth and from two holes perforated beneath its feet. Song poets and painters praised incense for its efficacy in dis-sipating gloom and stimulating artistic creativity. So largely did incense figure among the amenities of urbane life that a state monopoly was established to profit from its distribution.

Cizhou stonewares present a robust contrast to these elegantly restrained, monochrome porcelains of Ding and *qingbai*. Named after one major pro-duction area in Hebei province, Cizhou wares of great diversity were made at numerous other kilns across north China as early as the tenth century. Their characteristic decorative feature — creamy white slip (liquid clay) applied to the gray stoneware body and covered with transparent glaze — was exploited with extraordinary inventiveness by Cizhou potters. A cloud-shaped pillow (p. 62), which could have been made for daily use or for burial, combines sculptural and graphic treatment of this underglaze slip coating to create floral decoration of great strength and expressive rich-ness. Deeply carved peony blooms fill each of three discretely lobed sides, and the concave top juxtaposes two layers of incised decoration: a dia-mond-shaped panel of slip, through which a single luxuriant peony is incised to the dark clay, and cloud patterns incised and slip-inlaid in the surrounding dark clay. Though Cizhou kilns provided utilitarian wares for a wide, popular market, an object so technically and aesthetically assured clearly would have met aristocratic standards.

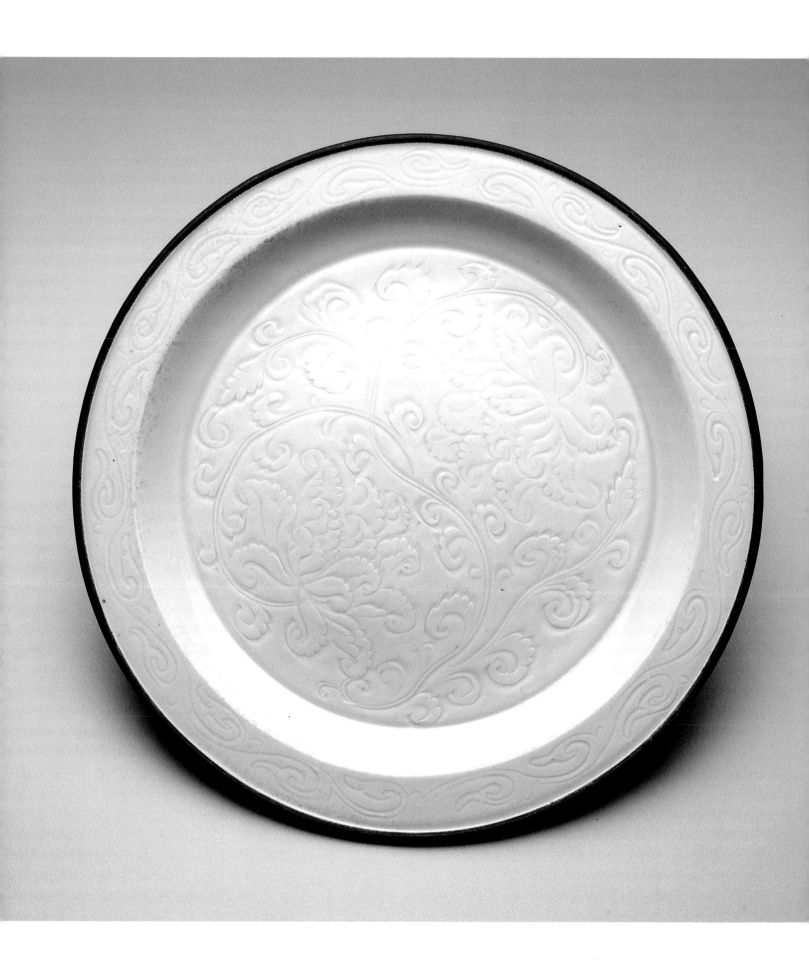

Dish
China, Northern
Song dynasty;
eleventh century
Ding ware; porcelain,
carved decoration,
metal rim

The twelfth-century conquests that ended the Northern Song stimulated a southern exodus of craftsmen, including Cizhou potters who brought their technical and decorative repertoire to several southern kilns. Among the most prolific and versatile of these were the Jizhou kilns, concentrated southwest of Jingdezhen. Slip-painting in underglaze iron pigment, a technique originally developed at the Cizhou kilns, was reinterpreted by Jizhou decorators with originality and style. Under a domed, foliated lid delicately painted with small fish, the globular contour of a Southern Song Jizhou jar (pp. 54, 63) is skillfully enhanced by a profusion of flowers. Three lobed frames enclosing individual sprays of peony, lily, and plum, fluently painted and accented with incised detail, are set off by blossoms and leaves of the lotus and plum, left in reserve against a painted background of iron brown. Such a carefully disposed and exquisitely painted design anticipates the more florid of the blue-and-white porcelains of the Yuan (1279–1368) and Ming (1368–1644) dynasties, whose decoration profoundly influenced ceramics throughout Asia, the Near East, and Europe.

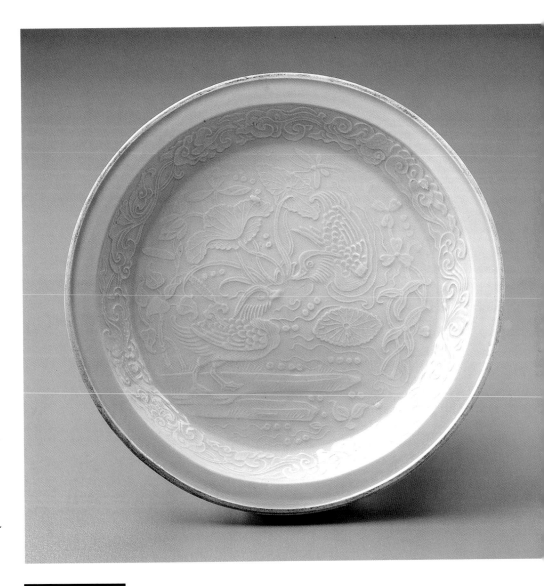

Small Dish
China, Jin dynasty
Twelfth century
Ding ware; porcelain,
molded decoration

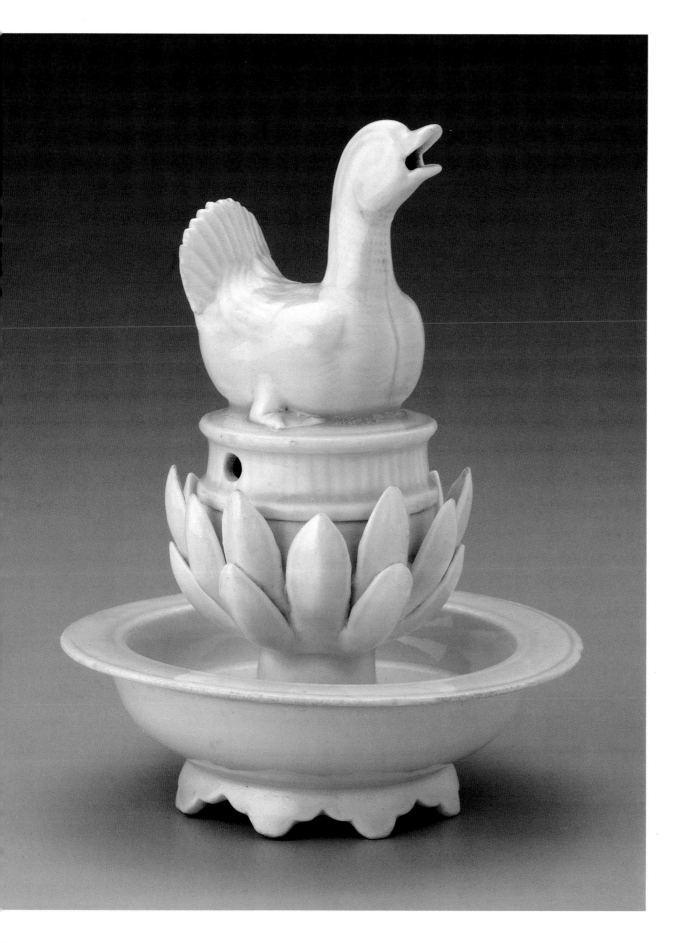

Incense Burner
China, Northern
Song dynasty
Late eleventh/early
twelfth century
Qingbai ware;
porcelain,
pale blue glaze

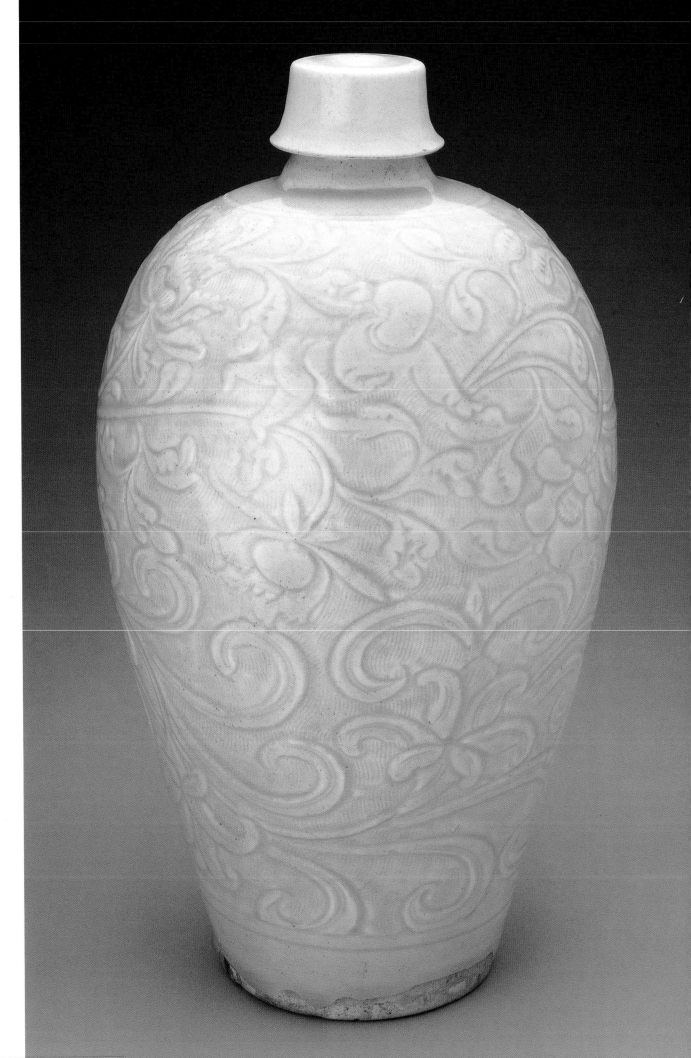

Vase (*Meiping*)
China, Northern
Song dynasty
Twelfth century
Qingbai ware;
porcelain,
pale blue glaze

Jar
China, Southern Song
dynasty; early
thirteenth century
Jizhou ware; stoneware,
underglaze iron slip

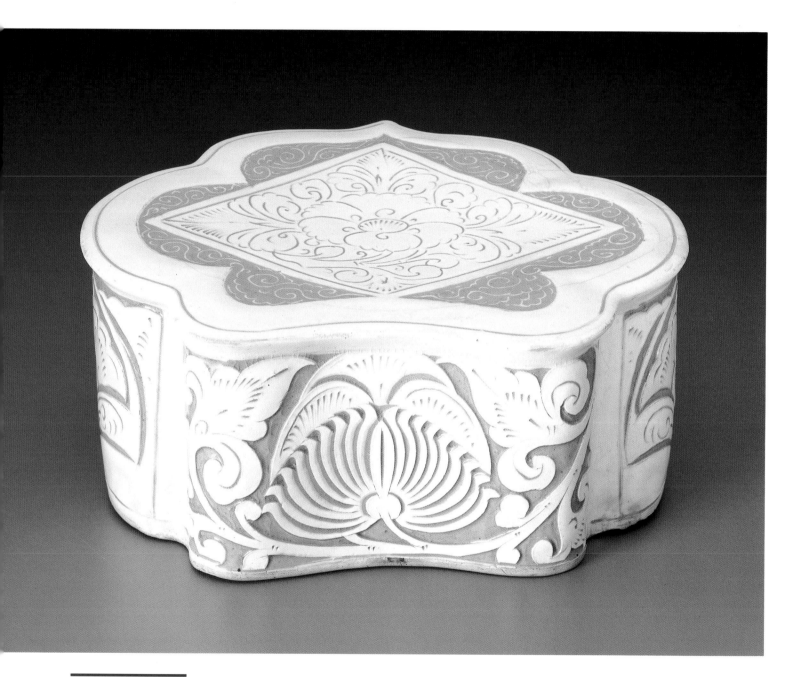

Cloud-Shaped Pillow
China, Northern Song
dynasty; late tenth/
early eleventh century
Cizhou ware;
stoneware, white slip

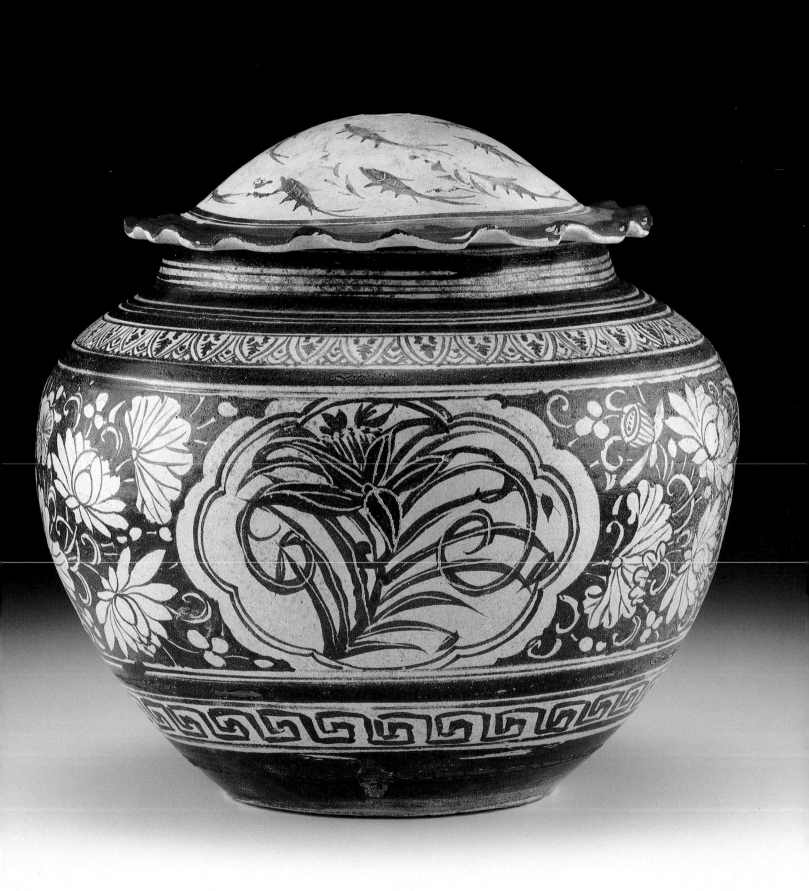

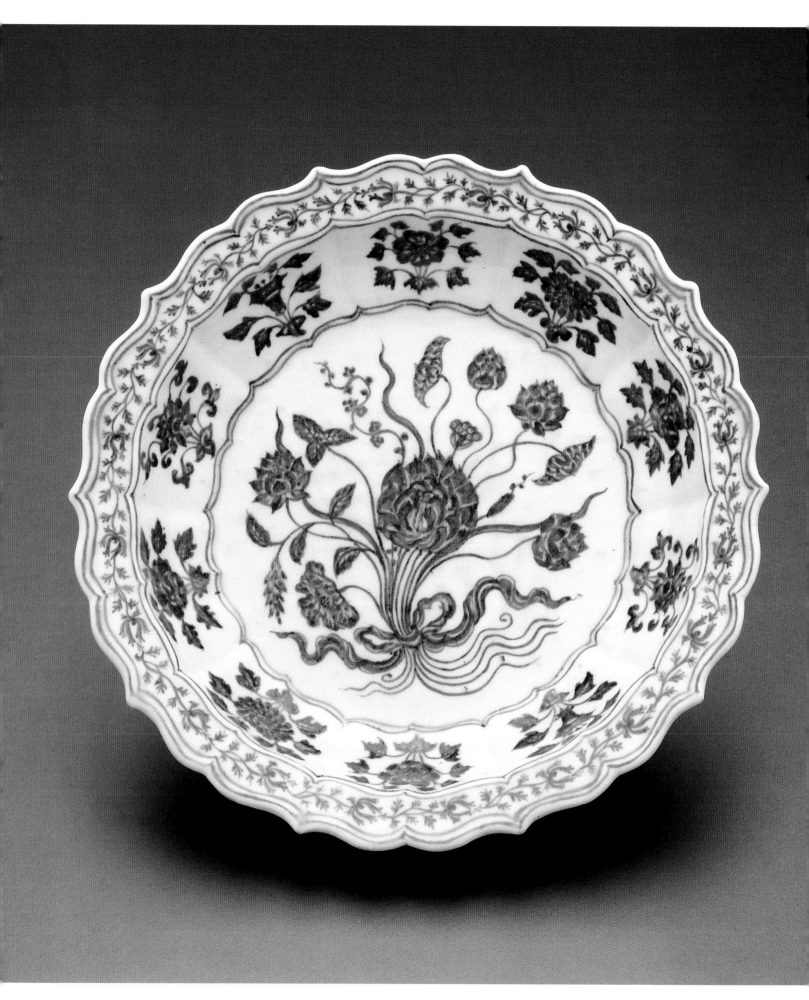

Dish
China, Ming dynasty
Xuande period, 1426–35
Porcelain, underglaze
blue decoration

Pair of Teabowls
China, Qing dynasty
Circa 1723–35
Porcelain, underglaze
blue and overglaze
red enamel decoration

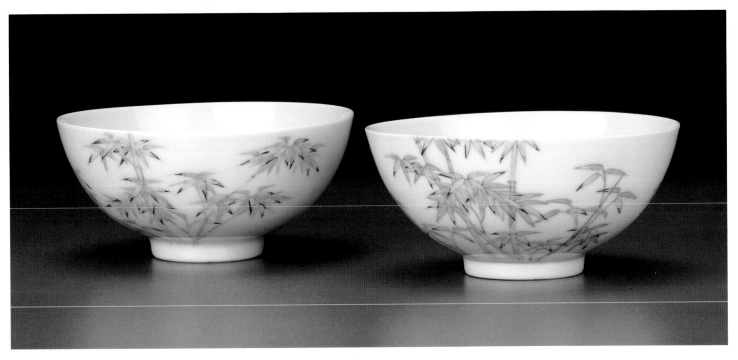

The Later Porcelain Traditions.

The flowering of blue-and-white porcelains under the Mongol Yuan dynasty reflected profound changes in aesthetics and patronage, as Jingdezhen potters imported cobalt ore from the Near East to create vibrant, underglaze-painted wares for a predominantly Islamic export market. The return to native rule under the Ming inspired more austere and elegant design. During the reign of the Xuande emperor (1426–35), blue-and-white wares made for the imperial household achieved unprecedented refinement. A dish in the Art Institute's collection (left), molded with a foliate rim and cavetto (a shape derived from Persian metalwork), is inscribed under the rim with a Xuande reign mark. Before the dish was glazed and fired, floral sprays surrounding a bouquet of lotus and sagattaria were painted in cobalt. Such exquisitely balanced form and decoration, precise drawing, and rich color distinguish Xuande as the classic age of blue-and-white porcelain.

Paler tones were favored for a slightly later Ming technique known as *doucai* (dovetailing or contending colors), in which underglaze-blue outlines were filled with overglaze enamel colors. Under the Yongzheng reign (1723–35) of the Qing dynasty (1644–1911), *doucai* was revived to create porcelains of extraordinary delicacy. A pair of teabowls (above), potted to "eggshell" translucency, are exquisite examples. Outlines of bamboo were painted in cobalt and covered with a transparent glaze before firing. The leaves were then colored with pale green, yellow, and red enamels, and the bowls refired at a lower temperature. The depiction of nature on these teabowls was certainly inspired by a long tradition of bamboo paintings on silk and paper (see frontispiece).

Traditions of Chinese Painting

A broadly simplified but useful outline of the long history of Chinese painting might be divided into several stages, each signaling the development and accrual of new meanings and purposes. The earliest surviving examples of painting are the naturalistic motifs and abstract patterns on ceramics unearthed from widespread sites and datable between 5000 and 2000 B.C. The curvilinear, double-gourd designs painted on a jar of the late Majiayao culture (p. 12) are used in a repetitive, decorative way, but may well have had symbolic meaning. More discrete images such as fish, birds, and human faces seem to reflect an assortment of religious, magical, and folk beliefs. Eventually, the expressive content of painting shifts from the potent spheres of magic and ritual to a stage in which meaning assumes more personal resonances. Personal significance is instilled in painting in a variety of ways, sometimes through subject matter with specific literary and historical associations, sometimes through references to stylistic antecedents that draw upon the revered, art-historical past, and sometimes through a combination of both. Once articulated, the defining stylistic modes and functions of these stages remain essential to the painting tradition, coexisting to varying degrees of acclaim. Even literati (*wenren*) artists of the eleventh century and after, whose aesthetic values derived from a restricted social and intellectual framework, produced bodies of work that combined these modes and functions; indeed, such a mixture can frequently be found within a single painting.

Representation.

That painting (as opposed to the decoration of objects) flourished during the Han dynasty is clear from the historical sources, which record numerous palace and tomb murals. Since these have rarely survived, however, we must infer Han painting styles from pictures in other mediums, such as the tomb doors with impressed designs of hunters within a very simply drawn landscape (pp. 30–31; discussion, p. 29). Despite their schematic rendering, these representations are true "figures in a landscape" rather than components of a decorative scheme. The nearly triangular mountains, arranged one behind the other, would remain the basic type for landscapes of the next several centuries. During the Tang dynasty, paintings of monumental scale adorned palace and temple walls in the capital at Chang'an. In the smaller formats of handscroll, hanging scroll, album leaf, and fan, a bit of silk or paper could encompass a microcosm.

Chinese painting of the first millennium was primarily figure painting. In the second millennium, landscape superseded figural art as the most significant genre of painting. Nevertheless, the figure-painting tradition continued to evolve, as shown by the anonymous late-thirteenth-century handscroll *Yang Pu Moving His Family* (opposite and pp. 68–69).

This is a narrative painting of a story popular during the Song period: Yang Pu, a famous recluse (by which the Chinese meant not a hermit, but a man who refused government office), having been at last persuaded to take a post in the Song bureaucracy, is shown moving his family and bidding farewell to his friends. The theme of leave-taking among gentlemen-scholars was a familiar one. The Song government, in an effort to prevent sectionalism and corruption, forbade officials from serving in their native districts and transferred them regularly. Given China's vastness, it was not likely that these men, once transferred, would ever see their friends again. Such partings were not only frequent, but often somber affairs, in which sadness, restrained by Confucian decorum, was ceremoniously expressed.

In the Art Institute painting, however, the "noble parting" theme has been thoroughly subverted. Yang is disheveled. His vehement expression and gesture, like those of his friends, violate Confucian ideals of dignity and composure. His wife, in similar disarray and nursing an infant, is already in midstream on the back of a water buffalo, along with a mischievous older child. A muddle of servants transports the remaining children and the family belongings. We can virtually hear the

Yang Pu Moving His Family
China, Yuan dynasty
Late thirteenth century
Handscroll; ink and light color on paper

tumult, so vividly and expressively has the artist rendered these figures. The unusually tall handscroll format, by giving full scope to the forceful drawing, enhances the animation of the scene. In Chinese art and literature, dogs and poultry had long been symbols of pastoral simplicity and ease. This rustic-looking family, with dog and goose in tow, appears to be trying, with great difficulty, to draw upon ideals of decorous conduct in preparation for a new, official life.

In China, as in no other culture, the art of landscape flourished, giving rise to two main traditions. The earlier, which reached maturity during the Five Dynasties period and the Song dynasty, offered idealized, symbolic representations of nature that were, at the same time, keenly observed and descriptively rendered. This mode was eventually displaced in critical esteem by literati painting — a mode more concerned with self-expression than with accurate description.

However deprecated by later critics, the more descriptive Song landscape tradition was never extinguished. An anonymous fourteenth-century hanging scroll titled *Flight of Geese,* for example (pp. 70, 71), is precisely rendered in a detailed manner that blends the Song tradition with newer stylistic elements. It also combines standard motifs of the landscape and flower-and-bird genres. Scattered across the foreground are mandarin ducks, lotus, and bamboo, a traditional grouping drawn from flower-and-bird painting of the Song dynasty. But the trees growing from the right side of the same area are treated in a contemporary, early fourteenth-century manner. These trees lead the eye upward into the middle distance, where geese taking flight over rushes signify autumn, a seasonal reference confirmed by the bare treetops. The touches of color used to highlight various forms in the foreground, and the

blue-green coloring applied to some of the rocks, are both archaizing features that emulate Tang dynasty painting. In the background are monumental mountain forms, convincingly portrayed as if shrouded in mist, derived from the Song landscape tradition.

The nineteenth-century painting *Wisteria and Goldfish*, by Xu-Gu (p. 79), is also vivid and convincing, even as its style is more expressive and its subject more symbolic than *Flight of Geese*. The head-on view of goldfish with bulging eyes and the clever depiction of wisteria — curving as if reflected in water, and framing the advancing fish — are boldly rendered. The ambiguous setting contributes to the painting's impact: the viewer looks across the surface and down into a body of water, a perspective that is at once unrealistic and intensely engaging.

Xu-Gu was a monk-painter, active in Shanghai in the late nineteenth century. Having deserted from the imperial army during the Taiping rebellion

(1850–64), he lived on the fringes of Chinese society. Little else is known of his life. His work is the culmination of several centuries of experimentation by successive generations of artists who, beginning in the seventeenth century, broke away from what had become the orthodox literati approach to painting. To evoke the tangibility of his subject, Xu-Gu has employed powerful brushwork, bright colors, and jarring images. Xu-Gu was not a gentleman-amateur but a professional painter, and the subject of this work was calculated to appeal to potential clients. Another painting of the same subject, titled *Purple Ribbons and Gold Seals*, reveals the symbolism of goldfish and wisteria. In ancient times, officials wore gold seals suspended from

Flight of Geese
China, Yuan dynasty
Late thirteenth/early
fourteenth century
Hanging scroll;
ink and color on silk

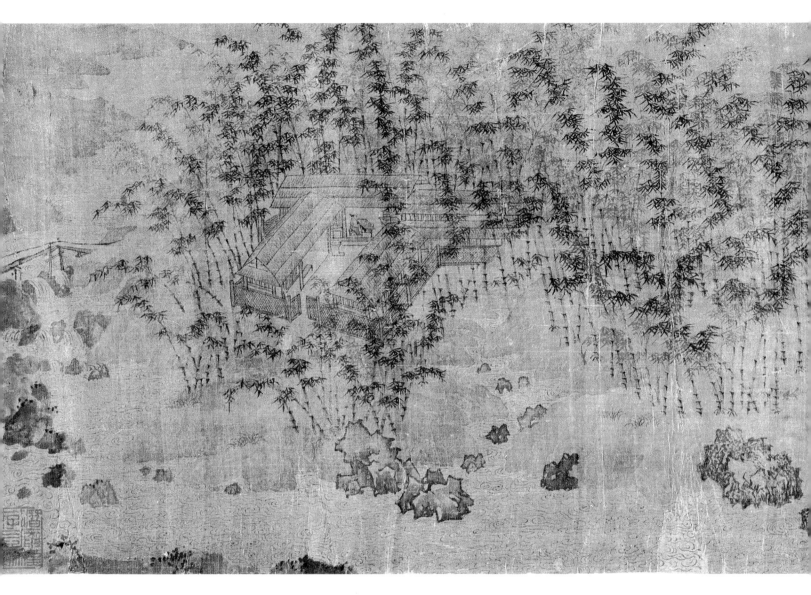

their waists by purple cords. The paintings were auspicious metaphors of high office, with the purple of the ribbons represented by the wisteria and the golden seals by the fish. Many a well-to-do Chinese scholar-official would have been glad to have such a work grace the walls of his house.

Literati Painting.

The class of scholar-officials, or literati, was not merely an important source of patronage for professional painters. Influential as painters since the eleventh century, the literati cultivated a spare, allusive, undramatic style (usually executed in monochrome ink on paper) beginning in the mid-sixteenth century. In fact, beginning in the Song dynasty, when the literati emerged as the ruling elite, the high arts by definition comprised

the mediums and genres they themselves practiced — poetry, calligraphy, and ink painting: those arts whose prerequisites were simply knowing how to read and how to wield a writing brush. All else, however appreciated, was considered mere craft.

As early as the Han dynasty, the writing of poetry had been valued as a way of expressing one's inmost thoughts and feelings. Calligraphy, the means by which poetry was recorded, rose to equal status during the third and fourth centuries. The elevation of painting, and its acceptance as a suitable avocation for gentlemen-scholars, occurred in the Northern Song. To be adopted by the literati, painting had to break from its more utilitarian reli-

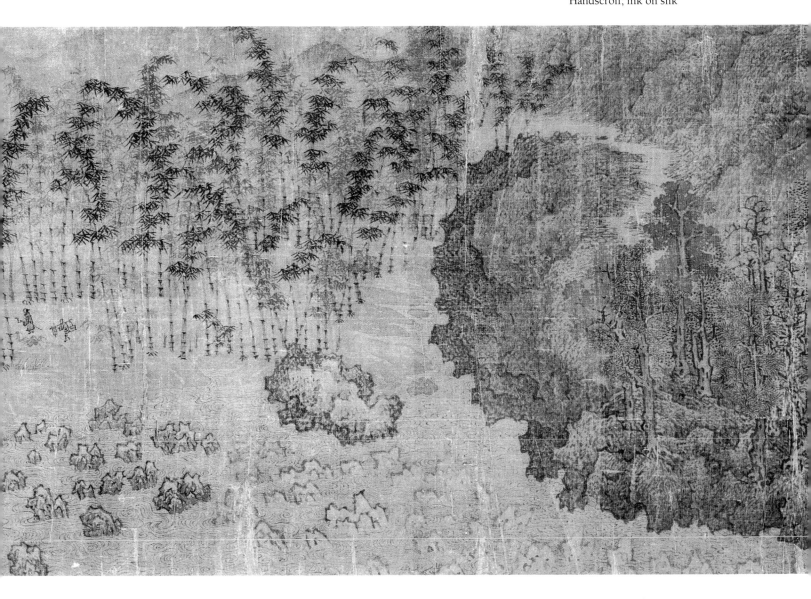

Detail of Wangchuan Villa
China, late Song/early Yuan dynasty
Late twelfth/early fourteenth century
Handscroll; ink on silk

gious and secular roles—from serving decorative, illustrative, or didactic purposes. Literati painting (*wenren hua*) was perceived as a vehicle for expressing the painter's character or feelings. This stage in the evolution of painting is augured in the writings of many Song scholar-officials, and summed up by the contemporary phrase "soundless poetry" (*wu sheng shi*). Stylistically, Northern Song painting theorists were the first to espouse calligraphic brushwork (as opposed to a more polished, typically painterly technique), but this did not become a hallmark of literati painting until later centuries.

The handscroll *Wangchuan Villa* (detail, above) exemplifies the new role and value of painting. Although it is attributed to Li Gonglin (c. 1040/49–1106), who is known to have painted a version of *Wangchuan Villa,* the style and handling of spatial recession in the Art Institute painting suggest a later date, perhaps the late thirteenth or early fourteenth century. The original *Wangchuan Villa,* painted by Wang Wei (701–761), no longer exists, but sequences of copies and

abundant literary references to it attest its seminal importance to the development of literati painting.

Wang Wei, whose poetic genius was acknowledged in his own time and ever after, was also a Tang scholar-official of high moral standing. In addition to painting his country estate,

Distant Mountains
Painted by Lu Zhi
(1496–1576)
China, Ming dynasty
1540/50
Hanging scroll;
ink and color on paper

Wangchuan Villa, Wang and his close friend, the poet Pei Di (b. 716) each composed a cycle of twenty poems eulogizing the beauty of the place. Although the poems were apparently not inscribed on Wang's painting, and the sequence of locales in the surviving copies does not coincide with that in the poems, later generations credited Wang with forging an unbreakable bond between the two mediums. The painting and poem-cycle were considered to derive from the same intention and to resonate with the same meanings and associations. And because Wang, a fine poet and member of the elite, was also an amateur painter, he fit admirably into the categories of the later painting theorists, who made him — retroactively — the fountainhead of literati painting.

Something of Wang Wei's original painting has presumably been transmitted through the copies of copies made by successive generations of artists from the Song dynasty on. In the present version, the continuous composition allows the viewer to wander through superb scenery and past handsome pavilions, taking in the particular beauties of such locales as the white rock rapids, the deer park, and the bamboo lodge nestled in its grove of tall bamboo. The format contributes to this effect, since handscrolls were intended to be unrolled one section at a time, so that one experienced the scenery sequentially, as if actually walking through the villa's grounds.

Wangchuan Villa served its owner mainly as a retreat from the cares and hazards of a government career. The Wangchuan poems and painting express an ideal seclusion and tranquility, themes favored by the literati, and ones that likewise inform the handscroll of the *Peach Blossom Spring* (detail, 76–

77), attributed to the painter Qiu Ying (d. 1552). The painting illustrates a story by the poet Tao Qian (365–427), of a fisherman who follows a stream, lined by banks of fragrant, blossoming peach trees, to an opening in a hillside through which he sees a gleaming light. Abandoning his boat, the fisherman pushes through the opening and emerges into a bucolic utopia of many centuries before his time. He hears the "crowing of chickens and barking of dogs," symbolizing prosperity and security, and he is shown perfect hospitality, which signals a virtuous society. Upon returning home, the fisherman reports his discovery to the authorities, who search in vain for the fabled land.

The scenes of the village utopia have a visionary quality that is enhanced by the blue-green landscape style. In Tang dynasty landscapes, mountains were commonly colored in this manner; thereafter the convention was used, as here, to convey a flavor of antiquity. The blue-green manner entails not only a color scheme but certain painting conventions, including simplification and repetition of landscape elements, and sharp, precise outlining of mountain contours. Such meticulous draftsmanship is associated with Qiu Ying, but this handscroll is most likely by an imitator of the seventeenth or eighteenth century. Qiu Ying painted for a living, customarily in colors on silk. In these respects, and in

his exquisite and detailed drawing, he was in direct opposition to the literati ideal. Nevertheless, Qiu Ying's paintings were esteemed by the literati for their archaistic style, poetic sources, and escapist subjects.

Similar interests and values are present in the handscroll *Bamboo along the Stream in Spring Rain* (detail, frontispiece), painted by the gentleman-scholar Xia Chang (1388–1470) for Zhou Jihong, a friend who had planted a bamboo grove around his retirement villa. Xia's dedicatory inscription describes the bamboo garden as "washing away ordinary thought," that is, as a place of purity and retreat from the "dusty world," not unlike the Bamboo House at Wang Wei's Wangchuan Villa. Xia then expresses an ancient and familiar metaphoric equation between the qualities of bamboo — which is green year-round and which bends but does not break in a storm — and those of the wise and virtuous man (by implication, Zhou). Xia was most active as a painter between 1439 and 1447, a period of temporary retirement from office taken to care for his sick mother. From that period comes this handscroll dated 1441, his earliest surviving dated painting. Xia's inscription makes clear that the painting was a gift: as a true gentleman-scholar, Xia Chang did not paint for pay.

The Role of the Past.
Chinese society and culture until very recent times might best be described as tradition-minded: the past was regarded as the repository of valuable precedents in all aspects of life. It seemed self-evident to aspiring Chinese painters that the best course of study was to diligently copy their illustrious predecessors. Personal style and fresh inventions, it was believed, would emerge only out of a thorough understanding and mastery of earlier works. Yet it remained for the literati painters, beginning in the latter

part of the fifteenth century, to create what has aptly been termed "art-historical painting," that is, paintings in deliberate emulation of the styles of earlier masters and intended more as homages to the past than as representations of the living world. Art-historical painting was a corollary of the literati emphasis on painting as self-expression. If the true theme of painting was the artist himself, the true mastery might best be demonstrated in the "creative transformation" of the styles of great predecessors. Not all the great painters of the past, however, were acceptable as predecessors. Only those who were considered ancestors of the literati tradition were fit subjects for emulation: gentlemen-amateurs whose preferred subject was landscape, whose preferred medium was ink on paper, and whose preferred style was deliberately artless and undramatic.

The hanging scroll of *Distant Mountains* (left) by Lu Zhi (1496–1576) is one of a sequence of studied reworkings of the lean, dry, painting style of the Yuan dynasty master Ni Zan (1301–1374). The so-called Ni style comprises a vertical format and composition, with the foreground occupied by an empty pavilion and a few trees sparely rendered in dry brushstrokes, a wide body of water in the middle ground, and, beyond that, a few distant mountains. Lu's accomplished rendition of that mode presents a more complex composition, in which the painter has deliberately represented a sequence of hillocks in the foreground and mountains in the far distance on different ground planes. The inconsistent, tilted ground planes, combined with the angular, dry brushstrokes that contour the landscape forms, create a highly ambiguous sense of space. To this very skillful paraphrase of the Ni mode, pale color has also been added, serving to blend the sharp, faceted surfaces of the mountains and hills and unifying the assorted elements of the compo-

sition into a single, harmonious vision. The artist's poem describes the person in the magnolia-wood boat (presumably the artist or the person for whom he made the painting) as gazing at the clearing autumn skies and distant, jadelike mountains.

Creative transformation of the past was not a monopoly of literati painters. Lan Ying (1585–c. 1664) was a professional whose characteristic style was suavely elegant and overtly appealing, placing him firmly outside the literati tradition. Nevertheless, Lan's many paintings after the manner of the old masters were praised by his literati contemporaries as indistinguishable from the individual styles that inspired them. An album of eight leaves by Lan pays tribute to six Yuan dynasty artists, including Ni Zan. *Autumn Clearing in the Misty Wood* (p. 78), the first leaf in the album, is after the style of Gao Kegong (1248–1310), who depicted many mist-filled landscapes with distant mountains. Gao's style itself referred back to the Song dynasty painters Mi Fu (1051–1107) and his son, Mi Youren (1075–1151). Landscapes such as those which Lan imitated were usually executed in ink,

Detail of Peach Blossom Spring
After Qiu Ying (d. 1552)
China; probably seventeenth/eighteenth century
Handscroll; ink and color on silk

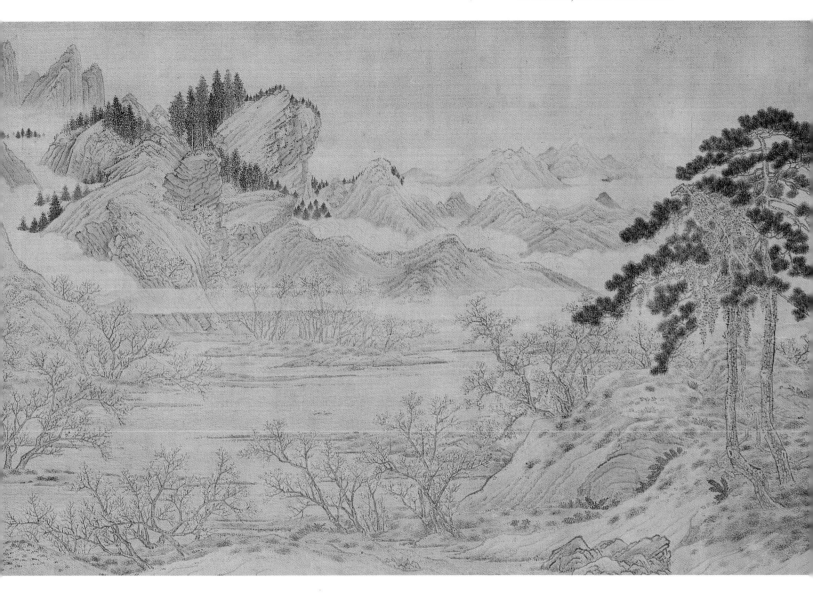

with slight touches of brown, blue, and green. Lan, drawing upon sixteenth-century experiments in this mode, has added broad areas of orange and red wash. His composition consists of two intersecting diagonals on which the landscape forms are arranged. The bright red of the trees along the foreground diagonal serves to emphasize their forward position; the paler orange and orange-brown of the mountains fading into the mist in the middle and far distance augment the sense of recession. These tonalities clarify the spatial relationships of the painting, while simultaneously contributing to the highly impressionistic character of the work.

This landscape album, made in 1642 when Lan was fifty-seven years old, reflects the painter's artistic maturity. After several decades of studying and copying the Yuan masters, he produced in these leaves new and more personal interpretations of their works, achieving the creative transformations that established his own artistic identity within the context of art of the past.

高彥敬尚書看雲林秋霽是做右法也 吉偶和士正之 壬午 吉璵

**Autumn Clearing
in the Misty Woods**
Painted by Lan Ying
(1585–c. 1664)
China, late Ming
dynasty; 1642
Album leaf; ink
and color on paper

Wisteria and Goldfish
Painted by Xu-Gu (1824–96)
China, Qing dynasty
Mid-nineteenth century
Hanging scroll; color on paper

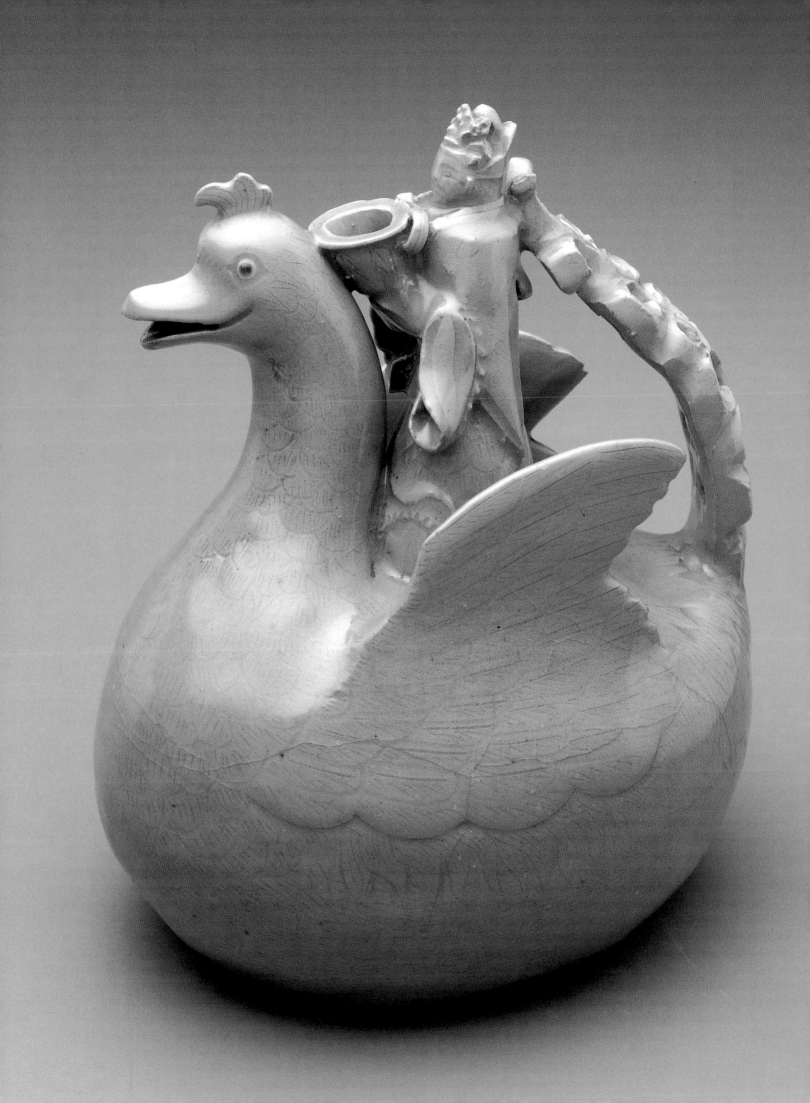

Ceramic Art of Korea

For almost two thousand years, Korean potters have produced a variety of beautiful, strikingly individualistic works for the residences of the aristocracy and for daily use in ordinary homes. Initially dependent on models from China for their techniques, shapes, and styles, the ceramicists of Korea so thoroughly transformed the lessons received as to yield new, purely Korean creations, distinctive for their qualities of spontaneity, informality, and understated elegance.

A mountainous peninsula jutting from the Asian landmass, which is dominated by China, Korea has a long history of military vulnerability, dictated to a large extent by its geography. Its borders are naturally defined by the modern-day Chinese provinces of Liaoning and Jilin to the north, the Sea of Japan to the east, and the Yellow Sea to the west. This location naturally affected Korea's cultural history, readily explaining the pervasive impact of China's ancient civilization. Korea was also a vital link between the continent and the Japanese archipelago, transmitting Chinese art and culture and the Buddhist faith, as well as disclosing its own achievements for eastward diffusion.

Japanese esteem for the unpretentious elegance of Korean wares resulted in the abduction and resettlement of Korean potters (in 1592 and 1597) and fostered the imitation of Korean styles and techniques by native Japanese pot-

ters. Appreciation of the casual assurance of Korean ceramics was, however, slow in coming to the West, where the technical precision and decorative refinement of Chinese porcelains had for centuries commanded the highest admiration. Only with the acceptance of the aesthetic standards of modernism in the early twentieth century was the significance of Korea's unique masterpieces finally widely perceived in the West.

In the tenth and eleventh centuries, a desire to imitate the olive- or bluish-tinted gray-green glazes of the Yue stoneware from southern China apparently prompted Korean potters to produce their own green-glazed wares. Having achieved the ability to manufacture glazed, high-fired stoneware during the previous, Unified Silla period (668–935), potters of the Koryŏ dynasty (918–1392) applied their knowledge and skills to the creation of these early green-glazed wares and then of celadon, in emulation of Chinese imperial taste. Korean celadon— characterized by a gray stoneware body covered with an iron-bearing glaze that turned green or greenish-blue when fired in an oxygen-reduced kiln— eventually reached such sophistication that, according to the Chinese envoy Xu Jing (1091–1153), even the Chinese admired it as surpassing their own ceramic productions.

A whimsical, bird-shaped ewer (opposite) is no doubt representative of the type of Korean celadon that was then highly regarded in China. The vessel's charm is a combination of technical refinement and stylistic naiveté,

characteristics that it shares with other ceramics of its type. The bird's body resembles a duck's, yet its head is crowned with a cockscomb, and its wings seem to belong to a much smaller creature. The extended tail-feathers are swept up into a reticulated handle, which also supports an elaborately clad human figure who stands on the bird's back, holding a bowl. Details of the bird's body, and of the rider's garments, were finely incised into the clay before glazing. The surface of the ewer browned slightly during firing in places where the glaze was more thinly applied; in contrast, the blue-green color deepened in the carved and concave areas where the glaze naturally pooled. With its carefully rendered details, fine incising, and delicately crackled, translucent glaze, this intricately constructed vessel is a technical tour de force that serves to illustrate Korean transformation of the Chinese celadon technique to create sculptures of inventive and fanciful subjects.

Adaptation of a Chinese vessel-shape is exemplified by a Korean inlaid celadon vase of a type called *maebyŏng* (Chinese: *meiping*; "prunus vase"). The Chinese *meiping* was originally a stolid, balanced form (see p. 61), whereas the Korean variant (p. 82) swells bulbously at the shoulder and tapers dramatically to a small base. The greenish surface of the glaze is decorated with three double-trefoil

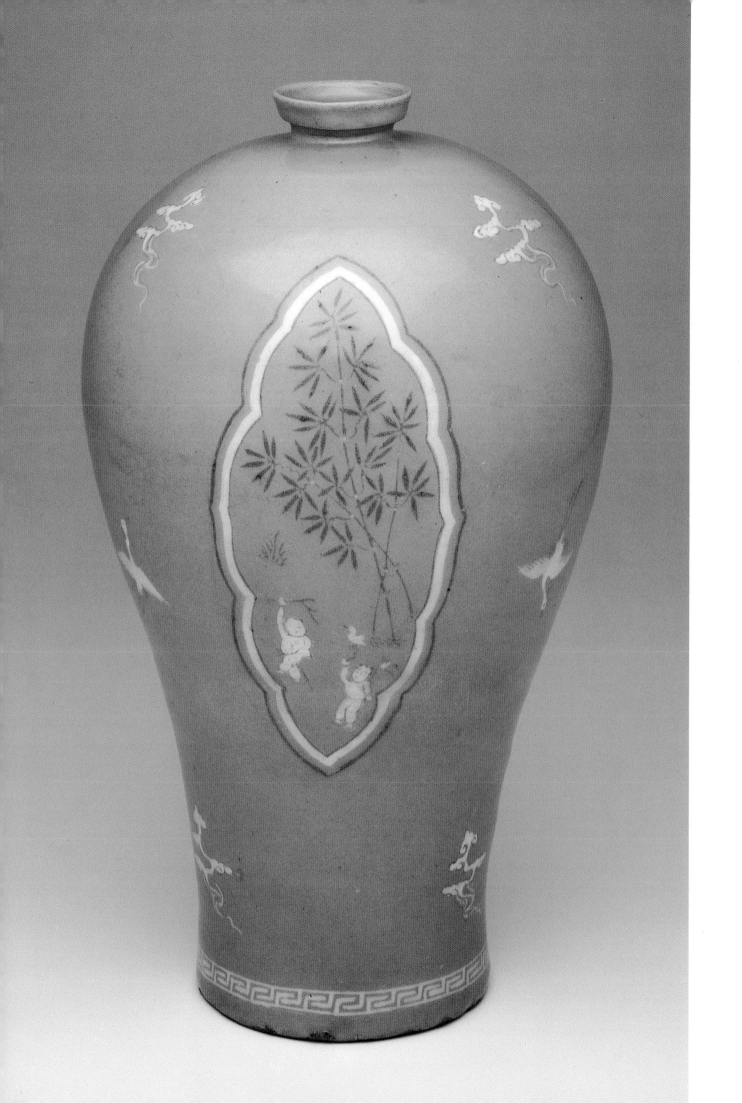

Vase (*Maebyŏng*)
Korea, Koryŏ, dynasty
Twelfth century
Stoneware, celadon
glaze, inlaid design

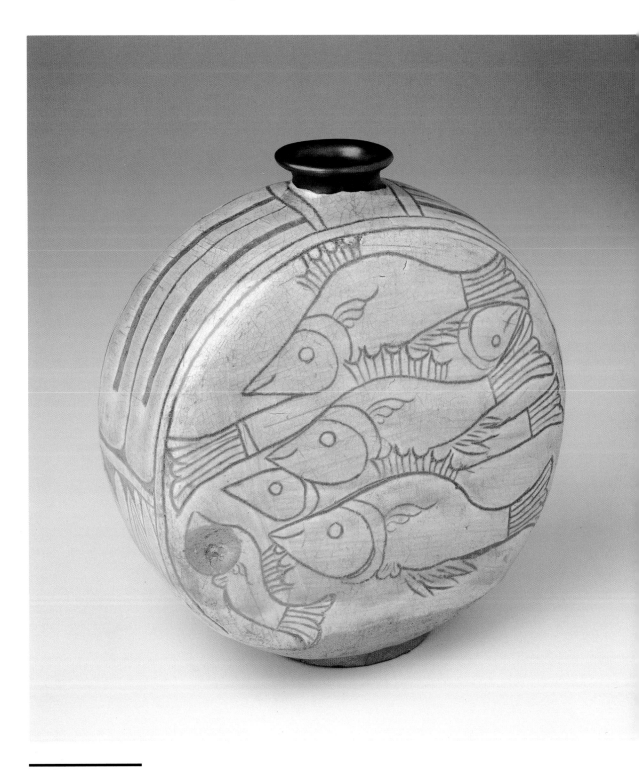

Flask
Korea, Chosŏn dynasty
Fifteenth century
Punch'ŏng ware; stone-
ware, carved slip design

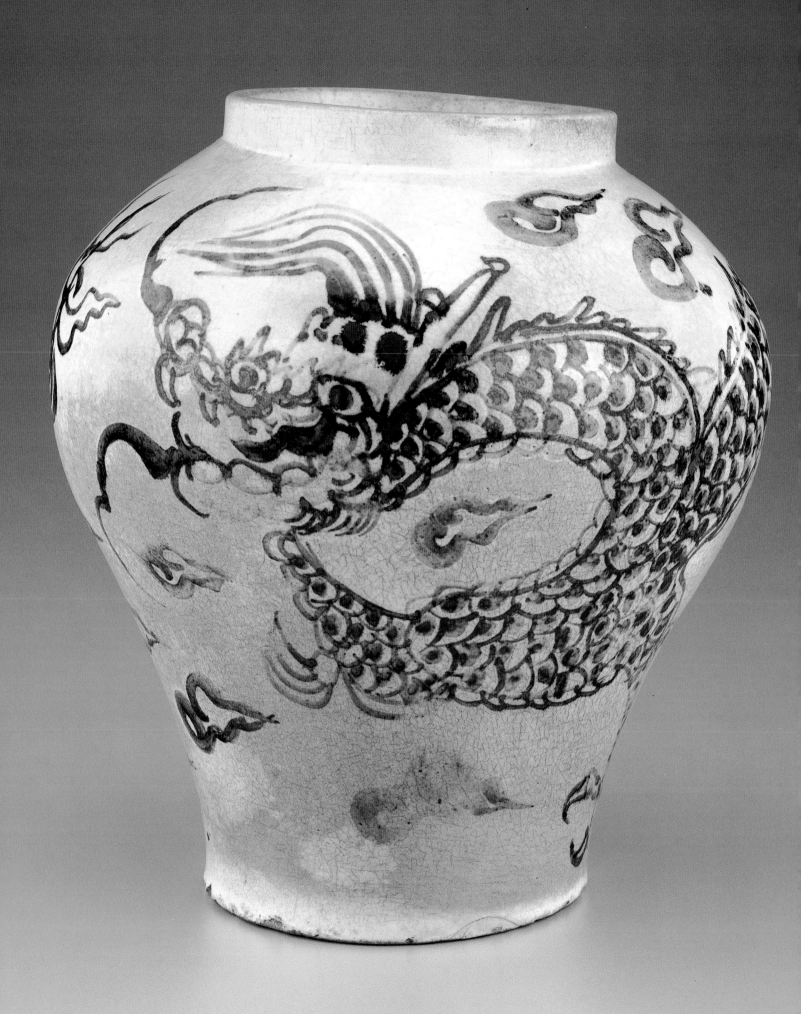

Jar
Korea, Chosŏn dynasty
Seventeenth century
Stoneware, underglaze
iron design

frames within which common painting subjects are rendered in ceramic inlay, a decorative method distinctive to Korea. The scene illustrated on page 82 shows two children chasing a butterfly in a garden, with a willow tree in the distance. The remaining scenes depict boys playing in a grove of bamboo and three white herons in a marsh. Between the three framed scenes, clouds and cranes — motifs frequently found on Koryŏ inlaid celadon — are scattered across the vessel's surface. All of these designs were incised into the surface of the wheel-thrown vessel before the clay had completely dried. The incisions were then filled with black or white ceramic inlay, and the vase was glazed and fired. The preparation and application of inlay — quartz, glass, and other materials mixed with potting clay to form the white; glaze materials crushed and melted in a technique known as fritting for the black — was a time-consuming process. Such delicately rendered designs on inlaid celadons, although at times conventionalized and derivative in their subject matter, represent a major technical achievement of the Koryŏ period.

The labor-intensive nature of inlaid celadon restricted its use to the court and aristocracy. As simpler and more straightforward decorative techniques became more widespread, the character of some Korean wares also changed radically. During the Chosŏn dynasty (1392–1910), a taste for more spontaneous and casual surface designs gradually altered the meticulous methods by which celadon had been produced in previous centuries. Vessels were more roughly shaped and their embellishments more freely applied; the bird-shaped ewer (p. 80) already reflects the beginnings of this attitude. In China, it might easily have been rejected because it would not have been considered flawless. The unevenness and browning of the glaze, the several cracks on the body, and even

the delightfully playful leftward lean of the bird, would have been adequate justification for discarding it.

That the Korean potter did not aim to produce ceramics of unvarying technical perfection is demonstrated by a striking fifteenth-century flask with carved decoration (p. 83). In technique, this drinking vessel illustrates some of the simplifications introduced during the Chosŏn dynasty. It was covered with slip (a mixture of clay and water) to which a white coloring agent was added; it was then incised with bold linear designs of a school of fish and a flowering lotus. After the slip had dried, the flask was glazed and fired. The character of these decorative designs contrasts markedly with those on the earlier, inlaid celadons, where the careful placement and distribution of delicately rendered motifs create an aesthetic very different in feeling from the expressive energy articulated on the sides of this drinking vessel.

The large, stoneware jar (opposite), covered with crackled, cream-colored glaze, is decorated with a vividly painted dragon among clouds — yet another example of the spontaneity and expressive power so characteristic of the best Chosŏn ceramics. The beast is milder than the typical Chinese dragon, whose prestigious role as carrier of thunder and rain is usually emphasized through its ferocious demeanor. The painted design on this seventeenth-century vessel was rendered in an iron pigment which was applied to the clay surface before glazing. Exposure to oxygen in the kiln during firing transformed the pigment into many subtle shades of brownish red and black. The long and sinuous body of the dragon encircles the jar, emphasizing and augmenting the vessel's ample shape. This integration of shape and design ultimately enhances the vivacious overall effect of a powerfully painted vessel.

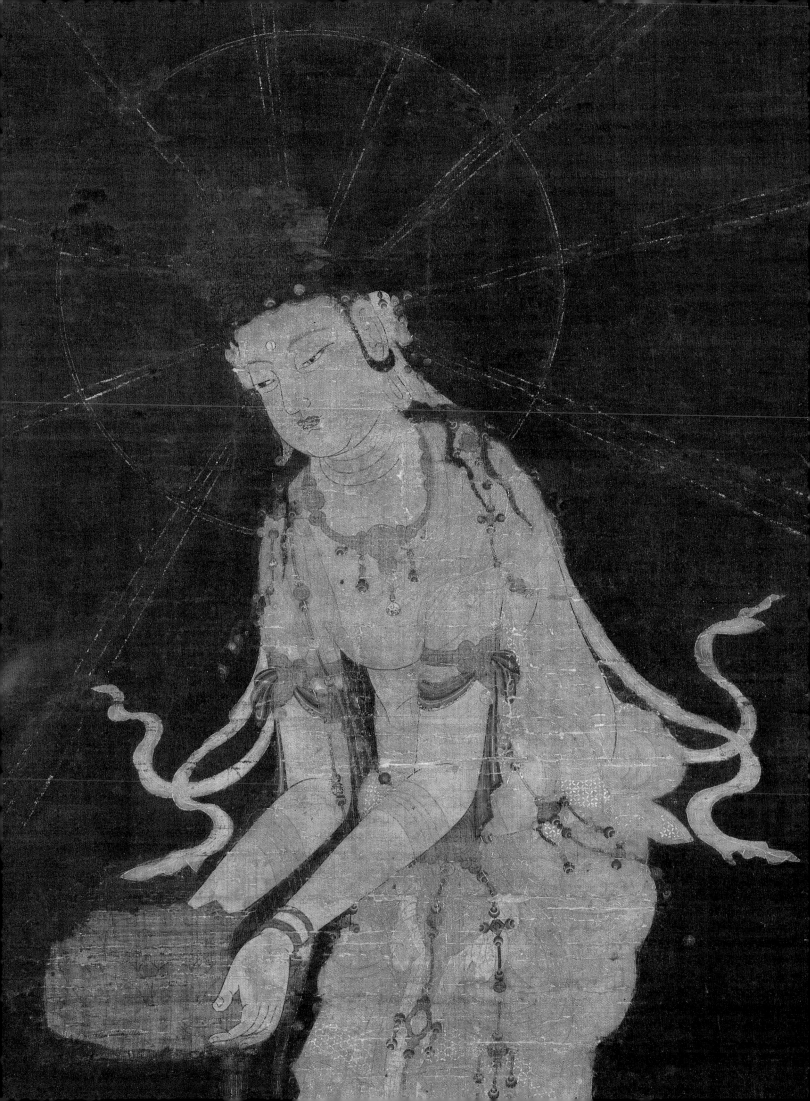

**Kannon Bodhisattva
(Detail of Descent of
the Amida Trinity)**
Japan, Kamakura period
Thirteenth century
Hanging scroll; ink, color,
and cut gold on silk
See pages 92–93

Resplendent Presence: Japanese Sacred Imagery

Buddhism arrived in Japan in the middle of the sixth century after a journey through the East Asian continent lasting nearly one thousand years. By the time it reached Japan, Buddhism had an established tradition of artistic expression and a sophisticated code of religious iconography. Yet, for all its age and venerability, Buddhism was ever a missionary faith, always brought in from outside. Though decidedly influential within the cultures it visited, Buddhism's relationship to worldly power was invariably tenuous. Its adherents used (and, at times, abused) access to the throne, and, as well, frequently suffered violent persecution. It continually lived through the cycle of the great belief systems — growth, corruption, and purification.

In the year 552, a diplomatic entourage from the Korean kingdom of Paekche visited the leaders of the powerful clans of central Japan, formally presenting a bronze Buddhist statue, copies of religious texts, and an endorsement for the new religion by the Paekche ruler. Buddhism had probably made earlier and less formal landfall in western Japan, but the ancient account of this official arrival has an appealing dramatic clarity. Prior to the arrival of Buddhism, Japanese religious sensibilities had little need for precise doctrines or for religious iconography. The natural world was considered benevolent and spiritually informative.

A reverence for place, especially in certain distinctive or auspicious natural forms, allowed for personification of the spiritual. The formidable mountain, a distinctive outcropping of rock, a huge, gnarled tree, each could be understood as points of abode for spirits, and were image enough. Ancestors, too, were revered, assuring the stability and productivity of clan and place. This native religious sensibility would later be called Shintō, or "the way of the gods." But an imagined realm of transcendent deities, rendered in a complex iconography, did not exist in pre-Buddhist Japan.

The Japanese who received the Paekche emissaries were involved in untidy clan rivalries, which pitted those suspicious of foreign influence against others who looked to the mainland for an efficient model of unified government. They clearly understood Buddhism to be part of the dominant Chinese culture, which skillfully integrated religion with the needs of state. After some decades of internal contention, the Japanese chose to emulate the Chinese model of state. Along with the Confucian ideal of a hereditary imperial line served by a bureaucracy, Buddhism was established as the official religion. Under the Emperor Shōmu (701–756), Japanese embrace of Tang Chinese Buddhist culture reached its apex. Shōmu mandated a system of monasteries and nunneries in each of the provinces with allegiance to Nara, the new capital, thus integrating control of the secular and spiritual realms. The pivotal event

of the eighth century was the construction in Nara of the main temple of Tōdai-ji, The Great Eastern Temple, and, housed within its central structure, a colossal cast-bronze Buddha. Dedicated in 752, this massive icon symbolized the easternmost advance of Tang international culture. Shōmu intended this remarkable accomplishment as a signal to the continent that a formidable power was emerging on the islands that were often spoken of derisively by the Chinese. The announcement was premature. The expense of constructing the Tōdai-ji complex and of establishing a network of subtemples virtually emptied the imperial coffers. In the process, Shōmu unwittingly created a secure base of power for a huge religious establishment. Bold attempts by monks to usurp civil power finally forced the court to move to Heian-kyō (Kyoto) at the end of the century.

At the close of the eighth century, the once prosperous state ateliers had to reconsider the time-consuming and expensive processes that had produced a magnificent array of religious sculpture. A diminutive yet stately bodhisattva image (p. 88), created about 770, is the only known example in a Western collection of a dramatic shift from Chinese-inspired production techniques. From the early seventh through most of the eighth century, a succession of materials,

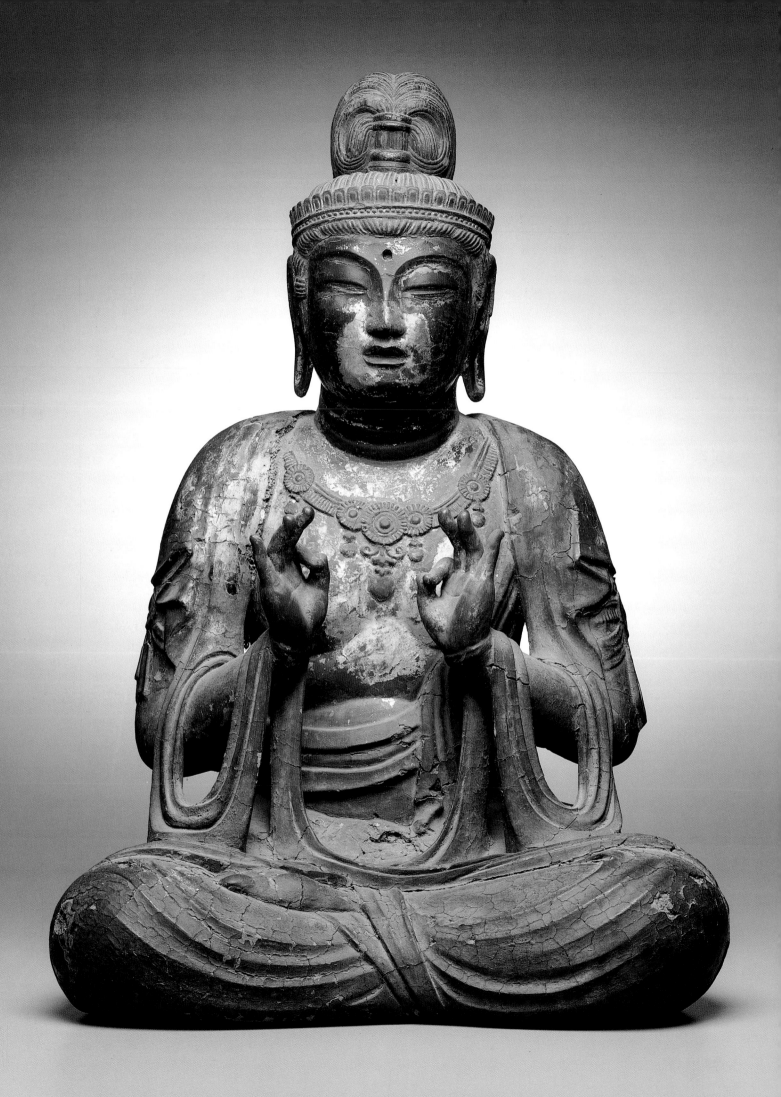

including clay, bronze, and lacquer, were used to create sculpture. Particularly appealing was the hollow-core dry-lacquer technique (see discussion, p. 43), but this process had become prohibitively time consuming and expensive. Through economic necessity, wood emerged as the medium of choice. Typically, a core of several joined wood pieces was carved into a schematic image, over which lacquer was applied to provide a workable substance for refining the form. (Sometimes, an already well articulated carving sufficed with only a protective layer of lacquer.) The resulting surface was finished and gilded so that the joints were invisible to even the most observant eye. Distant and mysterious, the bodhisattva figure is presented according to the metaphor of court aristocrat receiving supplicants, but here representing a heavenly realm. We can presume that this bodhisattva was an attendant in an ensemble of deity figures.

The wooden sculpture depicting a seated, shaven-pate monk (p. 90) is often misperceived as a Buddhist image. This figure is, in fact, an image of the Shintō deity Hachiman, and is one of the earliest examples of native Japanese accommodation to the arrival of Buddhism. Hachiman was the central spirit of place at Usa, in northeastern Kyūshū, a coastal area with a large copper mine on nearby Mount Kawara. At a time when native religionists were often antagonistic to Buddhism, priests of the Hachiman cult actually profited from the newly imposed relationship. Ore from Mount Kawara was used in the construction of the bronze Buddha at Tōdai-ji. Nara officials, eager to embrace Buddhism on a grand scale, nevertheless sought the good graces of the local deity protecting such a critical source of raw material. No single theory adequately explains the guise of Buddhist monk in which Hachiman eventually came to appear, but the priests of Hachiman clearly understood the power of the new faith, and were shrewdly ecumenical. The shrine's celebrated oracular powers were made accessible to members of the court, who journeyed there for discernment of knotty state or personal problems. Eventually, the bonds between the court and the cult developed to the extent that Hachiman was enshrined at Tōdai-ji.

Buddhism's close alignment with the Japanese aristocracy allowed the religion to flourish in privileged sanctuary and occasionally to rival civil power. The sometimes incestuous relationship between court and temple tended to emphasize or exaggerate several aspects of Buddhism. The priestly caste exercised exclusive right over matters of religious interpretation. Access to the divine increasingly became a function of mastery over arcane liturgical practice, and salvation became dependent upon the proper performance of ritual. The decline of court power in the twelfth century naturally invited pessimistic readings of Buddhism. But the heightened emphasis on the melancholy aspects of existence and the transience of all things spoke less of Buddhism's overall intentions than it did of the outlook of the chaplaincy of a declining class.

As early as the tenth century, individual thinkers and charismatic figures within the church establishment pointed to the corrupting relationship between government and belief. These individuals inveighed against world-weary pessimism and argued that the accessible compassion of Buddhism should be emphasized to an ever widening and needy audience. Revivalist sects invariably focused their teachings on one of the most popular of the transhistorical Buddhist deities, the Amida Buddha (Chinese: Amituo; see discussion, p. 39), "Lord of Infinite Light," who presides over the Western Paradise and welcomes deceased believers to rebirth within his spectacular realm. Amidism coalesced into its most powerful form under the monk Hōnen (1133–1212) and was called Pure Land Buddhism. Pure Land cosmology described distinct realms of existence and the passage through the realms in cycles of rebirth. Generally dismissive of esoteric approaches, Pure Land practitioners encouraged recitation of a simple hymn of praise: *Namu Amida Butsu,* "all praise the Lord Amida." This prayer sufficed as means of eventual access to the Western Paradise.

Amida was assisted by various bodhisattvas who acted as intercessors to the afflicted. Chief among these compassionate visitors was Jizō (Sanskrit: Kshitigarbha), who, in the guise of a handsome young monk, attended in particular to the needs of unprotected children and women. Along with the impressive growth of other Amidist beliefs, a particularly strong Jizō cult emerged in the twelfth century. This gentle deity provided painters and sculptors with an opportunity to articulate subtle nuances in facial expression and figure posture and to begin to apply some increasingly sophisticated understandings of realistic portraiture to an idealized, deified form. The Art Institute Jizō (p. 94), still in remarkably fine condition, exemplifies a refined understanding of spiritual and artistic intentions: It embodies both compassionate under-

standing and dignified reserve, avoiding the cloying and saccharine qualities of some similar images, which are often misbegotten as descriptions of intimacy.

A particularly elaborate icon type inspired by Amidism was the rendering of Amida Buddha's descent to earth to welcome the soul of one newly deceased. Among the most elegant versions of this miraculous vision is the triptych of paintings in the Art Institute collection (pp. 92–93). The central image of Amida is flanked by separate scrolls of the bodhisattvas Kannon and Seishi. Kannon (Chinese: Guanyin [see also pp. 38–39]; detail, p. 90), holds a lotus blossom upon which the soul of the deceased will be reborn in paradise. Seishi (Sanskrit: Mahāsthā-maprāpta), stands in the attitude of prayer. Sometimes the deceased is portrayed as well, often prone on a pallet surrounded by mourners. The figures in the present triptych appear against a blank background. Rather than offer the viewer an observer's perspective, as in some earlier representations, these large and imposing deities descend to engage the viewer as believer. It has been suggested that these paintings attended the bedside of a dying believer in order to inspire visions or provide consolation. Judging from the sumptuous use of materials, including cut gold foil, and by the exceptionally high standard

of painting, it is likely that a person of high rank commissioned this majestic triumvirate.

A startling contrast to the courtly figures of the Buddhist heavenly entourage is the fierce countenance of the esoteric Buddhist deity Fudō Myōō, "the immovable or unshakeable" (p. 95). He is one of five Myōō, or "lords of light," who guard the Buddhist Law. The Western eye fully expects to encounter such fanged, glowering figures in Christian images of hell. Here, however, Buddhist iconography demonstrates a wise and uncompromising assessment of the journey to Enlightenment. Not only is the Buddhist Law constantly under threat of assault, but the believer, treading a dangerous path, requires the muscular, well-armed resolve of divine forces no less than he or she needs compassion and consolation. Executed in the style of heightened realism developed during the Kamakura period, Fudō's piercing stare and protruding fangs express the intensity of his wrath against evil. Seated on a stylized rock formation, symbolizing his steadfastness, Fudō holds the attributes of rope and sword used to subdue evil forces and cut through ignorance, the source of all suffering.

Perhaps more engaging but no less unexpected than the righteous anger of Fudō Myōō is the painting of an ornately saddled deer (pp. 96, 97). This image represents the very conscious program launched by Buddhism to achieve correspondences with local religion both through the iconography of native deities and the geography of sacred sites. These correspondences would invariably reveal a local god as an emanation of an overshadowing Buddhist deity. In Japan, deer had long been perceived as divine messengers. Further, their image is synonymous with Kasuga Shrine, a Shintō site founded by the Fujiwara family at the foot of Mount Mikasa, on Nara's east-

Descent of the Amida Trinity
Japan, Kamakura period
Thirteenth century
Hanging scrolls;
ink, color, and cut gold on silk

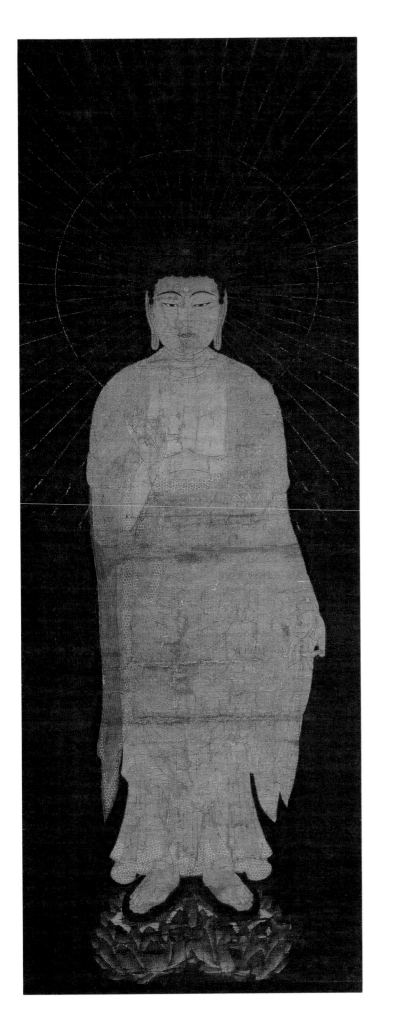
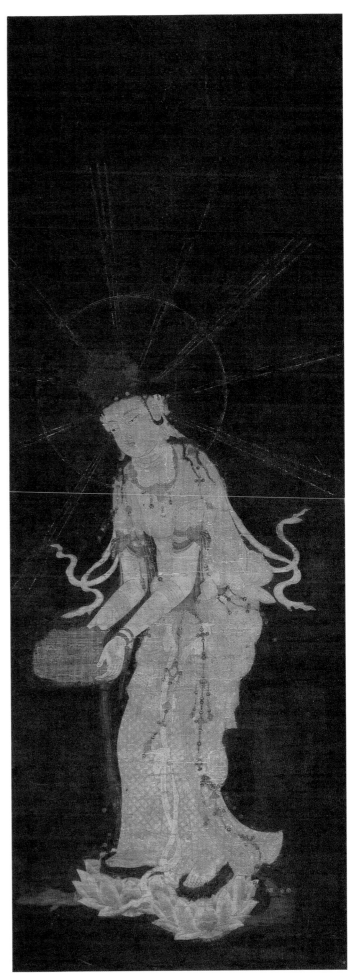

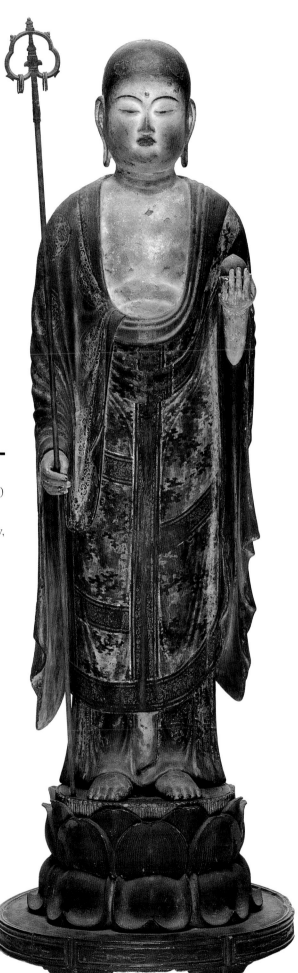

Jizō
Japan, Kamakura
period (1185–1333)
Late twelfth/
thirteenth century
Wood, polychromy,
gilding

Fudō Myōō
Japan, Kamakura period
Thirteenth/
fourteenth century
Wood with polychromy,
gilt-bronze

94

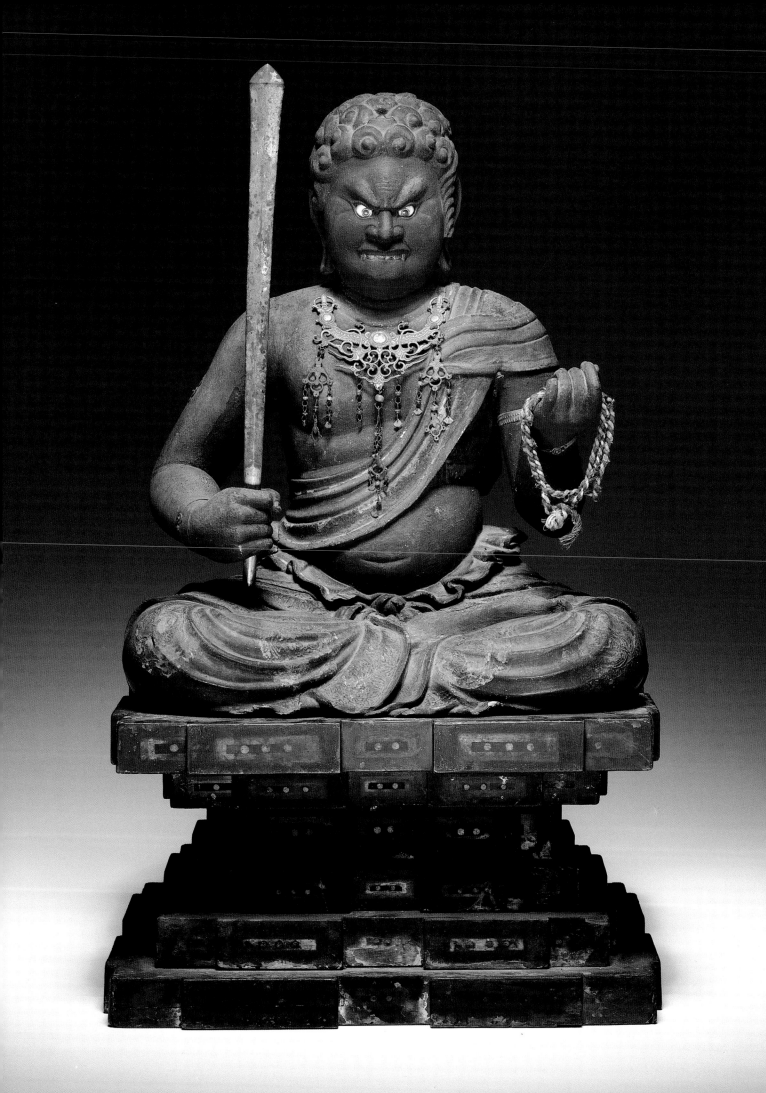

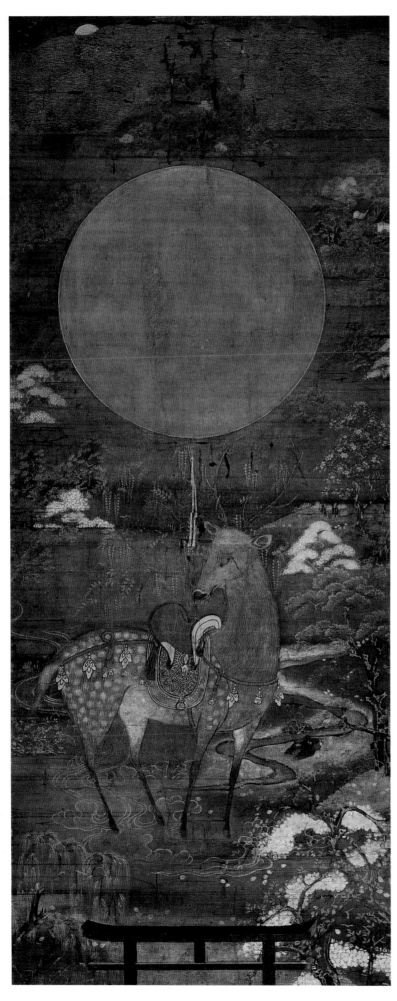

Kasuga Deer Mandala
Japan, Muromachi period
Fifteenth century
Hanging scroll;
ink and colors on silk

ern border, in the late 760s, not long
after the completion of Tōdai-ji. The
shrine housed the tutelary deities
of the politically preeminent clan as
well as guardian deities of recently pac-
ified eastern provinces. Tamemikazu-
chi no Mikoto, the deity of Kashima
(not far from present-day Tokyo), was
said to have been borne on a white
deer from the eastern provinces to
Mount Mikasa, a miraculous event that
handily paralleled political realities.

A bronze mirror is supported on the
deer's saddle by a wisteria vine (*fuji*),
the symbol of the Fujiwara family. The
mirror recalls the Japanese creation
myth of an angered Amaterasu Omi-
kami, the Sun Goddess successfully
lured from a cave by a mirror. This
delicate and rare painting presumes a
familiarity with the subject; much
of the usually depicted iconography
is implicit. Frequently seen in simi-
lar deer icons is the architecture of
Kōfuku-ji, a prominent Nara temple,
and of Kasuga Shrine itself. But here,
emphasis is on a lyrical presentation
of flora on the mountain path. The
moon peers over a mountain top, pro-
viding a conventional poetic reference
to Mount Mikasa. The artist offers the
viewer relief from pedantic symbolism
and presents a hauntingly rendered
animal as well as a delicate depiction
of landscape.

Conversion to faith in Amida is the
central theme of the narrative scroll
painting describing the history of the
Yūzū Nembutsu sect (details, pp. 98–
99, 100). Beginning in the Kamakura
period, it was customary for prosper-
ous temples and for sects to commis-
sion records of their foundings and
histories to be set down in a painted
narrative. These paintings were usually
done in the format of a horizontal
scroll, which was unrolled from right
to left and viewed in consecutive sec-

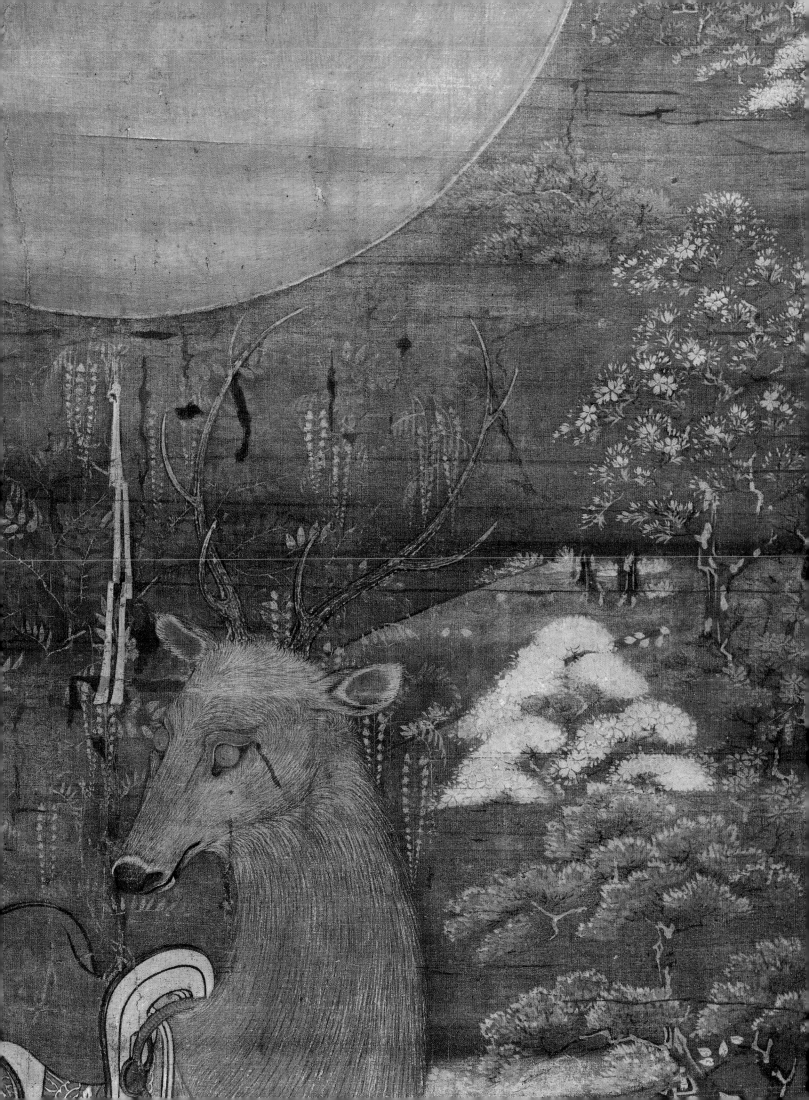

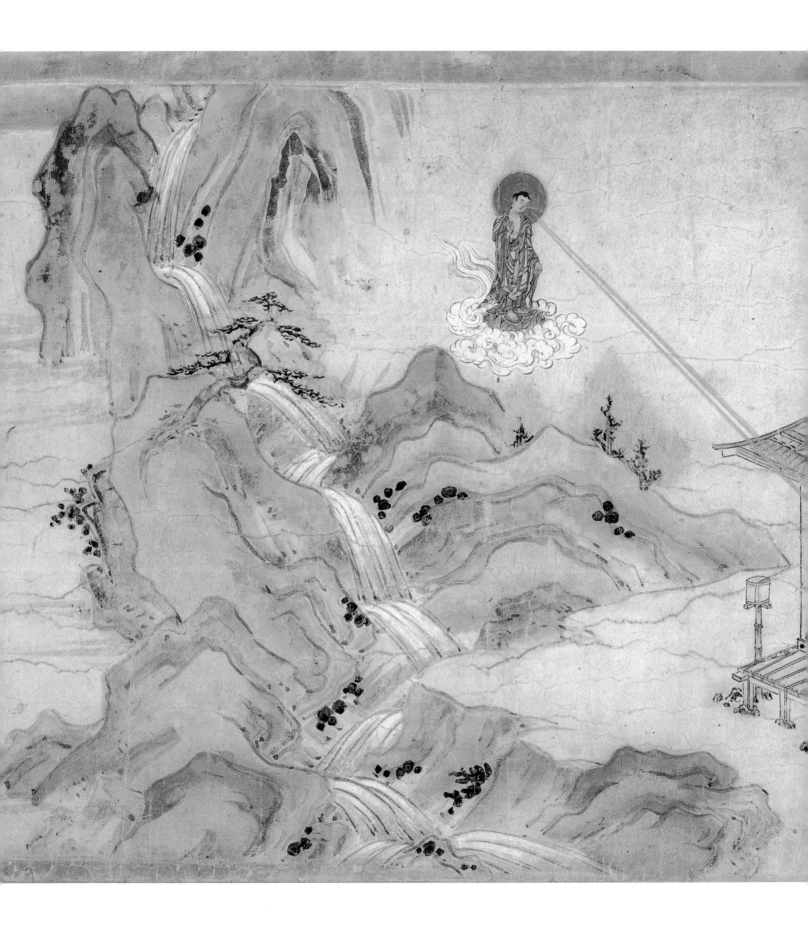

tions approximately the width of the
viewer's shoulders.

The Illustrated Legends of the Yūzū
Nembutsu recounts the life of the
sect's charismatic founder, the monk
Ryōnin (1073–1132) and the sub-
sequent growth of the faith following
his death. This painting was produced
in the mid-fourteenth century, during
a time of renewal and reorganization
for the sect. Ryōnin initiated his popu-
lar prayer movement in reaction to the
complicated ritual of court-dominated
Buddhism of the Heian period (794–
1185). *Yūzū* is a Buddhist concept
referring to the interrelatedness or
ultimate oneness of things. Ryōnin
employed this concept as part of a radi-
cally simple method for preaching sal-
vation and the means to attain rebirth
in the Western Paradise. Reasoning
from the interpenetration of all things,
he taught that meritorious actions
performed by one person could be
efficacious for many. Ryōnin asked his
followers to register their names in a
tally book, and to promise to recite the
brief *nembutsu* prayer at specific times
in homage to the Amida Buddha. The
account depicted in this lengthy scroll
is a charming blend of the prosaic and
miraculous. Deities, demons, aristo-
crats, and peasants, all newly converted
to Ryōnin's teachings, mingle within
lyrically depicted settings.

The charming rendering of the
famous Buddhist cleric Kūkai as a child
(p. 101) is yet another fine example of
medieval Buddhist painting recalling
a miraculous event in the life of a
religious founder. Kūkai (774–835),
posthumously titled Kōbō Daishi, was
the founder of Shingon — a Japanese

esoteric-Buddhist sect — and a revered
political and cultural leader. His erudi-
tion and religious vision were powerful
sources of regeneration and correction
of national focus after the move from
Nara to Kyoto at the close of the eighth
century. Cults reverencing Kūkai were
widespread and held that he was actu-
ally an earthly manifestation of the
bodhisattva Miroku (Chinese: Mi-le,
see also p. 40), the so-called future
Buddha. The fourteenth century, dur-
ing which this image of Kūkai was
painted, was a politically unstable
time. Probably in reaction to the de-
pressingly unsettled state of national
leadership, religious cults devoted to
Kūkai and other historical founder-
figures grew dramatically. Garbed in
elegant costume appropriate for a
child of the court, the subject and his
unusual, lotus throne are set within
a golden nimbus suggesting a trans-
parent bubble. Attached at the top of
the hanging scroll is a series of texts
inscribed on three sheets of decorative
paper. The inscription is a quotation
taken from Kūkai's *Goyuigo*, a set of
instructions said to have been prepared
by the master for his disciples. In the
quoted passage, Kūkai described a
dream of his youth, in which he was
carried aloft on a lotus flower to a
heavenly realm, where he conversed
with various buddhas. There are more
than a dozen known portraitlike pre-
sentations of young Kūkai, but only
this version has an appended inscrip-
tion dispelling any ambiguity as to the
subject's identity. To his devotees in a
tempestuous and worrisome age, this
blissfully ethereal image of Kūkai as a
child would have certainly brought
hope and reassurance.

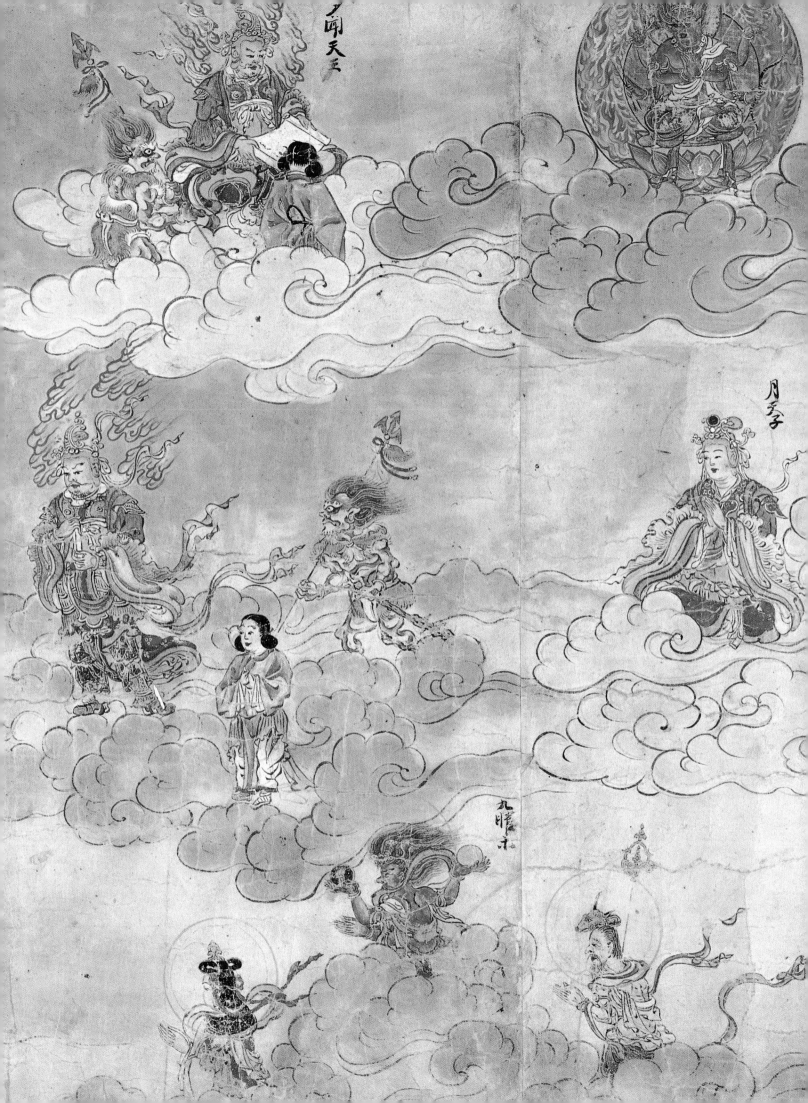

Detail of Legends of the Yūzū Nembutsu
Japan, Kamakura period
Fourteenth century
Handscroll; ink, color,
and gold on paper

**Kōbō Daishi
(Kūkai) as a Child**
Japan,
Kamakura period
Fourteenth century
Hanging scroll;
ink and color on silk

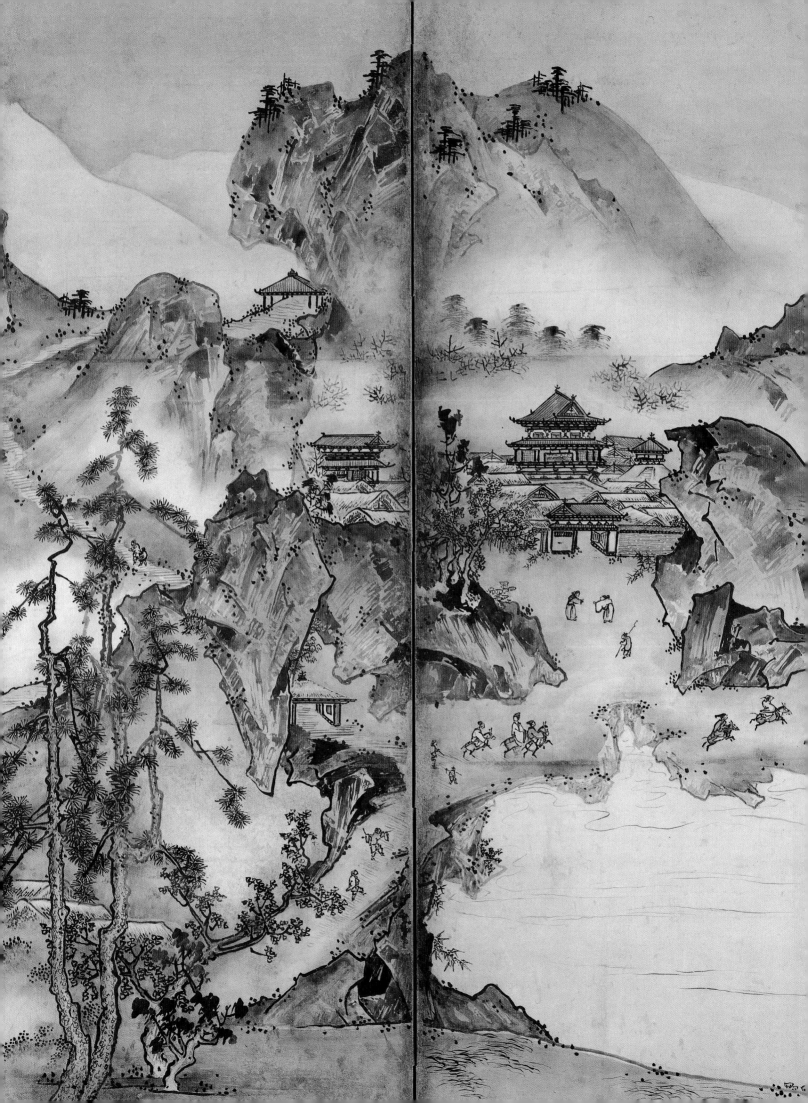

Images of Zen:
Visions of Severity and Surprise

Japan in the late twelfth century was convulsed by wrenching political and social change. The many who sought comfort or meaning in religion found the arcane and melancholy message of court-controlled Buddhism inadequate to their needs. It was at this time that gradually coalescing Amidist (Pure Land) sects began to assert strong appeal to all levels of the population. The direct, simple, and compassionate message of rebirth in the Western Paradise became a powerful source of spiritual regeneration.

The same climate of confusion and despair encouraged another emerging strain of Buddhism in Japan. Zen (Chinese: *Chan*) emerged as a distinct Buddhist sect in China during the sixth century. Drawing on features of Indian yoga and Chinese Daoism, Zen practitioners developed rigorous meditation techniques based on a sophisticated grasp of the relationship between spiritual advance and human physicality. Meditation pursued in the seated "lotus" position aggressively engaged the body in a "mind-emptying" process which sought to obliterate conceptual obstacles to Enlightenment. The breakthrough placed the meditator beyond the dichotomies engendered by the demands of self and into a realm of cosmic unity.

Each of the major Buddhist movements present in Japan since the sixth century — including, at that time,

the minimally represented Zen sect — prescribed some form of meditative practice. In the twelfth century, the presence of Zen monks who had returned from studying in China began to be felt as an important force in the establishing a defining religious and cultural perspective. But it was in the thirteenth century, following the chaos in China of Mongol invasions and the collapse of the Song dynasty, that Zen gained access to a new and powerful source of patronage in Japan. Large contingents of Chinese Zen monks fled to the safe haven offered by the recently established military regime in Kamakura. The affinities between the warrior's ethos and the unflinching internal gaze of the Zen adept attracted the attention of the new elite and extended the influence of both the transplanted Chinese Zen communities and native Japanese monks. First under the Kamakura shogunate and later when military control shifted to a succession of leaders from the Ashikaga family in Kyoto, Zen culture flourished. The renewal provided by Zen was broadly cultural. Monasteries were centers not only of prayer but of literature and fine art, and monks assisted rulers in the development of standards of critical taste.

The notion of Zen cultivating a visual aesthetic may seem antithetical to a religious perspective dedicated to uprooting the illusory and deceptive, and which seemed to scorn anything smacking of the effete. But Zen in fact produced a magnificent heritage of religious iconography and fostered

strong traditions of ink monochrome painting which — befitting the introspection that is part of the meditative life — was used to create individualistic expressions in calligraphy and landscape painting that were intended as portraits of the journeying soul. And, by commissioning humble earthenware vessels for use in the tea ceremony, Zen monasteries nourished a taste for the unexpected beauties of the rough and unadorned products of some indigenous kilns.

The art of Zen, at its best, contains a surprise, an edge of irony, a moment of epiphany that in some way suggests the sudden flash of Enlightenment. The imagined portrait of the bodhisattva Monju (Sanskrit: Mañjusrī; Chinese: *Wenshu*; p. 104) recalls that deity's miraculous appearance to the eleventh-century Chinese scholar Lu Huiching. Perplexed by certain questions of Buddhist doctrine, Lu made pilgrimage to Mount Wutai, legendary abode of Monju, in China's Shanxi province. On the climb, Lu encountered a strangely clad boy who advised him that the Buddha's teachings were simple and clear, but too often obscured by pedantry. Lu scolded the youth for his impertinence, only to suddenly realize that he was speaking with Monju. The image of Monju as a hemp-robed youth was a favorite of Zen monks. Monju's expression of scorn for excessive reliance on

**Monju in the Guise of
a Hemp-Robed Youth**
Japan, Muromachi period; 1415
Hanging scroll; ink and light
color on silk

Daruma
Japan, Muromachi period
Sixteenth century
Hanging scroll; ink and color
with gold foil on silk

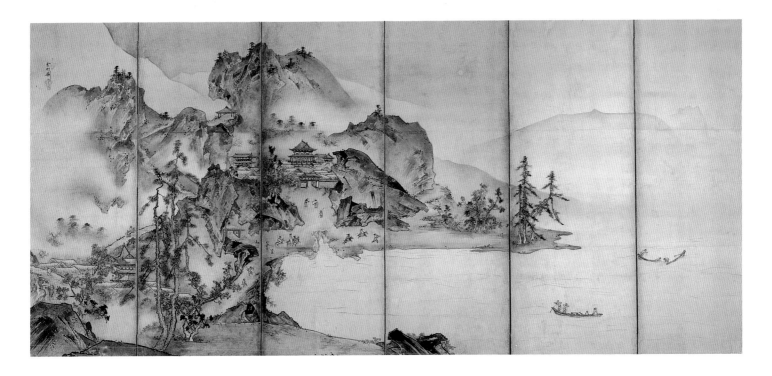

Landscape of the Four Seasons
Painted by Sesson Shūkei
(c. 1504–c. 1589)
Japan, Muromachi period
Second half of sixteenth century
Pair of six-fold screens;
ink and light color on paper

textual learning in the search for Enlightenment was central to the Zen perspective. In this icon, the gentle but determined features of the deity simultaneously beguile the petitioner and chastise intellectual pride.

The anonymous painter of a sixteenth-century icon of Daruma (Sanskrit: *Bodhidharama*; p. 105) was commissioned to infuse spiritual force into an image so popular as to verge on the cliché. The artist succeeded in producing a lavish and intimate rendering of stern intensity. Daruma (c. 470–c. 573), the founder of Zen in China, was the twenty-eighth patriarch of Indian Buddhism in the lineage beginning with Sakyamuni Buddha. The imagined portraits of this semi-legendary figure depicted, in one of several traditional poses, the visage

of an Indian prince hardened by years of meditation at the Shaolin monastery in southern China. Daruma icons were produced in China as early as the eighth century, but the genre came to Japan with the Chinese Zen émigrés in the thirteenth century. The patriarch's severe gaze was intended to reinforce the meditator in a single-minded search for the Buddha nature. The features of the present image, while appropriately unrelenting, take on a stolid fleshiness that suggests the work of a professional artist with experience in rendering secular portraits of warriors. A red robe emblazoned with gold-foil phoenix patterns dramatically frames the subject's face, contributing to a jarring blend of opulence and severity.

Though the influence of Zen may not be as immediately apparent in art forms lacking the specifically religious content of icons, the sect nonetheless had considerable impact in the development of other genres. With brush and black ink, the Japanese monk-painter projected and explored inner states. Landscape was a particularly favored mirror, but other subjects, such as bamboo or orchid, were equally conducive to spiritual vision.

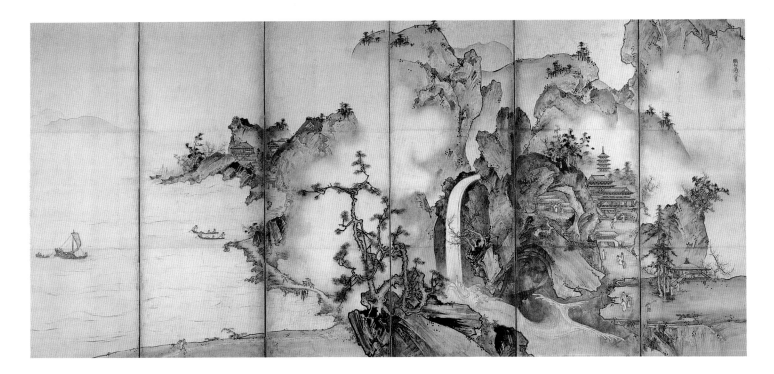

Major temples usually housed ateliers for monks who, while bearing other communal responsibilities, were largely given over to the business of painting.

Political chaos, particularly during the fifteenth century, scattered brilliant artists from the capital to the shelter and patronage of provincial warlords. The violence of displacement engendered powerful offspring in areas once thought to be the backwaters of cultural life. Sesson Shūkei (c. 1504–c. 1589) a Zen monk, lived his whole life in eastern Japan. His abodes included temples near Kamakura and in more northerly provinces above present-day Tokyo. Rumored to be the illegitimate son of a samurai, Sesson was unschooled in the refinements of the Kyoto ateliers. He vigorously asserted nature to be the best teacher, and he preferred private study of venerable Chinese paintings to sitting at the feet of a master. Sesson's paintings exude a nervous, unsettled mood that may well reflect a stubborn and spiritually defiant personality; but they also provide exquisitely sensitive readings of a century of profound national uncertainty. His landscape of four seasons (above) is regarded as a masterpiece of his middle or later years. Eschewing the more measured and flowing renderings of the genre,

Sesson's observation of seasonal shifts is secondary to his fascination with suggesting units of landscape, which split into abstract bits or are barely secured in the formal composition. Buddhist temples, at the center of each screen, provide the only stable anchors within a kinetic, foreboding atmosphere. Sesson all but eliminates paths of escape from this disturbing surface, disallowing the traditional leisurely lines of recession into the far distance. These screens can never be misconstrued as pleasantly decorative. Rather, as examples of the best of Zen-inspired art, they represent superb technique in the service of uncompromising spiritual search.

Tea was originally imbibed by Zen monks to insure alertness during meditation. During the fifteenth and sixteenth centuries, the tea ceremony evolved into a sublimely nuanced ritual, a complex interaction between host and guests that included the judicious selection of utensils. Tea masters often conveyed penetrating spiritual messages by employing surprisingly

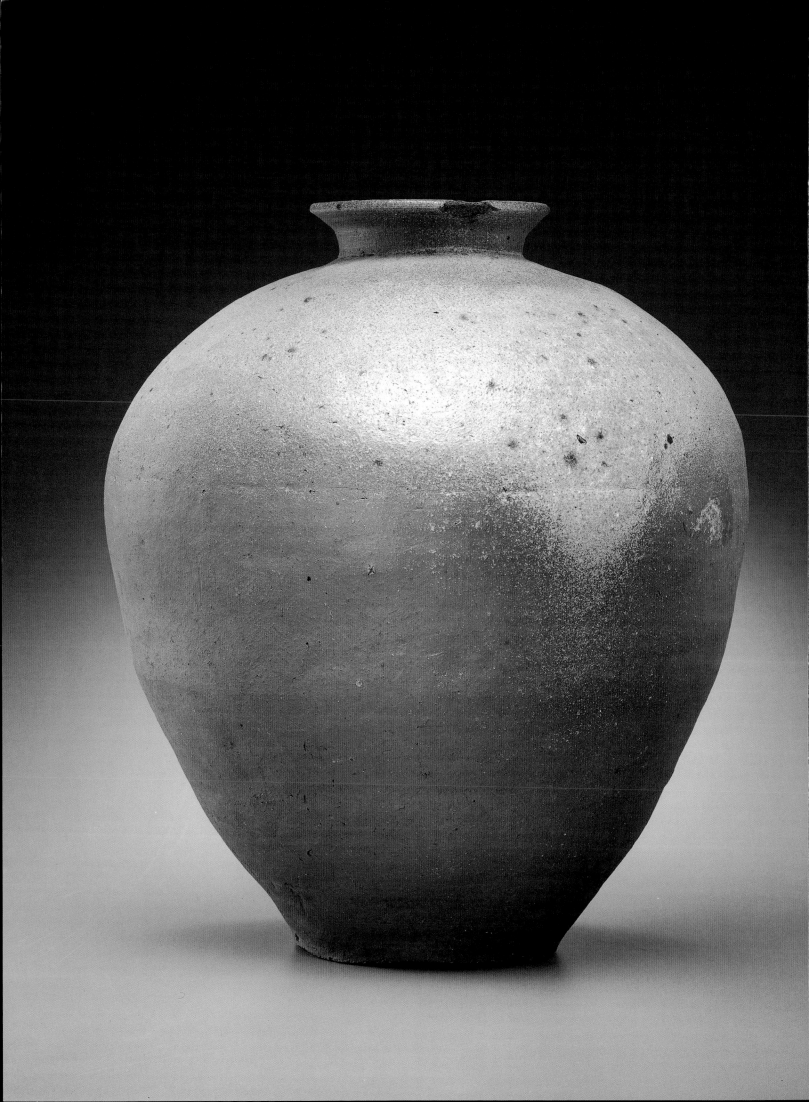

Jar
Japan, Muromachi period
Fifteenth century
Tamba ware; glazed
stoneware

humble vessels. Frequently favored were bowls and containers produced at kilns famed for rough utilitarian ware. Such wares were valued for the unpretentious individuality of their plain surfaces and random natural glazes, as well as other unpredictable effects of the firing process. A large storage jar (left) produced at the Tamba kilns, not far from present-day Osaka, is a fine example of the ware which inspired commissions of smaller pieces for use within the intimate tea room setting. The jar is wide-shouldered and slightly asymmetrical, with a precariously narrow foot. Such a large vessel may even have been placed outside the entrance to the tea hut. A smaller and even more eccentric vessel (right) is the product of the Iga kilns in the mountains east of Kyoto. The size of this storage jar suggests that it was adapted as a water container for use in the tea ceremony. The collapsed shoulder resulted either from a firing mishap or intentional multiple firings often used at the Iga kilns to induce distortion or cracking, or to bring small stones mixed in the clay to the surface. The natural glaze was produced from the ash of pinewood fuel used in the kiln. The immediate physical encounter with the chance aspects of such wares offered tangible insights into the nature of reality. Unlike the smooth and perfect shapes and surfaces of imported Chinese ceramics, the discoveries available to the sensitive user of indigenous pottery were as random, sudden, and surprising as Enlightenment itself.

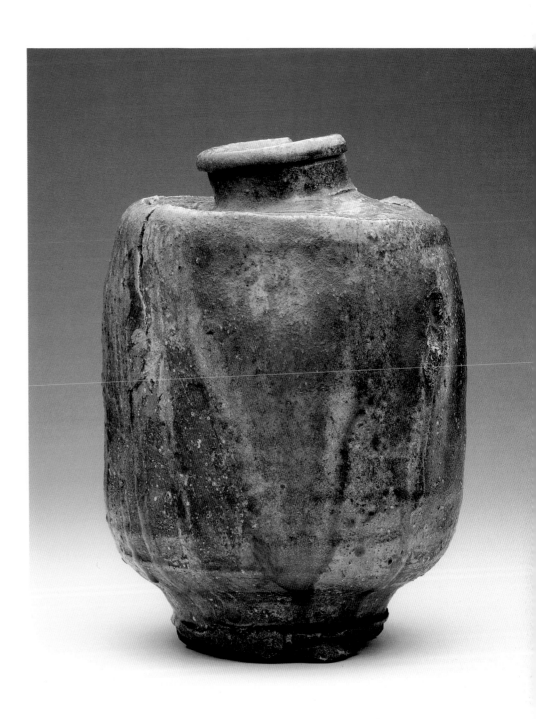

Jar
Japan, Momoyama period
Late sixteenth century
Iga ware; glazed
stoneware

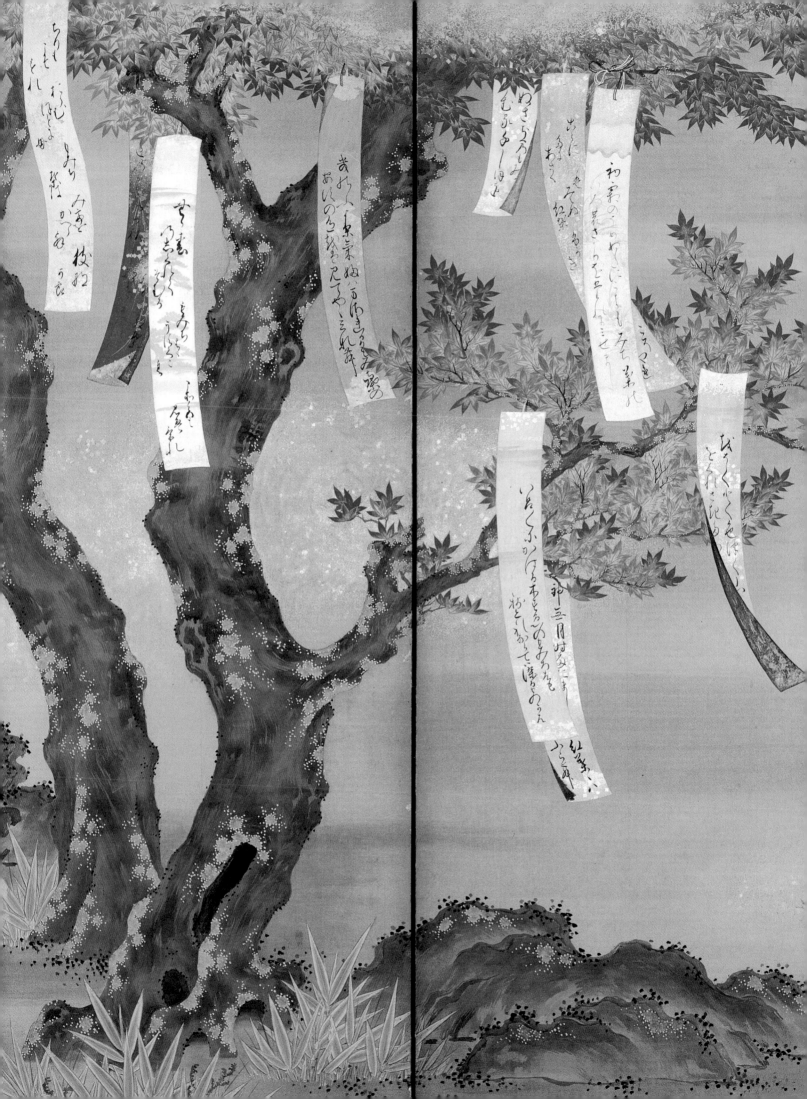

The Emergence of Japanese Decorative Taste

The spiritual vigor that Zen Buddhism provided for the fractured society of medieval Japan was often conveyed through cultural vehicles that bore a somewhat somber and distinctively Chinese imprint. As Japan moved toward national unity during the sixteenth century, however, the stern painted visages of Zen patriarchs and the multilayered subtleties of ink-monochrome were eventually eclipsed by a renewed indigenous passion for bold pattern and bright color. This passion was, in fact, the means to express a unified cultural heritage.

Developments in the theater presaged the shift toward a taste for brilliantly colored images infused with nuance. During the late fourteenth century, troupes of traveling actors who presented folk dramas and ritual performances at Buddhist temples and Shinto shrines forged a new genre called Nō. The plays of this refined dramatic form were based on folktales and classical literature and were, consequently, pervaded with a Buddhist cosmological perspective. Tales were enacted through regally cadenced music and dance and with the declamation of masked and opulently costumed performers.

A *nuihaku,* or silk robe, in the Art Institute collection (pp. 112, 113) was probably created for secular use and

later given to a Nō acting troupe by an aristocratic patron. Made during the Momoyama period (1568–1603), it is the only known costume of its age and kind in the West. The robe was constructed through expensive and labor-intensive techniques that included paste-resist dyeing, impressed gold leaf, and silk embroidery. Autumn flowers and tiny narrative scenes—suggesting vignettes from classical literature—enliven the spaces formed by a bold cross-hatch pattern. The audience of a Nō play could enjoy the satisfying vision and stately motion of actors in such opulent robes while gleaning something of the characters' roles and motivations from the symbolism encoded in their costumes. On a deeper level, the audience could also savor the implications of the Nō visual aesthetic. Beneath a shimmering veneer of beauty and artifice remained the tangled complexities of the world and the human heart: fate, retribution, tragedy, and redemption. This union of spectacular surface and spiritual substance represented the highest aspirations of the decorative traditions that would flourish during the next three centuries.

By the beginning of the seventeenth century, Japanese political control was firmly in the hands of the Tokugawa family. Although the capital and imperial court remained in Kyoto, the Tokugawa shoguns would rule for the next several centuries from Edo (later called Tokyo), far to the east. Following more than a century of civil war

and, at the same time, the assimilation of a brilliant but fundamentally foreign aesthetic perspective, the Japanese of the Edo period (1603–1868) sought to reaffirm a national cultural identity. At this time, the refined sensibilities of court life as revealed in the aristocratic art and literature of the Heian (794–1185) and early Kamakura (1185–1333) periods were nostalgically idealized by many as the apex of Japanese culture. During the Edo period, political unification and prosperity engendered new power alignments that made access to the emblems of "authoritative" cultural standards available to quite distinct social groups. Disenfranchised aristocrats attempted to reassert the privilege of cultural arbitration by avidly patronizing a renaissance of courtly taste, while the military rulers swiftly provided brides for the imperial bloodline and, in short order, proclaimed their own right to the ancient cultural mantle. The economic backbone of the new prosperity, a thriving class of merchants and entrepreneurs, also provided enthusiastic patronage for the arts of courtly revival. The new blend of patronage and taste in turn relaxed the once rigid lines defining particular artistic schools and lineages.

Increasingly eclectic styles appeared as artists applied painting and design

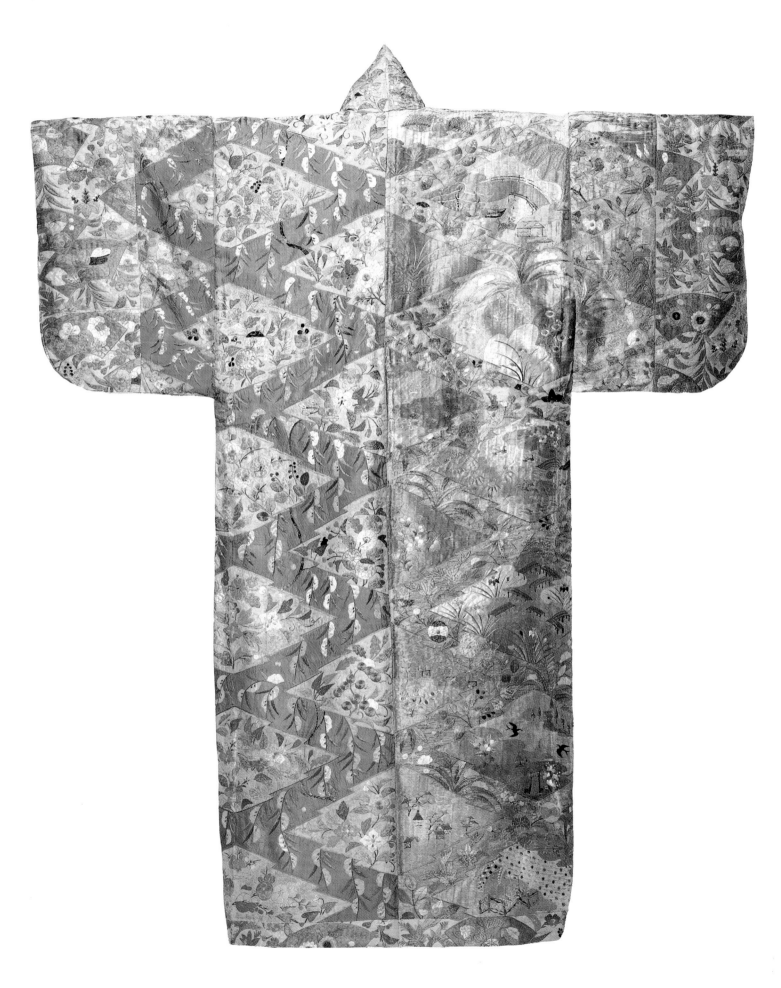

**Nō Drama Costume
(*Nuihaku*)**
Japan, Momoyama period
Sixteenth century
Silk, plain weave;
patterned with areas
of resist dye and gold-leaf;
embroidered

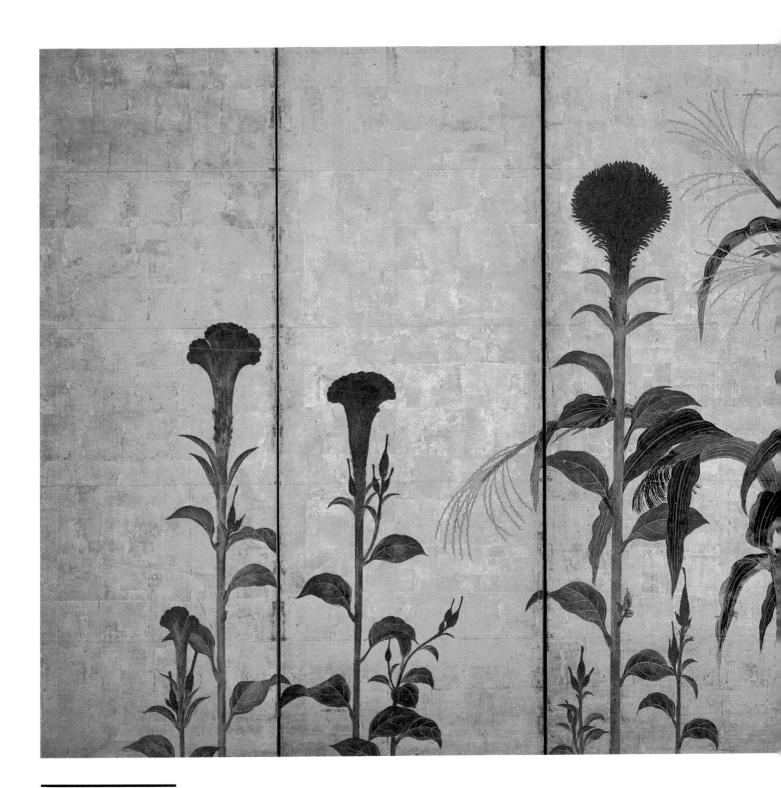

Maize and Cockscomb
Japan, Edo period
Mid-seventeenth century
Six-fold screen;
colors and gold leaf on paper

Flowering Cherry and Autumn Maple with Poem Slips
Painted by Tosa Mitsuoki (1617–1691)
Japan, Edo period; circa 1675
Pair of six-fold screens; ink, color, gold leaf and powder on silk

skills to a widening range of media. Significantly, pattern designers trained in the textile industry likewise adapted their sensibilities to painting. This phenomenon of influence between mediums is elegantly embodied in a seventeenth-century painted screen depicting a bounty of maize and cockscomb (detail, front cover, and pp. 114–15). The surviving half of an original pair, the screen's design of an exultant autumnal cornucopia could well be imagined on the hem of a garment. Perspective disappears as the intricately rendered forms and colors of the plants, situated on a ground of gold leaf, seem to press against the painted surface. This lavish presentation employs all the techniques of the ancient court painters while brimming with

the curiosity and confidence of the Edo period. The plants are presented with the accuracy of botanical drawing, hinting at the encyclopedic interest in natural science. And the assertive presence of maize, a grain not native to Japan, indicates the willingness of artist and patron to assimilate the new.

Bursting with a similar sensual fullness, but evoking a much more world-weary mood, is the pair of screens with idyllic depictions of a flowering cherry and an autumn maple (p. 110 and above). Signed by the premier court painter Tosa Mitsuoki (1617–1691), these paintings were either commissioned by or given to the imperial consort Tofukumon-in, wife of emperor Gomizuno-o and daughter of the Tokugawa shogun. Narrative rather than purely decorative in presentation, the screens recall the elegant court custom of spring and autumn foliage viewing. The branches are hung with narrow slips of paper inscribed with appropriate seasonal poems, affixed by courtiers of the viewing party who have since left the scene. Both screens are meditations on the inevitable loss of beauty, brilliantly echoing the melan-

choly aesthetic of the twelfth-century Heian court. What remains of the glory of the court are words wafting in the breeze.

The pair of screens depicting fields of millet under sun and moon light (pp. 118–19) is, in stylistic treatment, quite like that of the maize and cockscomb, while in intention they echo the darker concerns of Tosa's cherry and maple trees. Mature millet is clustered hard to the foreground of each screen and rendered with exacting and individual precision. In contrast to the near verisimilitude of the botanical elements, the rest of the painting is rendered in an almost casually schematic way. Clouds formed from gold leaf and pigment stretch pronouncedly across the sky as sun and moon peer through highly mannered, scallop-edged openings. The deliberate contrast of flat, simple form and minuscule detail suggests the existence of a middle plane, a permeable arena in which the intercourse of the real and the floridly imagined is possible. This painting

is more than a study of the effects of light and atmosphere. The sun and moon in command of the heavens was an element of much early Buddhist iconography, which signified through their dual presences the embrace of Buddhist authority over the whole of the cosmos. The celebratory mood of the painting retains the mild corrective of an ancient spiritual context, not unlike the aesthetic of Nō drama. Beneath the elaborate and glimmering surface of harvest is the gently disruptive suggestion that this abundance too is fleeting.

An approximate contemporary of these screens is a much smaller painting attributed to Ogata Kōrin (1658–1716), a profligate scion of an im-

Millet Under the Aspects of Sun and Moon
Japan, Edo period; late seventeenth century
Pair of six-fold screens; ink, color, and gold leaf on paper

Millet Under the Aspects of Sun and Moon
Japan, Edo period; late seventeenth century
Pair of six-fold screens; ink, color, and gold leaf on paper

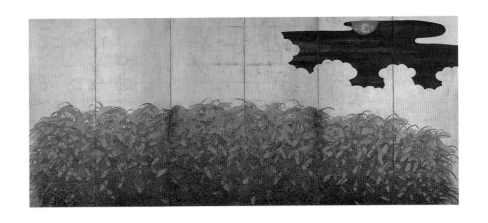

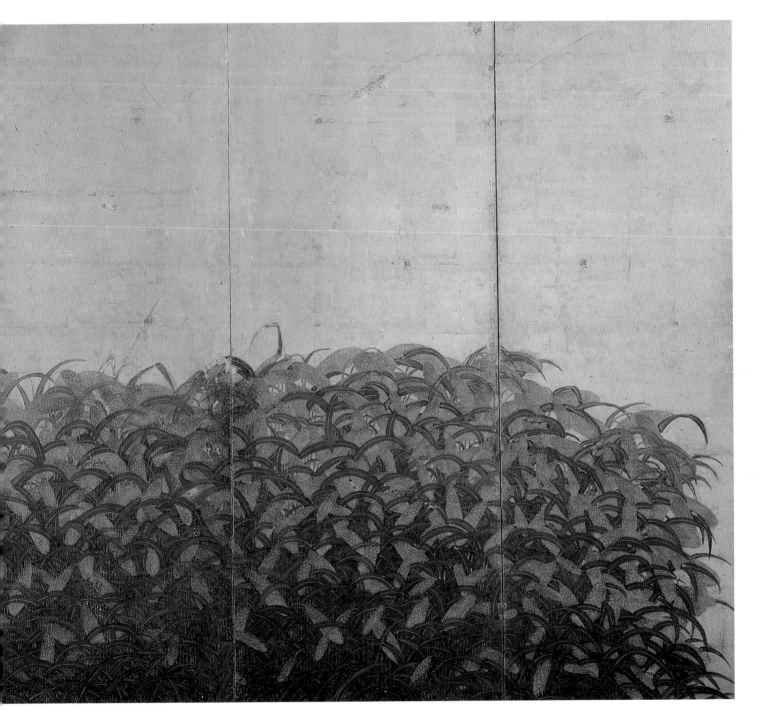

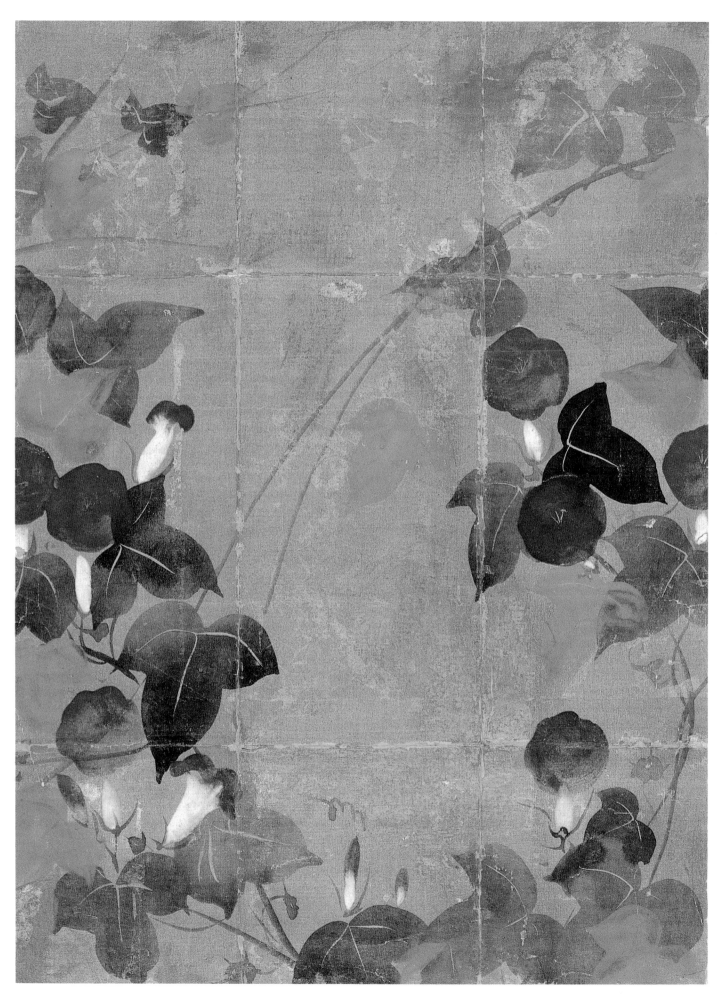

120

Incense Wrapper
Attributed to Ogata Kōrin
(1658–1716)
Japan, Edo period
Seventeenth/eighteenth
century; wrapper mounted
on hanging scroll; ink and
color on gold-ground paper

portant Kyoto textile family and the painter who led the courtly renaissance into its second century. Kōrin stands at the head of a lineage that embraced a more markedly decorative style. His evocative painting of morning glories (opposite) is rendered in a mix of opaque pigment and occasionally translucent black-ink wash on thick, gold paper. This work is now mounted on a hanging scroll, but the precise folds still visible on the surface indicate its original use as a wrapper for carrying grains of incense. *Koawase* (the matching of scents) was yet another refined aristocratic pastime adopted in the Edo period by a widening audience. Blends of incense were prepared and lighted, and the participants engaged in a guessing game to name the ingredients by the scent of the wispy smoke. Beyond executing commissions for the standard painting formats, Kōrin—partly in keeping with his reputation for foppish eccentricity—enjoyed expending his consummate skills and costly material on seemingly inconsequential items. One legend tells of his arrival at a picnic bearing his repast in a wrapped leaf. As the artist sat to dine, he opened his packet and the leaf interior was revealed to be covered in gold foil—an elegant touch duly noted by the other guests. As the party concluded and the

guests discarded their unadorned leaves, Kōrin too casually tossed off his gold-lined wrapper. This gesture of studied disregard was intended as an act of cultivated hedonism; but it also referred to the notions of evanescence and decay. Kōrin's wrapper was perhaps intended as a version of another metaphor, that of the cherry blossom blown prematurely from its branch. His incense wrapper provided a format for similar (though less blatant) expression of the same theme. Talent, material, and beauty were invested in an ancillary item whose function of repeated folding and unfolding implied inevitable damage and impermanence.

The appropriation of striking color, pattern, and largely native imagery extended as well to ceramics, although the taste for colorful ceramics long preceded the Japanese ability to produce them. During the Ming dynasty (1368–1644), the Chinese manufactured certain of their highly accomplished polychrome porcelains exclusively for the Japanese market. The production of porcelain requires supplies of kaolin (a fine, white clay) and mastery of advanced kiln technology. These prerequisites came together in Japan in the early seventeenth century, after deposits of kaolin were discovered in western Kyushu. Korean potters skilled in porcelain manufacture had been brought to western Japan somewhat earlier, following Japanese military exploits on the Korean peninsula (see discussion, p. 80).

In porcelain, the reawakened thirst for color had finally found a suitable ceramic medium. Its consistent, milky, and hard surface could display a satisfying palette of enamels, both over and under its glaze. The name Kakiemon is synonymous with the creative development of polychrome porcelain in Japan. Accounts suggest that Sakaida Kizaemon (1596–1666) of Arita, in

western Kyushu, perfected the manufacture of these wares during the 1640s and was honored by his feudal lord with the name Kakiemon after creating two exquisite porcelains in the forms of persimmons (*kaki*). For perhaps four succeeding generations, the Kakiemon name signified porcelains of a decorative style that was prized in both China and Europe, where, during the eighteenth century, it was aggressively imported, and then imitated. In Arita, indigenous flower vases, bowls, and dishes were produced in the same kilns as ewers and candlesticks for export to Europe.

On the surfaces of a fluted bowl (p. 122), a sure-handed painter applied asymmetrical floral sprays. While the casual array of flowers playfully contrasts with the bowl's structural regularity, a swirling-tailed phoenix in the perfectly circular center conforms to and complements the bowl's geometry. A more vigorous subject is rendered in underglaze blue on a small white plate (p. 123). The energetic execution of darting fish imparts a surprising sense of generous scale to this small piece. Artists practiced in animating an expanse of empty paper or silk with a few brush strokes clearly approached the white bodies of blank porcelains with similar assurance.

Virtually all Japanese fine art and literature of the Edo period developed with some reference to the aesthetics of the Heian court. As thematic or compositional sources, as standards of unsurpassed elegance, and even as occasional foils for comedy or satire, the words and images of ancient court poets and artists were the implicit arbiters of culture. As the explosively energetic metropolitan cultures of Edo and Osaka flourished, Japan found both reassurance and challenge in its recreated past. In its latter years, the hereditary rule of the Tokugawa shogunate proved sluggish and inept, having lost the dynamism with which it

Bowl
Japan, Edo period
Late seventeenth/early
eighteenth century
Arita ware; porcelain
with enamel decoration
(Kakiemon-style)

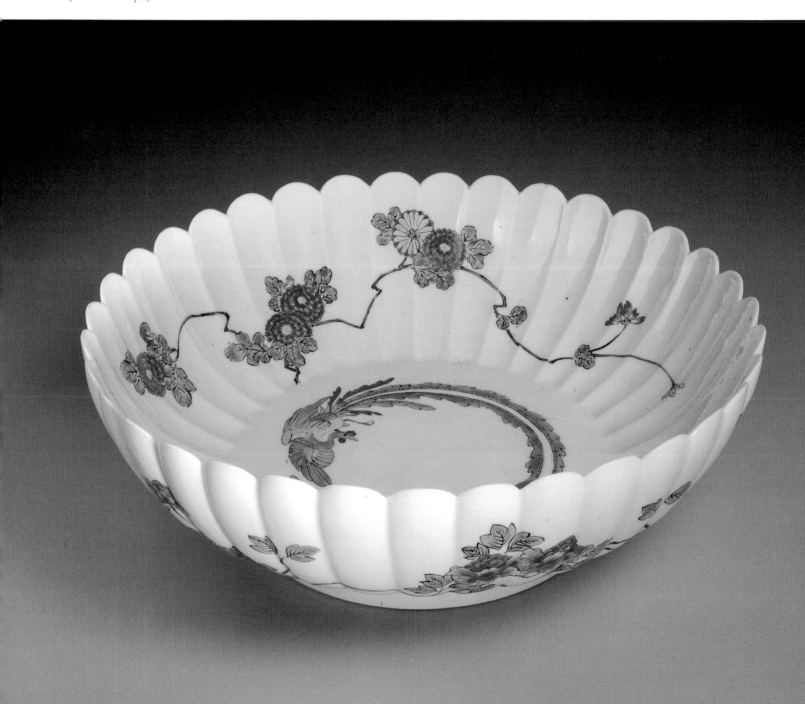

had once unified the nation. Facing domestic pressures and new international challenges, the shogunate attempted to ward off contenders to political power, among them a movement intent on restoring imperial authority and recapturing the cultural vitality of the Heian court.

A group of Kyoto artists became the symbolists for the royalist movement. Reworking the images of the Heian court in a more contemporary vocabulary, these artists attempted to reactivate the memory of a courtly aesthetic that they believed had been sapped of genuine resonance. One of their number, Reizei Tamechika (1823–1864), produced the pair of diminutive, six-fold screens (pp. 124, 125) on which the figures of twelve court poets of the past are displayed above panels of gold foil. Calligraphed above each figure is his or her name and a representative poem. Poetry contests had been a quintessential court exercise, in which skills were matched in composing and linking verses of the thirty-one syllable form called *waka*. Images of poets engaged in contests took many forms, but most frequently the stately seated figures were rendered, as here, in three-quarter profile against a blank background, and with occasional supporting paraphernalia to indicate the subject's rank or function. The vibrant colors and detail of Tamechika's screens exemplify his passion for precision. Less an energetic reimagining of a vital cultural force than a fond tribute to a lost past, the screens suggest a delicacy frozen in time. The jewel-like clarity of these remembered images implies their fragility and evokes the poignancy of the failed dream of true imperial and cultural restoration.

Tamechika's idealistic dedication to the imperial cause made him an unwitting victim of political intrigue. An indefatigable student of ancient paintings, he went to great lengths to copy and adapt works in numerous collections. He was assassinated in 1864 by a fellow royalist who had mistaken the artist's innocent visit to the painting collection of a shogunal lieutenant as an act of treachery.

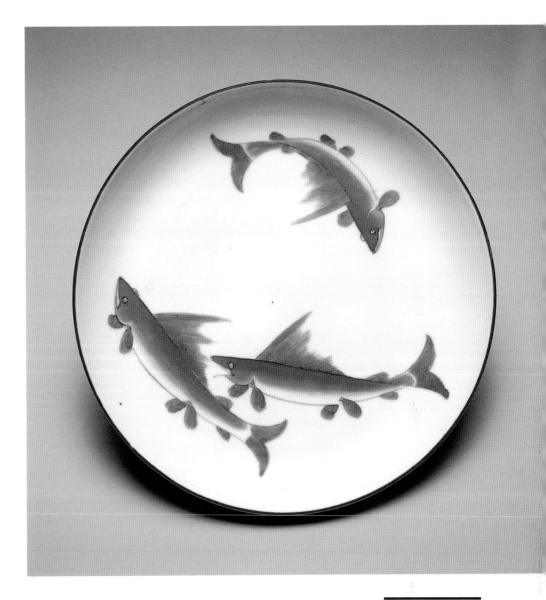

Plate
Japan, Edo period
Eighteenth century
Arita ware; porcelain
with underglaze
blue decoration

The Twelve Poetic Immortals and Their Poems
Painted by Reizei Tamechika
(1823–1863)
Japan, Edo period; 1850
Pair of six-fold screens;
color on paper

左　歌宮女御

袖
しく秋の

きしし露
露とし

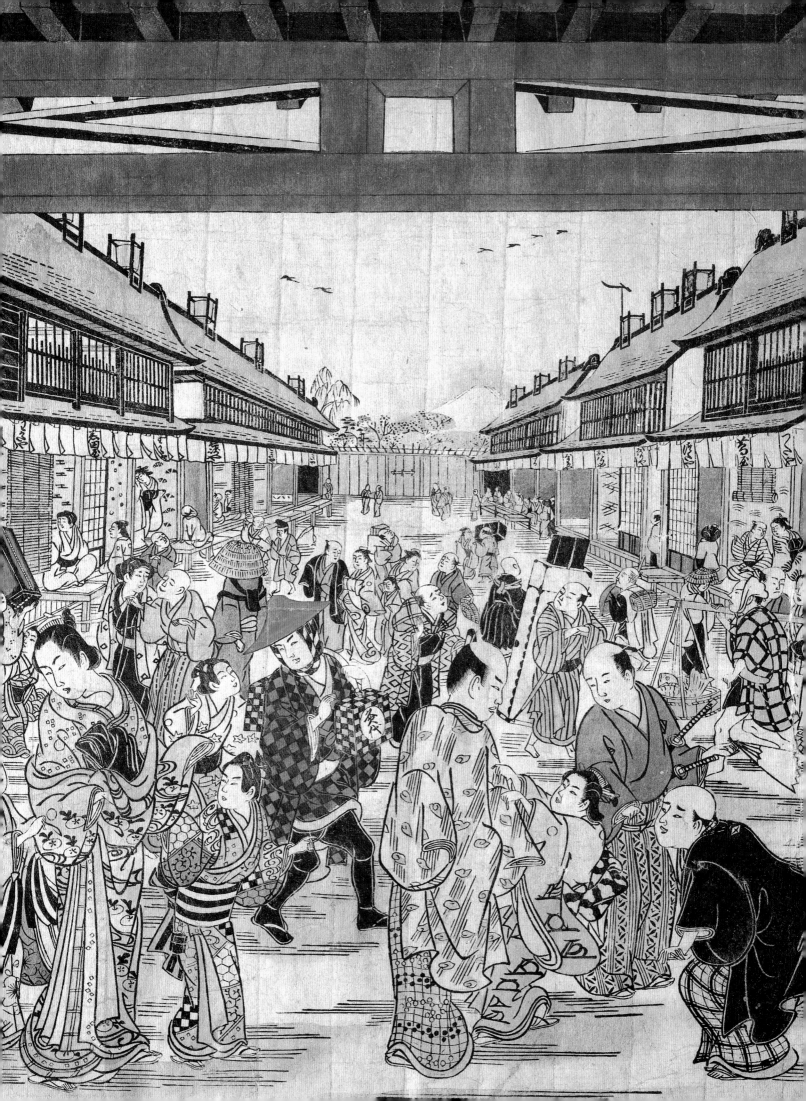

**Detail of
Naka-no-cho Street
of the Yoshiwara**
By Torii Kiyotada
Japan; circa 1735
Woodblock print
See pages 132–33.

Images of the Floating World

The period later known as Edo (1603–1868), named in recognition of the central political and cultural role of Japan's burgeoning eastern metropolis, was one of relative prosperity, political stability, and ever-tightening social constraint. A succession of shoguns from the Tokugawa family ruled the nation out of the new *de facto* capital, while the imperial family and court aristocrats fulfilled largely ceremonial roles in Kyoto.

The rulers balanced two rather disparate energies: a movement toward an ever more rigid and hierarchical definition of social roles, and the sheer vitality that is inherent in any rapidly expanding urban culture. Wealth was no longer simply a function of rank or birthright; merchants upheld the stability of the social order. Yet, in the neo-Confucian ranking espoused by the government, merchants occupied the lowest rung on a ladder topped by samurai, below both farmers and artisans. This reflected the ancient Chinese notion of merchant as a kind of necessary parasite who lived off the honest labors of others. The newly monied class was, nevertheless, free to appropriate the traditional art forms and literature that were once the private domain of the aristocracy. The merchant class also formed a significant patronage for the artistic interpretation of a newly forming arena of calculated pleasure, the "floating world" (*ukiyo*). Originally a Buddhist

term for the melancholy and transitory realm of human existence, *ukiyo* was later applied to the atmosphere of shifting fashion, fantasy, and ephemerality that characterized the pursuit of pleasure in the urban licensed quarters. The latter designation was more lighthearted, but not altogether innocent of the Buddhist nuance. Images of this world, printed or painted, were called *ukiyo-e.*

Few images more forcefully reflect the complex intentions of seventeenth-century Japanese urban culture than does Sugimura Jihei's hand-colored print offering a glimpse of a brothel interior (pp. 128–29). In a single sweep of brilliantly robed and pivoting bodies, Jihei recorded a moment of awkward miscue in the elaborate fictional sequence of flirtation, seduction, and submission. An overeager patron lurches from his seated position to grasp the waist of a demurely resisting courtesan. Rather than meet his impatient gaze, she casts a conspiratorial glance at a female attendant who averts her eyes and quickly moves to exit the scene. With remarkable visual economy, Jihei suggested the web of complicities and implicit understandings that were the underpinnings of the pleasure world. At one obvious level, the viewer is invited as voyeur to observe a groping boudoir farce. But in a composition filled with straining postures and covert glances, the artist went well beyond a mundane recording of lust. He represented an elaborate social fiction and the scurry of arrangements required to sustain it. In unprecedented disregard for the artist's

traditional choices of anonymity or a signature modestly placed in the corner of the print, the name Jihei fully participates in the action of the moment. It is written on the black waistband of the man, while the characters for Sugimura are applied to the design of the courtesan's gown. Whether as a gesture of self promotion or witty notation of personal predilection, Jihei boldly suggested his immersion in the world he was recording.

The woodblock print medium was originally monopolized by the Buddhist establishment, beginning in the eighth century, for the mass production of texts and icons. The simple technology of engraving relief images on a wood block, inking the block, and then impressing the reverse image on single sheets of densely fibered paper was sufficient to fulfill the medium's missionary function. Printed outlines embellished with hand-applied pigments, identical to the method used by Jihei, marked the limit of Buddhist innovation. In the early seventeenth century, the texts and images of classical literature were block printed. This early and tentative dissemination through mass production had, by midcentury, become the format of choice for eliciting visions of the floating world. From the middle of the seventeenth century, woodblock prints, in the service of new and expanding patronage, had moved in steady progression from the use of ink mono-

The Insistent Lover
By Sugimura Jihei
(active circa 1680–98)
Japan, Edo period
Circa 1680
Woodblock print

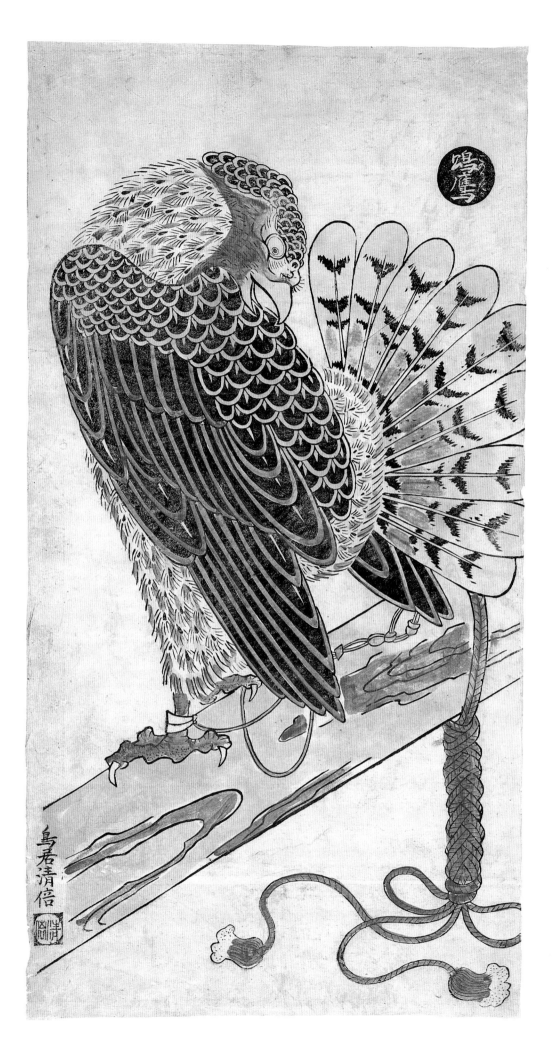

Sparrow Hawk
By Torii Kiyomasu I
(active circa 1696–1716)
Japan, Edo period
Circa 1710
Woodblock print

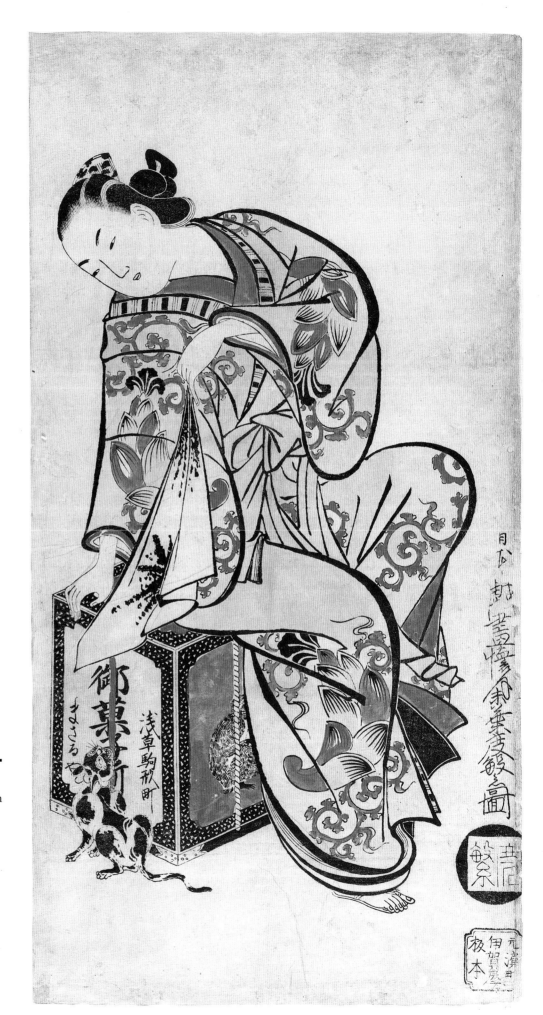

**Woman Playing
with a Cat**
By Kaigetsudō Dohan
(active 1710–16)
Japan, Edo period
Circa 1710
Woodblock print

chrome and hand-colored images to two- or three-colored images produced by multiple blocks and inkings. This trend toward more elaborate and lushly colored works culminated in the 1760s with the creation of images on single sheets colored by pigments from numerous blocks and occasionally enhanced by embossing.

In a culture that otherwise preferred masking feeling within a complex etiquette, the astute artist could discover rich and varied subject matter in the rapidly expanding worlds of pleasure. Prostitutes and actors, in the business of being observed, were most often the subjects of widely proliferating prints. Historical and classical themes were not neglected as overt topics, but they were frequently woven into contemporary settings.

Among the most popular and recognizable *ukiyo-e* were the female images produced by a succession of artists belonging to the Kaigestsudō studio: a somewhat generic melange of delicate features enveloped in richly patterned and blousey kimono. The garment suggested a body fullness curiously but not unpleasantly out of proportion to the revealed anatomy. Most beauties of this type, called *bijin,* stand in an elegant, curving posture. A rare image by the artist Dohan (active 1710–16) depicts a woman seated on a cord-bound cake or candy box, toying with a cat in amused distraction (p. 131). The partially obscured image of a monkey (*saru*) on a box panel plays on the inscribed confection shop's name, Masaruya. Records indicate that the shop was in the neighborhood of the Kaigestsudō studio. Perhaps a straightforward advertisement, or even a humorous reference to the shopmaster's favorite courtesan, the image is replete with allusions to seductive dangers. The literate viewer would also note an oblique reference to the incident from the eleventh-century *Tale of Genji* in which a woman of court, normally obscured

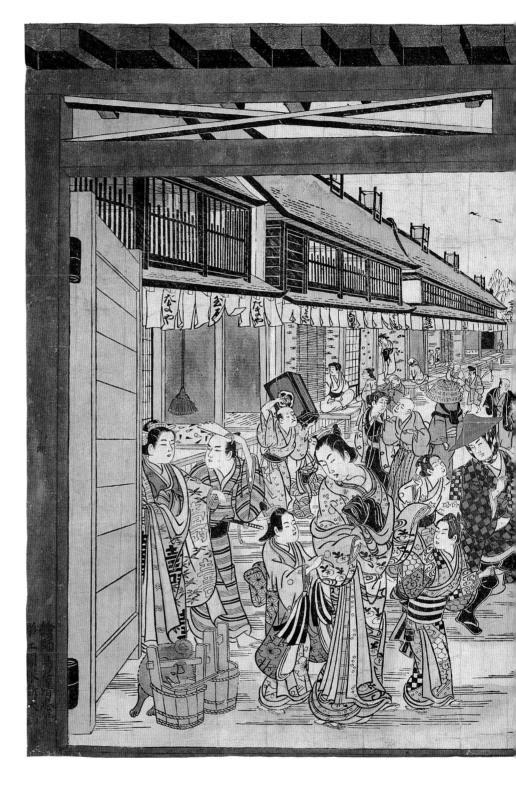

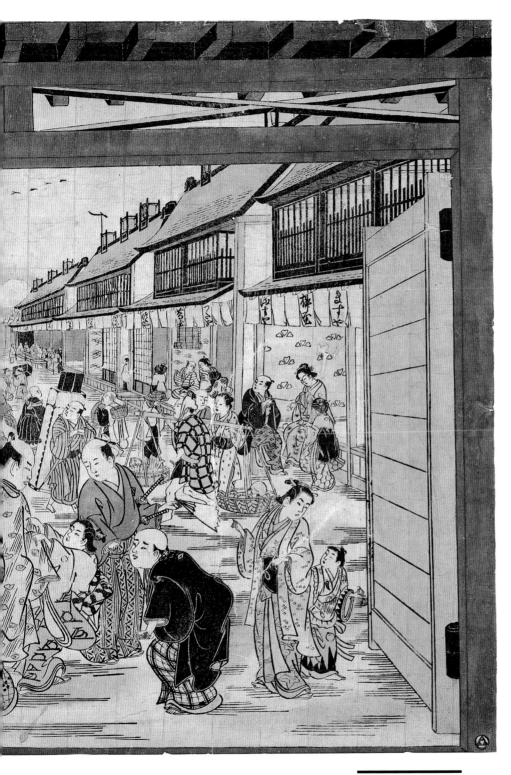

Naka-no-cho Street of the Yoshiwara
By Torii Kiyotada
(active circa 1720–50)
Japan, Edo period
Circa 1735
Woodblock print

from suitors by a woven reed curtain, is inadvertently exposed by a tug from her playful cat. In Dohan's print, the feline is both reflective and revelational of female sexuality.

Hawks and falcons were emblematic of the warrior. Poised, obedient, but never fully domesticated, the hunting bird in its tethered ferocity symbolized power trained to serve. A subject for paintings traditionally commissioned by samurai, the image in printed form enjoyed a brief popularity during the early eighteenth century, particularly when rendered by the master Torii Kiyomasu (active c. 1696–1716; see p. 130). In its posture, the hawk — rendered by an artist who was also well known for depictions of full-bodied, curvilinear *bijin* — is remarkably similar to Dohan's courtesan. That the hawk image would emerge from a studio largely concerned with the glorification of carnal indulgence is jarringly suggestive. The taloned fowl transcends its original incarnation as a reflection of the warrior persona, hinting at another kind of constrained and explosive passion.

Edo's first pleasure quarters were licensed in 1617 and located in a drained swamp area called Yoshiwara. The original site was situated within Nihonbashi district, now at the center of modern Tokyo's business district. When a fire destroyed much of Edo in 1657, the licensed quarters were relocated to the northeast, not far from the Asakusa Temple. Torii Kiyotada (active c. 1720–50) offers a glimpse through the Yoshiwara entryway and down Naka-no-cho street, revealing a bustling, ordered exuberance (pp. 126 and left). As tradesmen gingerly weave among patrons and courtesans, the tug and jostle of persuasion essential to the commerce of the Yoshiwara is effectively conveyed. The variety of figures and pleasure establishments are arrayed along a taut visual axis. The artist assembled and underscored the contending forces of order and persua-

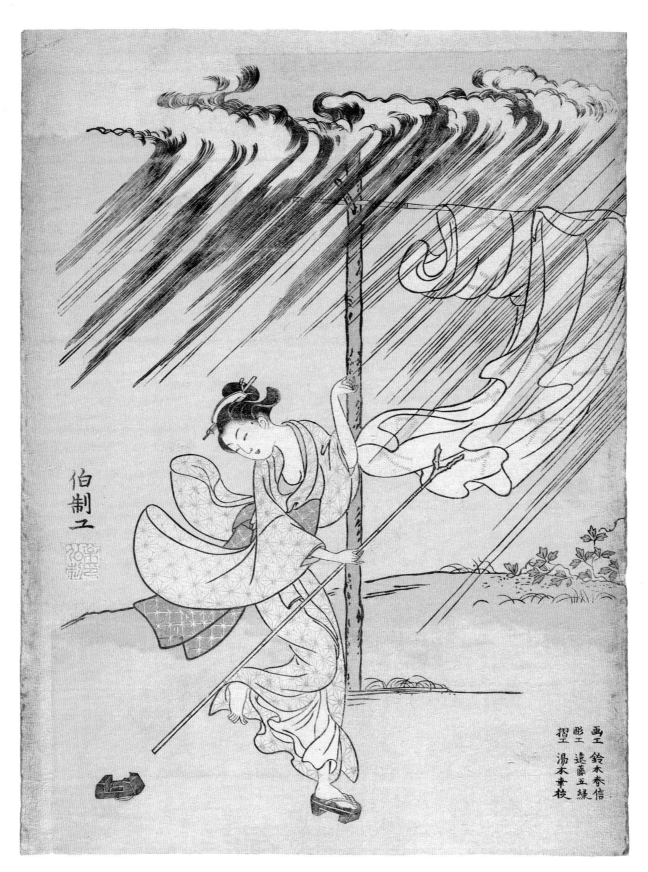

Young Woman in a Summer Shower
By Suzuki Haranobu
(1724–1770)
Japan, Edo period
1765
Woodblock print

Woman Holding a Comb
By Kitigawa Utamaro
(1753–1806)
Japan, Edo period
Circa 1798
Woodblock print

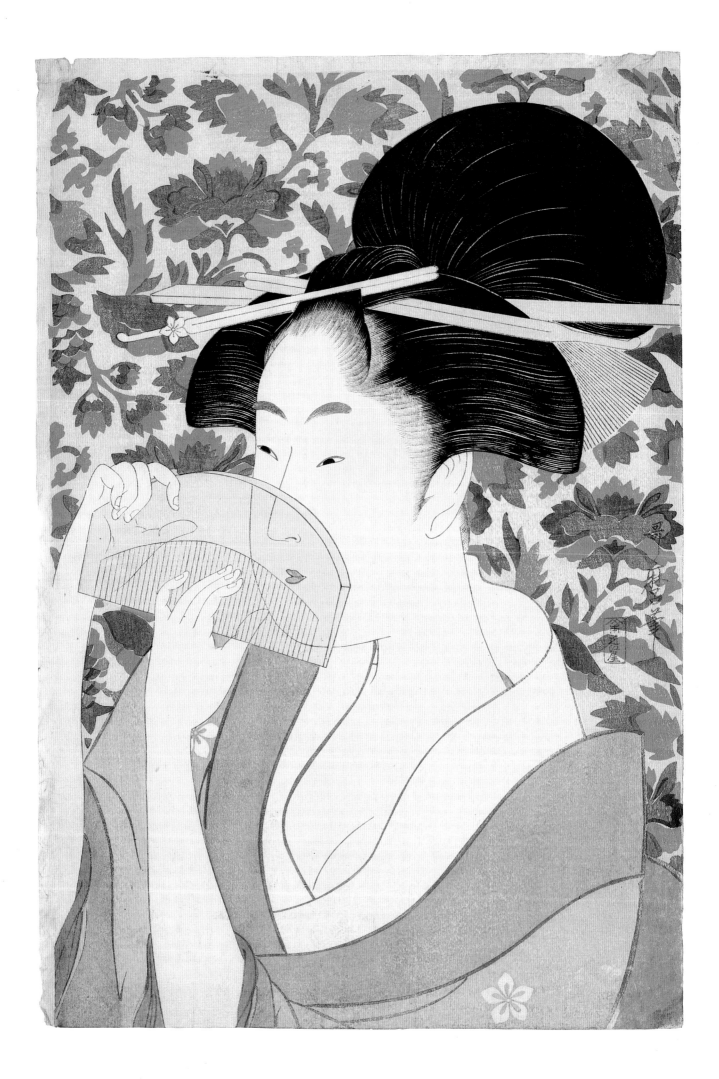

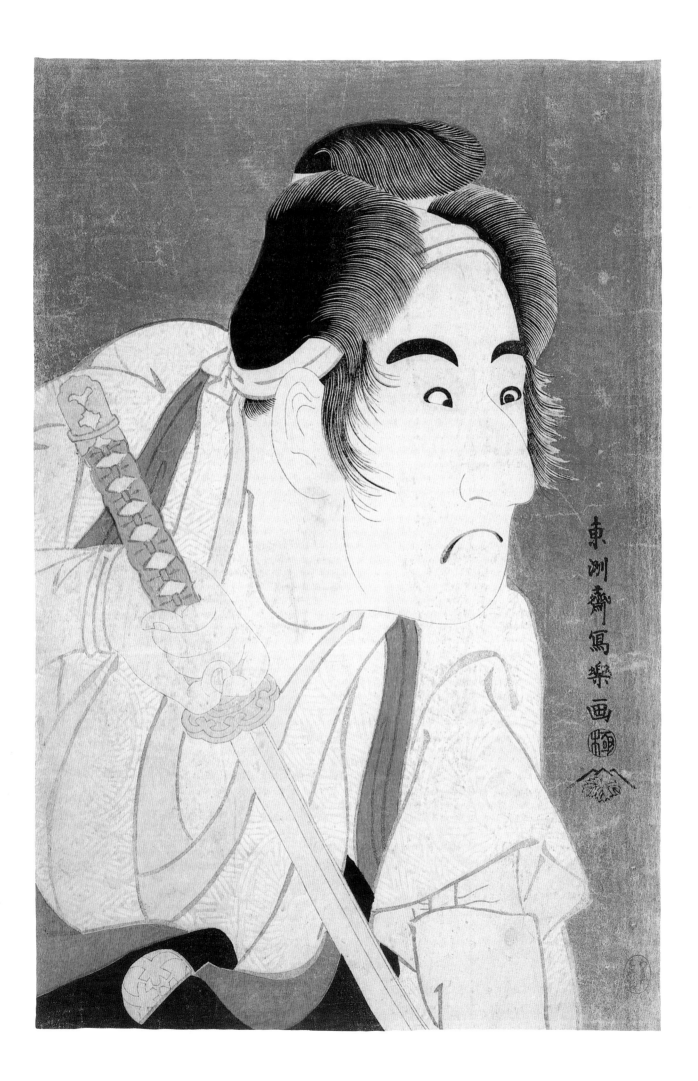

**The Actor Bandō
Mitsugoro as Ishii Genzō**
By Tōshūsai Sharaku
(active 1794–95)
Japan, Edo period; 1794/95
Woodblock print

sion by use of the single vanishing-point line, a Western compositional device made available to Japanese artists through European prints. The woodblock print was an especially effective format for experimentation with such imported techniques. While multiple impressions disseminated such "other ways of seeing" to a wide audience, the perceived ephemeral nature of the medium in no way threatened mainstream modes of expression. There is more than visual deception in Kiyotada's charming rendition of happy commerce, however. Yoshiwara was a guarded, carefully monitored enclosure, as stratified and regulated as the larger society whose needs it served. For every courtesan whose beauty was celebrated in print or painting, many of lesser rank endured the routine and anonymous brutalities of their profession.

Yet, for some of its patrons, Yoshiwara was more than a collection of brothels. The better establishments served as salons which catered to a sophisticated clientele who understood that the relative freedoms allowed within the "tea houses" were intellectual as well as sensual. An image of a lithesome young woman bounding to rescue a hanging garment from a sudden shower (p. 134) tells as much about patronage of the day as it demonstrates tastes for the coyly revealing. The viewer is allowed to observe a young woman in charmingly unavoidable dishabille. The rain and swirling cloud are stylized beyond any threat of true ferocity. A foot accidentally bared and a sudden glimpse of leg are offered for their mild but obvious erotic quality. Titillation is a pleasant distraction from the far more interesting function of the print as a calendar (*egoyomi*). What at first glance seems a tie-dyed pattern on the hanging garment is actually a configuration of ideograms representing numbers that correspond to the date of 1765. Calendar prints

suddenly surged in popularity in that year, perhaps stimulated by the opening of the shogunal observatory in Edo, an event that called for ingenious *egoyomi* and other commemorative gifts. Calendar publication was a government monopoly, and private production nominally skirted detection by use of clever encoding. The artist responsible for this print, Harunobu (1724–70), seems to have benefitted from the kind of indulgent patronage eager to impress and therefore willing to finance the costly technique of multiple-block color printing. Harunobu's meteoric rise to favor started with this propitious year, 1765, and continued well through the end of the decade. His style dominated the period and created a taste for the full-color, block-produced print. Regardless of the expense incurred in this complex and time-consuming technique, a growing audience would settle for nothing less.

The remaining years of the eighteenth century witnessed an intensive production of *bijin* and actor images. Lavish celebrations of an idealized female form and bombastic portraits of popular Kabuki personalities would, by the century's end, begin to hint at the subtleties of individual emotion beneath the assumed and demanding roles. Now, images of courtesans, while often still salacious, might also reveal the churlish pout of an inexperienced girl or the resigned melancholy of a seasoned performer. Actors emerged from beneath layers of makeup and stylized poses. Idiosyncrasies of individual physiognomy became as prominent as surface flamboyance.

The prints and paintings of Kitagawa Utamaro (1754–1806) are synonymous with an unceasingly devoted observation of the female form. Whether depicted individually or in flawlessly composed figural groups, Utamaro's women invariably suggest more than a mere record of ogled beauty. A young

**Clear Day with a
Southern Breeze**
By Katsushika Hokusai
(1760–1849)
Japan, Edo period
Circa 1831
Woodblock print

**The Ghost of
Kohada Koheiji**
By Katsushika Hokusai
(1760–1849)
Japan, Edo period
Circa 1831
Woodblock print

woman peering through a tortoise shell comb (p. 135) is rendered as a playful explorer, her delicate and traditionally garbed form framed by a bolt of European fabric. Within an image of apparent lighthearted play, the artist established contending moods of innocent modesty and alluring exotica. She peers through the semitransparent, polished shell, allowing the viewer to marvel along with her at the material's sheer substance and, implicitly, to pay heed to Utamaro's technical wizardry.

Far from gentle but equally compelling are the prints of Japan's most enigmatic artist, Tōshūsai Sharaku, whose entire oeuvre of bold caricatures appeared during a ten-month period that bridged the years 1794 and 1795. Whether a well-known artist using a pseudonym to experiment with a new style, an actor briefly testing another talent, or simply an artist with an extraordinarily short period of brilliance, the true identity of Sharaku remains a mystery. The scowling Ishii Genzō, as portrayed by the actor Bandō Mitsugorō II (p. 136), is completely theatrical in his fierce determination. The prominent nose is perhaps an exaggeration of the actor's already notable feature. The character appears in the *Hanaayame Bunroku Soga* (The Iris Soga of the Bunroku Era), a drama based on a 1701 incident in which Akabori Genyoemon was slain by the brothers Ishii Genzō and Ishii Hanzō to avenge their father's murder. The bloody retribution, a scandalous disruption of Tokugawa civil order, shocked and intrigued the Edo population. It was also remarkably prefigured by a complex twelfth-century incident of filial revenge in the Soga family, an historical occurrence that had inspired numerous literary interpretations in the ensuing centuries. Since commentary on contemporary politics or reference to disorder within the realm was officially discouraged, the tactic of encoding of distasteful incidents —

including the recent murders — in the language of a classic Japanese tale was gingerly employed by many Edo period artists and writers.

The Tokugawa government's reaction to economic crisis was the occasional issuance of sumptuary edicts whose real and symbolic intention was to proclaim austerity and generally encourage a high moral tone. Actor and courtesan prints were directly affected by these laws. If not banned entirely, the use of multiple pigments and semiprecious materials in the making of prints was curtailed. In the early nineteenth century, other subjects, notably landscape and historical topics, were substituted. When the bans were lifted, landscape survived and thrived as a newly favored genre. The indulgent visions of the pleasure quarters and theater had run their course, and the public now seemed avaricious for images of an outside world.

Prints chronicled the scenery along the major travel routes that linked Japanese cities. They also celebrated the vistas of the cities themselves and explored imagined panoramas of far-off lands. The images comprising a study of Mount Fuji by Katsushika Hokusai (1760–1849) are among the most familiar and majestic of the expansive, nineteenth-century visions. Startling as it looms over the vast Kanto Plain, the volcano Fuji, an ancient pilgrimage site long featured in religious iconography, was ever present to the citizens of Edo. In his series, produced during the late 1820s and early 1830s, Hokusai offered alternating views of overpowering force and prosaic familiarity. Visually dominant or reduced in scale, the mountain is the focus of each composition, whether observed from the perspective of laboring tea harvesters or from the relaxed verandas of the metropolis. Second in the sequence is the image "Clear Day with a Southern Breeze," better known simply as "Red Fuji."

**Night Snow
at Kambara**
By Andō Hiroshige
(1797–1858)
Japan, Edo period
Circa 1833
Woodblock print

The massive profile is observed in late summer or early autumn. Jagged veins of early snow appear near the peak. The surface glows like an ember in the dawn light and, in the finest impressions, is a splendid blend of subtle color gradations. A schematically rendered forest skirts the mountain's base and the blue sky is filled with curious cloud patterns that the artist borrowed from European models, perhaps as an injection of novelty.

At the same time that his views of Fuji were enthralling the public, Hokusai issued a *Ghost Tale* series that included the grotesquely haunting skeletal apparition of the murdered Kohada Koheiji (p. 140). Some of the earliest Japanese literature records a taste for tales of the horrible and distressingly supernatural. The market for illustrated gothic fiction, much of it ostensibly structured around Confucian moralizing principles, was strong in the late Edo period. From the first years of the nineteenth century, Hokusai was much in demand as an illustrator for these cheaply produced books. Far more elaborately conceived were the plates of the *Ghost Tale* series, each a chilling distillation of a specific horror story. Kohada Koheiji was an itinerant actor drowned by his wife's lover. Preparing to exact his revenge, he peers over a mosquito net at the slumbering, doomed couple.

The commercial success of Hokusai's panoramic views of Mount Fuji was a lesson not lost on the artist Hiroshige (1797–1858). In 1832, Hiroshige was invited to accompany a shogunal expedition to Kyoto. The route, called the Tokaido (after the administrative district through which it passed), originated at Nihonbashi in Edo and moved

**View from Komagata
Temple near Azuma Bridge**
By Andō Hiroshige (1797–1858)
Japan, Edo period
Circa 1857
Woodblock print

generally from east to west along the Pacific coast. The Tokaido had fifty-three outposts or stations. Hiroshige's sketches of the journey formed the basis for his later print series *Fifty-Three Stations of the Tokaido*. The series actually contains fifty-five distinct scenes, because the mountain village Kambara, the sixteenth station, exists in two states. Kambara is blanketed in a heavy and softly falling snow. Villagers trudge bent and huddling against the cold. In the first state of the print, Hiroshige rendered the dark sky only across a narrow expanse at the top. In the second state, illustrated here (pp. 142–43), the dark sky is placed at mid-level and the upper register became a snow-laden expanse. This reversal from the first image greatly enhances the sense of a heavy, umbrellalike cloud-cover, while the falling snowflakes contrast all the more dramatically against the dark sky. While most of the scenes described by Hiroshige in this series can in some way be matched with observable, "true views," the depictions of Kambara and of the forty-sixth station, Shōno, have frustrated generations of scholars who have searched for topography even remotely resembling them. Interestingly, in both instances the artist's primary goal is the effective rendering of dramatic atmospheric effects.

Hiroshige's sweeping observations of the eastern metropolis, as seen in

his *One Hundred Famous Views of Edo*, comprise the last homage by a major Japanese artist to a world about to disappear. The prints were produced between the years 1856 and 1859, with a few carried out by pupils after the master's death in 1858. During the following decade, devastating and relentless change would shake the whole of Japan's social structure. The fall of the shogunal government and unstoppable waves of Western influence would forever alter the face of the nation. The new government stripped the Buddhist establishment of privilege and taxed it so heavily that the expansive, park-like grounds of the temples were drastically reduced. The physical source of much of Hiroshige's delightful vision would survive only in pitiful vestiges.

The artist conceived this series within the time-honored genre of "famous place" depictions. The place may be noted as the site of a significant historical event, for beautiful views, or as a place referenced in earlier literature, particularly poetry. The sites carry multiple accretions of meaning. The depth of possible meanings alluded to in a "famous place" in Edo was, in one sense, testimony to the patina of age that this once upstart city had acquired after it had usurped Kyoto as a center of power.

The Komagata Temple at Azuma Bridge is the fifty-fifth view (opposite), and is part of an internal sequence (prints fifty-five through sixty-three) that observes scenes along the Sumida River, the major north-south waterway of Edo. "Komagata" means, literally, the shape of a colt. The derivation of the name is somewhat vague. The temple housed a famous image of the Bato or Horsehead Kannon. The Bato Kannon functioned in the pantheon of Buddhist deities as a protector of the animal world. In images of this deity, a small horsehead ornaments or emerges from the figure's head. Perhaps the

wooden supplicatory prayer plaques called *ema*, or "horse paintings" might also be a source for the name.

Viewed from the thoroughfare of the Sumida River, or from other distant vantage points, the silhouette of this large temple was surely imposing. Yet Hiroshige jarred convention by offering a perspective that gives only a glimpse of the temple architecture and the bridge. The view is from above, almost level with the bird's-eye vantage of the cuckoo (*hototogisu*) that streaks across the rain-swept sky. As in about one-third of the most compositionally adventurous prints in this series, an immediate foreground element, in this case the red flag of the cosmetics vendor and bird, are the prominent features, the points of reference from which the scene is considered. A technically superb block carving and printing exquisitely suggest the atmosphere of sweeping sheets of rain, rain-bearing clouds, and clear horizon. The rendering of the cuckoo is strikingly archaistic, yet another carefully considered nuance for an already well-understood classical allusion. Mention of the bird's distinctively chilling screech was, from ancient times, woven into poetry of the late spring and early summer. It suggested the haunting cry of a woman's unrequited love. The red flag underscores this allusion to feminine concerns and perhaps to the anxiety that accompanies inadequate or fading beauty. With the only visible reference to human figures being the tiny jottings of boatmen on the river, Hiroshige achieved a remarkably complex and poignant statement. No longer present are the statuesque courtesan figures with attendant symbols indicating their emotional disposition. Although Hiroshige scanned the horizon to create a generous panorama, the true subject of his print is the intensity and pain of human existence lived out under the casually rendered roofs and on the distant streets of Edo.

Catalogue

Objects are listed chronologically within chapters.

PREHISTORIC AND EARLY DYNASTIC CHINA

Globular Jar (*Guan*)
China (Gansu or Qinghai province)
Late neolithic period (circa 5000–
circa 1700 B.C.), Majiayao culture,
Banshan phase
Circa 2500 B.C.
Burnished orange buff earthenware
with painted decoration
31.5 × 44.5 cm (at handles)
The Rice Foundation, 1990.125
Ill. p. 12

Ax (*Yue*)
China (probably Shandong province)
Late neolithic period (circa 5000–
circa 1700 B.C.), probably Dawenkou culture
First half of third millennium B.C.
Jade (nephrite)
15.6 × 9.5 × 0.5 cm
Edward and Louise B. Sonnenschein
Collection, 1950.308
Ill. p. 13

Tubular Prism (*Cong*)
China (probably Zhejiang or Jiangsu province)
Late neolithic period (circa 5000–
circa 1700 B.C.), Liangzhu culture
Third millennium B.C.
Jade (nephrite)
26.7 × 7.6 × 7.6 cm
Edward and Louise B. Sonnenschein
Collection, 1950.526
Ill. pp. 10 (detail), 14

Tripod Wine Vessel (*Jia*)
China
Shang dynasty (circa 1700–circa 1050 B.C.)
Twelfth century B.C.
Bronze
H. 51.5 cm; diam. 23.5 cm
Lucy Maud Buckingham Collection, 1926.1599
Ill. p. 17

Wine Vessel (*Fanglei*)
China
Shang dynasty (circa 1700–circa 1050 B.C.)
Twelfth/eleventh century B.C.
Bronze
45.1 × 24.8 (at handles) × 13.2 (at mouth) cm
Lucy Maud Buckingham Collection, 1938.17
Ill. p. 18

Wine Vessel (*Fangyi*)
China
Western Zhou dynasty (circa 1050–771 B.C.)
Late eleventh century B.C.
Bronze
32.8 × 18.4 × 14.4 cm
Lucy Maud Buckingham Collection, 1932.971
Ill. pp. 20, 21 (detail)

EASTERN ZHOU AND HAN DECORATIVE STYLE

Bell (*Bo*)
China
Eastern Zhou dynasty (770–256 B.C.)
First half of fifth century B.C.
Bronze
62.2 × 43.6 × 36.8 cm
Lucy Maud Buckingham Collection, 1938.1335
Ill. pp. 22 (detail), 24

Arched Dragon Pendant
China
Eastern Zhou dynasty, Warring States period
(475–221 B.C.)
Fourth/third century B.C.
Jade (nephrite)
9.2 × 16.8 × 0.7 cm
Edward and Louise B. Sonnenschein
Collection, 1950.640
Ill. p. 25

Sheath with Bird and Dragon
China
Western Han dynasty (206 B.C.–A.D. 9)
Second/first century B.C.
Jade (nephrite)
10.6 × 5.7 × 0.5 cm
Through prior gifts of Mrs. Chauncey B.
Borland, Lucy Maud Buckingham Collection,
Emily Crane Chadbourne, Mary Hooker Dole,
Edith B. Farnsworth, Mrs. Mary A. B.
MacKenzie, Mr. and Mrs. Chauncey B.
McCormick, Fowler McCormick, Mrs. Gordon
Palmer, Grace Brown Palmer, Chester D.
Tripp, Russell Tyson, H. R. Warner, Joseph
Winterbotham, Mr. and Mrs. Edward Ziff,
1987.141
Ill. p. 26

Garment Hook (*Daigou*)
China (reportedly from Jincun, Henan province)
Eastern Zhou dynasty, Warring States period
(475–221 B.C.)
Fourth/third century B.C.
Bronze inlaid with gold and silver and inset
with jade
8.3 × 8.3 × 2.0 cm
Lucy Maud Buckingham Collection, 1930.703
Ill. p. 26

Wine Vessel (*Hu*)
China (reportedly from Jincun, Henan province)
Eastern Zhou dynasty, Warring States period
(475–221 B.C.)
Fourth/third century B.C.
Bronze with gold and silver with inlays
H. 14.6 cm; diam. 8.9 cm
Lucy Maud Buckingham Collection, 1930.481
Ill. p. 25

Wine Vessel (*Hu* or *Zhong*)
China
Western Han dynasty (206 B.C.–A.D. 9)
Second/first century B.C.
Bronze with incised decor and applied mercury
amalgams of gold and silver
H. 46 cm; diam. 36 cm
Lucy Maud Buckingham Collection, 1927.315
Ill. p. 27

FURNISHINGS FOR THIS WORLD AND THE NEXT

Pair of Tomb Chamber Doors
China (probably Henan province)
Western Han dynasty (206 B.C.–A.D. 9)
First century B.C.
Gray earthenware with impressed and carved
decoration
Left door: 92.6 × 52 × 7.2 cm
Right door: 91.4 × 49.9 × 7.2 cm
Lucy Maud Buckingham Collection, 1924.447,
1924.447a
Ill. pp. 30, 31

Mastiff (Tomb Figure)
China
Eastern Han dynasty (A.D. 25–220)
Second century

Brick-red earthenware with green lead glaze
H. 32.3 cm
Gift of Russell Tyson, 1950.1630
Ill. p. 33

Funerary Urn (Hunping)
China
Western Jin dynasty (265–316)
Late third century
Stoneware with olive-green glaze and molded
and applied decoration
H. 48.7 cm; diam. 27.5 cm
Through prior bequests of Mary Hooker Dole,
Grace Brown Palmer; through prior gifts of
Josephine P. Albright in memory of Alice
Higgenbothem Patterson; through prior gift of
Mrs. Kent S. Clow; Russell Tyson Fund;
Robert C. Ross Endowment, 1987.242
Ill. pp. 28 (detail), 34

Vase (Hu)
China
Sui dynasty (581–618)
Gray stoneware with pale green glaze
and molded and applied decoration
H. 41.6 cm; diam. 23 cm
Gift of Russell Tyson, 1951.299
Ill. p. 35

BUDDHIST SCULPTURE: DIVINE COMPASSION AND WORLDLY ELEGANCE

Head of Guanyin
China (probably Hebei province)
Late Northern Qi (550–577) or Sui (581–618)
dynasty
Late sixth century
Marble with traces of metal fittings at crown
H. 68.6 cm
Samuel M. Nickerson Collection, 1923.1114
Ill. pp. 38 (detail), 39

Mi-le Buddha
China
Tang dynasty (618–907)
Dated 705
Limestone
82.6 × 33.0 × 30.2 cm
Gift of Miss Alice Getty, 1924.115
Ill. pp. 36 (detail), 40

Bodhisattva
China (reportedly from the Canfosi temple,
Hebei province)
Tang dynasty (618–907)
Circa 725/50
Limestone with traces of polychromy
H. 172.7 cm
Lucy Maud Buckingham Collection, 1930.85
Ill. p. 41

Head of a Luohan
China
Northern Song (960–1127), Liao (907–1125),
or Jin (1115–1234) dynasty
Circa eleventh century
Hollow dry lacquer
H. 28.6 cm
Gift of The Orientals, 1928.259
Ill. p. 42

CERAMICS AND SILVER OF THE GOLDEN AGE

Equestrienne (Tomb Figure)
China
Tang dynasty (618–907)
First half of eighth century
Buff earthenware with traces of polychromy
56.2 × 48.2 cm
Gift of Mrs. Pauline Palmer Wood, 1970.1073
Ill. pp. 44 (detail), 46

Armored Guardian (Tomb Figure)
China
Tang dynasty (618–907)
First half of eighth century
Buff earthenware with polychromy
and gilding
H. 96.5 cm
Gift of Russell Tyson, 1943.1139
Ill. pp. 48, 49 (detail)

Seated Woman with Mirror (Tomb Figure)
China
Tang dynasty (618–907)
First half of eighth century
Earthenware with three-color (sancai)
lead glazes
H. 30.8 cm
Gift of Mrs. Pauline Palmer Wood, 1970.1075
Ill. p. 50

Horse (Tomb Figure)
China
Tang dynasty (618–907)
First half of eighth century
Buff earthenware with three-color (sancai)

lead glazes and molded decoration
62.9 × 78 cm
Gift of Russell Tyson, 1943.1136
Ill. p. 51

Jar
China
Tang dynasty (618–907)
First half of eighth century
Buff earthenware with three-color (sancai) lead
glazes and molded decoration
H. 30.5 cm, diam. 23.5 cm
Lucy Maud Buckingham Collection,
1924.292
Ill. p. 52

Stem Cup
China
Tang dynasty (618–907)
First half of eighth century
Silver with chased, repoussé, ringmatted, and
parcel-gilt decoration
H. 4.8 cm; diam. 7.6 cm
Gift of Russell Tyson, 1945.308
Ill. p. 53

Scissors
China
Tang dynasty (618–907)
First half of eighth century
Silver with chased and ringmatted decoration
L. 20.7 cm
Lucy Maud Buckingham Collection,
1926.1592
Ill. p. 53

SONG CERAMICS AND LATER PORCELAIN TRADITIONS

Urn
China
Northern Song dynasty (960–1127)
Late tenth/early eleventh century
Longquan ware; gray stoneware with olive-
green glaze and underglaze carved and combed
decoration
H. 31.8 cm; diam. 16.8 cm
Bequest of Russell Tyson, 1964.783a–b
Ill. p. 56

Cloud-Shaped Pillow
China
Northern Song dynasty (960–1127)
Late tenth/early eleventh century
Cizhou ware; gray stoneware with white slip
and carved, incised, and inlaid decoration
9.7 × 21.5 × 17.9 cm
Lucy Maud Buckingham Collection, 1924.307
Ill. p. 62

Dish
China
Northern Song dynasty (960–1127)
Eleventh century
Ding ware; porcelain with underglaze carved
decoration and metal rim
H. 2.3 cm; diam. 24.4 cm
Lucy Maud Buckingham Collection, 1924.325
Ill. p. 58

Incense Burner
China
Northern Song dynasty (960–1127)
Late eleventh/early twelfth century
Qingbai ware; porcelain with pale blue glaze
H. 19 cm; diam. 15 cm
Gift of Russell Tyson, 1941.963
Ill. p. 60

Small Dish
China
Jin dynasty (1115–1234)
Twelfth century
Ding ware; porcelain with underglaze molded
decoration
H. 1.8 cm; diam. 14.2 cm
Lucy Maud Buckingham Collection, 1925.1009
Ill. p. 59

Vase (*Meiping*)
China (probably Jingdezhen, Jiangxi province)
Northern Song dynasty (960–1127)
Twelfth century
Qingbai ware; porcelain with pale blue glaze
and carved and incised decoration
H. 41.9 cm; diam. 23.2 cm.
Gift of Russell Tyson, 1944.596a–b
Ill. p. 61

Jar
China (probably Yonghezhen, Jiangxi province)
Southern Song dynasty (1127–1279)
Early thirteenth century

Jizhou ware; buff stoneware painted with
underglaze iron slip
H. 22.86 cm; diam. 24.13 cm
The Rice Foundation, 1990.118a–b
Ill. pp. 54 (detail), 63

Dish
China
Ming dynasty (1368–1644)
Xuande mark and period (1426–35)
Inscribed on underside of rim: *Da Ming Xuande
nian zhi* (Made in the Xuande [reign] of the
Great Ming [dynasty])
Porcelain with underglaze blue decoration
H. 5.1 cm; diam. 27.3 cm
Gift of Russell Tyson, 1955.1204
Ill. p. 64

Pair of Teabowls
China
Qing dynasty (1644–1911)
Yongzheng mark and period (1723–35)
Inscribed inside foot-ring: *Da Qing Yongzheng
nian zhi* (Made in the Yongzheng [reign] of the
Great Qing [dynasty])
Porcelain with underglaze blue and overglaze
red, yellow, and pale-green enamels (*doucai*)
H. 4.4 cm; diam. 9.5 cm
Bequest of Henry C. Schwab, 1941.551a–b
Ill. p. 65

TRADITIONS OF CHINESE PAINTING

The Wangchuan Villa
Attributed to Li Gonglin
(circa 1040/49–1106)
China
Late Song (960–1279) or early Yuan
(1279–1368) dynasty
Late twelfth/early fourteenth century
Handscroll; ink on silk
26.3 × 554 cm
Kate S. Buckingham Fund, 1950.1369
Ill. pp. 72–73 (detail)

Yang Pu Moving His Family
China
Yuan dynasty (1279–1368)
Late thirteenth century
Handscroll; ink and light color on paper
52.7 × 231.1 cm
Kate S. Buckingham Fund, 1952.9
Ill. pp. 66 (detail), 68–69

Flight of Geese
China
Yuan dynasty (1279–1368)
Late thirteenth/early fourteenth century

Hanging scroll; ink and color on silk
64.8 × 38.1 cm
Gift of The Orientals, 1953.439
Ill. pp. 70 (detail), 71

Bamboo-Covered Stream in Spring Rain
Xia Chang (1388–1470)
China (Kunshan, Jiangsu province)
Ming dynasty (1368–1644)
Dated 1441
Handscroll; ink on paper
41.3 × 1500 cm
Kate S. Buckingham Fund, 1950.2
Ill. frontispiece (detail)

Distant Mountains
Lu Zhi (1496–1576)
China (Suzhou, Jiangsu province)
Ming dynasty (1368–1644)
1540/50
Hanging scroll; ink and color on paper
105.7 × 31.1 cm
W. L. Mead Fund, 1953.159
Ill. p. 74

Autumn Clearing in the Misty Woods
(from album *Landscapes in the Styles of
Ancient Masters*)
Lan Ying (1585–circa 1664)
China
Late Ming (1368–1644) or early Qing
(1644–1911) dynasty
Dated 1642
One of eight album leaves; ink and color on
paper
30.5 × 40.6 cm
Samuel M. Nickerson Fund, 1958.395
Ill. p. 78

Peach Blossom Spring
After Qiu Ying (died 1552)
China
Late Ming (1368–1644) or early Qing
(1644–1911) dynasty
Probably seventeenth/eighteenth century
Dated 1550 and attributed to Wen
Zhengming (1470–1559) in colophon
Handscroll; ink and color on silk
32.4 × 394.4 cm
Kate S. Buckingham Fund, 1951.196
Ill. pp. 76–77 (detail)

Wisteria and Goldfish
Xu-Gu (1824–1896)
China (Yangzhou, Jiangsu province)
Qing dynasty (1644–1911)
Mid-nineteenth century
Hanging scroll; color on paper
147.3 × 80.7 cm
Gift of Florence Ayscough and Harley
Farnsworth MacNair, 1943.150
Ill. p. 79

CERAMIC ART OF KOREA

Ewer
Korea
Koryŏ dynasty (918–1392)
Twelfth century
Stoneware with celadon glaze and incised
decoration
21.4 × 17.7 × 13.2 cm
Bequest of Russell Tyson, 1964.1213
Ill. p. 80

Vase (Maebyŏng)
Korea
Koryŏ dynasty (918–1392)
Twelfth century
Stoneware with celadon glaze and inlaid
decoration
H. 33.5 cm; diam. 19.8 cm
Gift of Russell Tyson, 1950.1626
Ill. p. 82

Flask
Korea
Chosŏn dynasty (1392–1910)
Fifteenth century
Punch'ŏng ware; stoneware with carved
slip decoration
22.3 × 20.2 × 13.1 cm
Bequest of Russell Tyson, 1964.936
Ill. p. 83

Jar
Korea
Chosŏn dynasty (1392–1910)
Seventeenth century
Stoneware with underglaze iron decoration
H. 30.5 cm; diam. 29.1 cm (at shoulder)
Kate S. Buckingham Endowment, 1986.997
Ill. p. 84

RESPLENDENT PRESENCE: JAPANESE SACRED IMAGERY

Seated Bodhisattva
Japan
Nara period (710–784)
Circa 775
Wood core, dry lacquer, traces of gold leaf
61.0 × 43.2 cm
Kate S. Buckingham Endowment, 1962.356
Ill. p. 88

**Hachiman in the Guise of a Monk
(Sōgyō Hachiman)**
Japan
Heian period (794–1185)
Tenth century
Wood with traces of white pigment
53.3 × 46.4 cm
Gift of the Joseph and Helen Regenstein
Foundation, 1960.755
Ill. pp. 90, 91 (detail)

Jizō
Japan
Kamakura period (1185–1333)
Late twelfth/thirteenth century
Wood with polychromy and gilding
H. 54.6 cm
Gift of the Joseph and Helen Regenstein
Foundation, 1961.635
Ill. p. 94

**Descent of the Amida Trinity
(Amida Sanzon Raigō)**
Japan
Kamakura period (1185–1333)
Thirteenth century
Set of three hanging scrolls; ink, color, and cut
gold on silk
Each scroll 137.2 × 50.2 cm
Gift of Kate S. Buckingham, 1929.855–57
Ill. pp. 86 (detail), 92, 93

Fudō Myōō
Japan
Kamakura period (1185–1333)
Thirteenth/fourteenth century
Wood with polychromy and gilt-bronze
accessories
H. 41.6 cm
Gift of the Joseph and Helen Regenstein
Foundation, 1958.321
Ill. p. 95

Legends of the Yūzū Nembutsu
Japan
Kamakura period (1185–1333)
Fourteenth century

Handscroll; ink, color, and gold on paper
30.5 × 1176.9 cm
Kate S. Buckingham Collection, 1956.1256
Ill. pp. 98–99, 100 (details)

**Kōbō Daishi (Kūkai) as a Child
(Chigo Daishi)**
Japan
Kamakura period (1185–1333)
Fourteenth century
Hanging scroll; ink and color on silk
86.7 × 48.9 cm
Gift of the Joseph and Helen Regenstein
Foundation, 1959.552
Ill. p. 101

Kasuga Deer Mandala
Japan
Muromachi period (1333–1568)
Fifteenth century
Hanging scroll; ink and colors on silk
125.4 × 50.8 cm
Kate S. Buckingham Endowment, 1960.314
Ill. pp. 96, 97 (detail)

IMAGES OF ZEN: VISIONS OF SEVERITY AND SURPRISE

Jar
Japan
Muromachi period (1333–1568)
Fifteenth century
Tamba ware; glazed stoneware
59.5 × 52.9 cm
Gifts of the American Friends of China, Mrs.
William Bloom, Mrs. John Alden Carpenter,
Mrs. Polly Root Collier, W. Everett Fox, Newton
S. Noble, Jr., and Russell Tyson, through
exchange, 1987.147
Ill. p. 108

**Monju in the Guise of a
Hemp-Robed Youth (Nawa Monju)**
Japan
Muromachi period (1333–1568)
1415
Hanging scroll; ink and light colors on silk
92.7 × 40.3 cm
Samuel M. Nickerson Fund, 1929.68
Ill. p. 104

Daruma
Japan
Muromachi period (1333–1568)
Sixteenth century
Hanging scroll; ink and colors on silk
109.2 × 54 cm
Russell Tyson and Samuel M. Nickerson
endowments, 1992.98
Ill. p. 105

Landscape of the Four Seasons
Sesson Shūkei (circa 1504–circa 1589)
Japan
Muromachi period (1333–1568)
Second half of sixteenth century
Pair of six-fold screens; ink and light color
on paper
156 × 337 cm
Gift of the Joseph and Helen Regenstein
Foundation, 1958.168
Ill. pp. 102 (detail), 106, 107

Jar
Japan
Momoyama period (1568–1603)
Late sixteenth century
Iga ware; glazed stoneware
H. 33 cm, diam. 24.5 cm
Through prior gifts of Josephine P. Albright in
memory of Alice Higinbothem Patterson,
Mrs. Tiffany Black, John Carlson, Mrs. Kent S.
Chow, Edith Farnsworth, Alfred E. Hamill,
and Mrs. Charles S. Potter and Mrs. Hunnewell
in memory of Mrs. Freeman Hinkley,
1987.146
Ill. p. 109

THE EMERGENCE OF
JAPANESE DECORATIVE TASTE

Nō Drama Costume (*Nuihaku*)
Japan
Momoyama period (1568–1603)
Sixteenth century
Silk, plain weave; patterned with resist dyeing,
impressed gold leaf, and embroidered with silk
in satin, single satin, surface satin, and stem
stitches; couching
160.6 × 133.1 cm
Restricted gift of Mrs. C. H. Worcester,
1928.814
Ill. pp. 112, 113 (detail)

Maize and Cockscomb
Japan
Edo period (1603–1868)
Mid-seventeenth century
Six-fold screen; colors and gold leaf on paper
59.4 × 169.5 cm
Kate S. Buckingham Fund, 1959.599
Ill. pp. 114–15

**Millet Under the Aspects of Sun
and Moon**
Japan
Edo period (1603–1868)
Late seventeenth century
Pair of six-fold screens; ink, color, and gold leaf
on paper
150.4 × 349.2 cm
Restricted gift of the Rice Foundation,
1989.625a–b
Ill. pp. 118–19

**Flowering Cherry and Autumn Maple
with Poem Slips**
Tosa Mitsuoki (1617–1691)
Japan
Edo period (1603–1868)
Circa 1675
Pair of six-fold screens; ink, color, gold leaf and
powder on silk
142.5 × 293.2 cm
Kate S. Buckingham Collection, 1977.156-157
Ill. pp. 116, 117

Incense Wrapper
Attributed to Ogata Kōrin (1658–1716)
Japan
Edo period (1603–1868)
Seventeenth/eighteenth century
Wrapper mounted on hanging scroll; ink and
color on gold-ground paper
33 × 24.1 cm
Russell Tyson Purchase Fund, 1966.470
Ill. p. 120

Bowl
Japan
Edo period (1603–1868)
Late seventeenth/early eighteenth century
Arita ware; porcelain with polychrome enamel
decoration (Kakiemon-style)
Diam. 20.2 cm
Gift of The Orientals, 1934.98
Ill. p. 122

Plate
Japan
Edo period (1603–1868)
Eighteenth century
Arita ware; porcelain with underglaze-blue
decoration

H. 2.85 cm; diameter 19.36 cm
Samuel M. Nickerson Endowment, 1976.112
Ill. p. 123

**The Twelve Poetic Immortals and
Their Poems**
Reizei Tamechika (1823–1863)
Japan
Edo period (1603–1868)
1850
Pair of six-fold screens; color on paper
Each 80.6 × 313.2 cm
Kato Real Estate Fund, 1990.197.1–2
Ill. p. 124

IMAGES OF THE
FLOATING WORLD

The Insistent Lover
Sugimura Jihei (active circa 1680–98)
Japan
Edo period (1603–1868)
Circa 1680
Woodblock print
27.3 × 40.6 cm
Clarence Buckingham Collection, 1935.406
Ill. pp. 128–29

Woman Playing with a Cat
Kaigetsudō Dohan (active 1710–16)
Japan
Edo period (1603–1868)
Circa 1710
Woodblock print
55.9 × 29.2 cm
Gift of Kate S. Buckingham to the Clarence
Buckingham Collection, 1925.1740
Ill. p. 131

Sparrow Hawk
Torii Kiyomasu I (active circa 1696–1716)
Japan
Edo period (1603–1868)
Circa 1710
Woodblock print
54.9 × 28.6 cm
Clarence Buckingham Collection, 1925.1733
Ill. p. 130

Naka-no-cho Street of the Yoshiwara
Torii Kiyotada (active circa 1720–50)
Japan
Edo period (1603–1868)
Circa 1735
Woodblock print
43.2 × 89.5 cm
Clarence Buckingham Collection, 1939.2152
Ill. pp. 126 (detail), 132–33

Young Woman in a Summer Shower
Suzuki Haranobu (1724–1770)
Japan
Edo period (1603–1868)
1765
Woodblock print
28.6 × 22 cm
Clarence Buckingham Collection, 1957.556
Ill. p. 134

The Actor Bandō Mitsugoro as Ishii Genzō
Tōshūsai Sharaku (active 1794–95)
Japan
Edo period (1603–1868)
1794/95
Woodblock print
37.5 × 24.7 cm
Clarence Buckingham Collection, 1940.1086
Ill. p. 136

Woman Holding a Comb
Kitagawa Utamaro (1753–1806)
Japan
Edo period (1603–1868)
Circa 1798
Woodblock print
38.7 × 26.5 cm
Clarence Buckingham Collection, 1925.3068
Ill. p. 135

Clear Day with a Southern Breeze
(from *Thirty-Six Views of Mount Fuji*)
Katsushika Hokusai (1760–1849)
Japan
Edo period (1603–1868)
Circa 1831
Woodblock print
26.3 × 38 cm
Clarence Buckingham Collection, 1928.1085
Ill. pp. 138–39

The Ghost of Kohada Koheiji
Katsushika Hokusai (1760–1849)
Japan
Edo period (1603–1868)
Circa 1831
Woodblock print
25.4 × 18.1 cm
Clarence Buckingham Collection, 1943.602
Ill. p. 140

Night Snow at Kambara
(from *One Hundred Views of Edo*)
Andō Hiroshige (1797–1858)
Japan
Edo period (1603–1868)
Circa 1833
Woodblock print
24.1 × 36.8 cm
Clarence Buckingham Collection, 1925.3517
Ill. pp. 142–43

View from Komagata Temple near Azuma Bridge
Andō Hiroshige (1797–1858)
Japan
Edo period (1603–1868)
Circa 1857
Woodblock print
36 × 24.1 cm
Clarence Buckingham Collection, 1925.3744
Ill. p. 144